ANGE IS THE
ST THING THAT
EVER DONE ON
E ONLY THING
BE BIGGER IS
TO STOP IT"
~BILL M

Addressing
CLIMATE CHANGE

An illustrated biography of the annual
United Nations Climate Change Conference
COP18/CMP8, DOHA, THE STATE OF QATAR

Addressing
CLIMATE CHANGE

An illustrated biography of the annual
United Nations Climate Change Conference
COP18/CMP8, DOHA, THE STATE OF QATAR

Addressing Climate Change

Published & Photographed by Henry Dallal

For more information see:
www.henrydallalphotography.com
email: henry@henrydallalphotography.com

Text: Christopher Hack & Chad Carpenter

Design & project management: Terry Jeavons
www.tjco.co.uk email: terry@tjco.co.uk

Additional photography: Sallie Shatz and her team, Andreas Hofer,
Elena Stavenko and Terry Jeavons

Pre-press production: XY Digital

Printed & bound by Castelli Bolis Poligrafiche SPA, Italy.
Printed on GardaMatt Art paper produced by Cartiere del Garda (Italy) with
celluloses coming from certified and controlled forests and plantations.

ISBN 978-1-908531-537

Contents

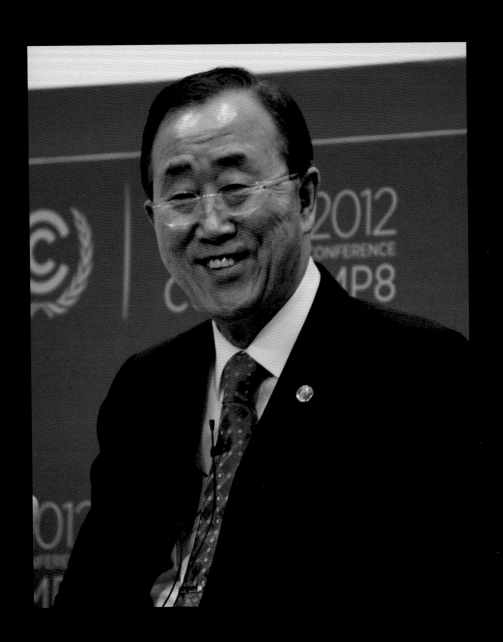

The United Nations Framework Convention on Climate Change (UNFCCC) is vital in the world's efforts to address one of the greatest challenges of our time.

Tackling climate change will require the continued commitment of the international community to the UNFCCC process. This collection of photographs sheds light on the important work taking place within this collaborative arena.

I congratulate the State of Qatar for playing such a constructive role as host to the Conference of the Parties, and thank the people of Qatar for their hospitality.

HE Ban Ki-moon
UNITED NATIONS SECRETARY-GENERAL

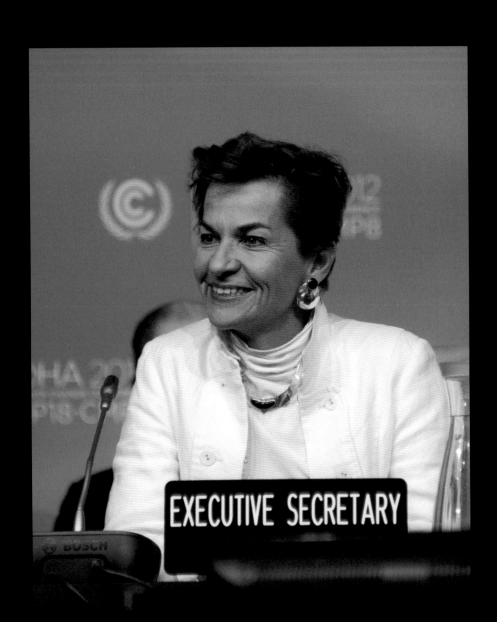

The annual UN climate change conference provides a venue for international negotiations on curbing greenhouse gas emissions and adapting to the inevitable effects of climate change. Climate change is the foremost challenge of our time and meeting this challenge requires hard work by many different individuals and groups. Much of this effort happens at the UN climate change conference. At this inclusive event, government delegates, civil society, private sector actors, scientists and activists come together to further the climate dialogue. The many different meetings, the people and the location give each conference its own unique character and personality, and ensuring that all this comes together and results in a successful UNFCCC COP can be a daunting task. This photographic book presents an excellent visual depiction of COP18 held in December 2012 at the unrivalled Qatar National Convention Centre in Doha. These photographs truly give an authentic behind-the-scenes look at both the negotiations and the events that accompanied them.

Now is an exciting time as the international process, buoyed by progress in national governments and the private sector, moves towards meeting the commitment to enact a new, universal climate agreement and to raise immediate ambition to combat climate change. I support this progress and hope this photographic book becomes part of a historic record that highlights COP18 as an important milestone. I applaud the initiative by the Qatari COP18 Presidency to capture the excitement of COP18 in a format that helps people understand how governments and non-government representatives come together to address climate challenge.

Ms Christiana Figueres
EXECUTIVE SECRETARY OF THE UNITED NATIONS FRAMEWORK CONVENTION ON CLIMATE CHANGE

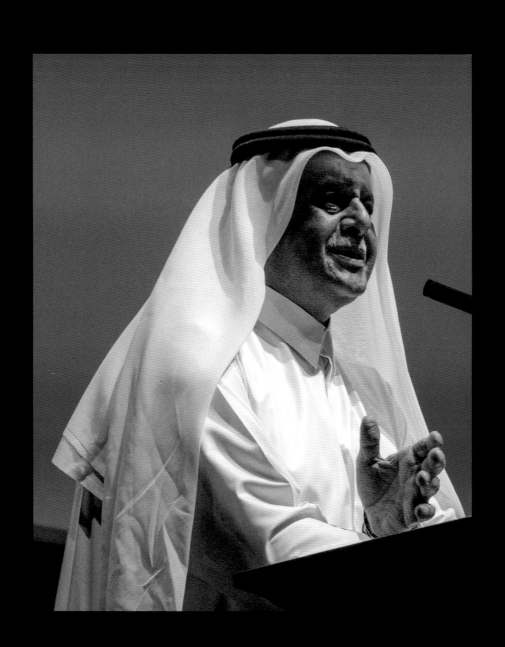

COP18/CMP8 achieved great progress in our common fight against climate change. Significant policy advancements were agreed upon, not least of which were a second commitment period of the Kyoto Protocol and a reinforcement of the Durban Platform negotiations track.

Of equal importance, the Doha Conference strengthened the renewed trust placed by Parties in the climate change negotiations process — an essential regain initiated at COP16 in Cancun and strengthened in Durban at COP17. It is indeed my hope that Doha will retrospectively mark the advent of an ever more transparent and productive approach to COPs — one in which each country feels respected, accounted for and listened to.

I will forever rejoice in these important achievements and remain grateful for the tireless cooperation and support of delegates, observers and NGOs. Despite the pressure and intensity inherent to climate change negotiations, everyone stepped up and contributed their part for Doha 2012 to be a resounding success.

A special note of thanks goes to civil society members — particularly the Arab youth — who played an essential role in bridging the gap too often felt between policymakers and citizens, science and government, academia and industry. Congratulations to all COP18/CMP8 participants on a truly outstanding conference.

HE Abdullah bin Hamad Al-Attiyah
PRESIDENT OF COP18/CMP8

Introduction

There are few moments when our world comes together and speaks with one voice. Addressing the issue of climate change is surely one of them. Humankind has made breathtaking advances since the beginning of the industrial age in the 18th century. We have witnessed the global population grow from one to seven billion; we have realised previously unimaginable achievements in science, industry, education, healthcare, the arts and culture. However, there has been a price for this progress. We have damaged our only home — stripping the land, emptying the seas and threatening the diversity of life with our pollution. But perhaps the farthest reaching impact is the one we have had on our global climate system. The fossil fuels, changes in land use and expansion of agriculture that have driven development over the past century have led to the release and concentration of trillions of tonnes of waste gas in the atmosphere.

Greenhouse Gas

One of the primary drivers of the global climate change we are experiencing is a group of gases commonly referred to as 'greenhouse' gases which, because of the way they trap heat, increase global temperatures. The concentration in the atmosphere of one of the most common greenhouse gases, carbon dioxide, was broadly stable for millennia. However, since the start of the industrial age less than 300 years ago it has almost doubled, currently measuring more than 400 parts per million (ppm) and it's still growing — rapidly.

While the very nature of scientific exploration means there will and should always be rigorous debate on facets of the issue, there are some things we can measure empirically and establish as fact. The rising concentration of carbon dioxide in our atmosphere is one such observable certainty.

If we as a global community are to keep pushing forward, we must find ways to support progress without further compromising our own future and the home that we leave to our children. This means tackling greenhouse gas and global climate change, which is a challenge that no single government or country — no matter how powerful — can fix alone. It requires international cooperation and collaboration on a new scale. Global climate change will only be tackled when the nations of the world come together and speak with one voice.

This is the global challenge addressed by the United Nations climate change negotiations process. Through a framework for agreements, collaboration and negotiations, these annual conferences of COP (Conference of the Parties) bring together the leaders of governments and civil society to address this global challenge.

Earth Summit

Since the 1970s, there has been growing scientific concern about the effects of civilisation on the Earth's climate. In 1988, an Intergovernmental Panel on Climate Change was established to pull together and review international research on the issue. Its first report, two years later, was so troubling that the international community demanded a political response. In June 1992, the nations of the world came together for 11 days in Rio de Janeiro, Brazil, to address the problem. At this United Nations Conference on Environment and Development — later known as the Earth Summit — thousands, including more than a hundred heads of State, sought ways to support economic growth and development while limiting further damage to other species, systems and the environment. World leaders committed themselves on various issues including protecting forests, preserving biodiversity and tackling climate change.

At the end of the Summit, governments adopted a UN agreement, namely, the United Nations Framework Convention on Climate Change (UNFCCC). The object was to 'stabilise greenhouse-gas concentrations in the atmosphere at a level that would prevent dangerous [human] interference with the climate system'. While the 1992 agreement did not set specific limits on the amount of greenhouse gas countries could produce, it established a framework for negotiation limits and response measures.

Birth of 'COP'

The first formal meeting of the parties that had signed the Rio agreement gathered in Berlin in 1995, to review progress and to begin setting formal commitments. The 'Conference of the Parties', as it was known, would become an annual event and, for ease of reference, was abbreviated to 'COP' with the Berlin meeting known as COP1.

The administrative body that overseas the treaty and the annual COP conferences is based in Bonn, Germany, and is known by the title of the Rio agreement: United Nations Framework Convention on Climate Change (UNFCCC).

Kyoto Protocol

There have been 19 annual COP conferences since 1995. As in any ongoing multinational negotiation, some years have seen significant progress and the resulting agreements have come to be known by the name of the host city or country. COP3, hosted by Kyoto, Japan, in 1997, served as just such a milestone. At this gathering, a majority of the world's industrialised countries committed to cut their emission of greenhouse gases.

They pledged to cut emissions by between 6–8 per cent below the levels measured in their countries in 1990, and to achieve these cuts by a percentage point over the period 2008–2012.

At a chilly 6am on the first morning, the United Nations flag is raised over the Qatar National Convention Centre. For the next two weeks, the venue becomes sovereign UN territory, policed by members of the UN's own force.

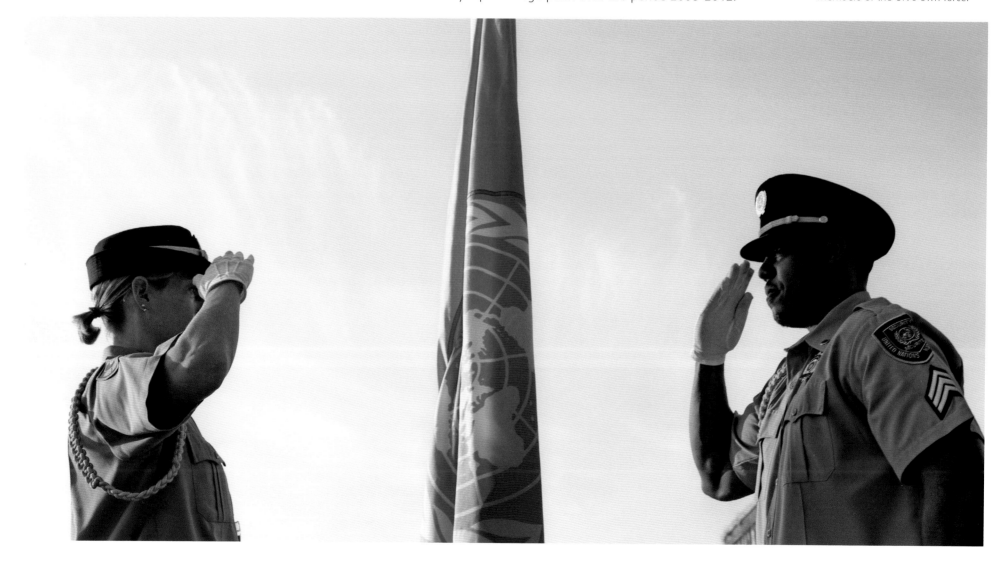

The agreement did not set reduction targets for developing countries. The Kyoto Protocol was hailed as a significant breakthrough, with the nations of the world taking meaningful steps to address climate change and create a more sustainable future.

The Kyoto Protocol came into force as a treaty in 2005, and from that year, the annual COP conference has also played host to a separate meeting made up of the signatories to the Kyoto

Protocol. This became known as the 'Conference ... Meeting of the Parties to the Kyoto Protocol' abbreviated to 'CMP'. So the 2005 conference, in Montreal, Canada, in November of that year, became known as COP11/CMP1. Discussion began on a second commitment period after 2012, that would require States to make yet deeper cuts to their emissions.

Over the years, COP conferences have delivered a range of agreements on many supporting issues, including finance for developing countries working to reduce emissions; allowing countries to 'trade' some of their gas-emission quotas under the Kyoto limits; allowing industrialised countries to meet emission targets by funding emissions reductions in other countries; and giving countries credits for preserving or restoring ecosystems, such as forests and wetlands, soak up and convert, store or sequester greenhouse gases.

Mitigation and Adaptation

The next landmark came in 2007 at the conference in Bali, Indonesia, when delegates began working towards a new Kyoto commitment period, and agreed a road map that included longer-term pledges of cooperation; an agreement to replace the Kyoto Protocol after it expired; and a plan to pay developing countries to preserve their forests.

Two words that were increasingly coming into use as a result of the process were 'mitigation', which related to efforts to reduce emissions or soak up the gases using such natural systems as forests; and 'adaptation', which addressed how countries could prepare proactively for expected changes, such as rising sea levels, and how nations most immediately at risk, including small-island States in the Caribbean and the Pacific, could begin preparing for the dramatic challenges ahead.

In 2009, plans for a new Kyoto-style agreement emerged at the COP15/CMP5 conference in Copenhagen, Denmark. However shifts in the global economy and rapid development in nations such as China and India had introduced new challenges to the process. Some industrialised nations were rethinking the commitments made in Kyoto and there seemed to be little appetite for tightening limits on emissions.

Pre-existing sculptures along Doha's Corniche seem to resonate with the values of COP18.

In 2010, the conference gathered in Cancun, Mexico, and agreed to create a $100-billion fund to help industrialised countries support mitigation and adaptation projects in developing countries. While COP16/CMP6 created this critical funding tool, identifying the source of the funds would be the job of future negotiations. The following year, COP17/CMP7 took place in Durban, South Africa, and concluded with a 60-hour marathon session that produced the Durban Platform: a broad agreement to negotiate a long-term, universal mitigation agreement by 2015.

The Doha Climate Gateway

When the conference came to Doha in 2012, the optimism for what could be built on the momentum of the Durban Platform was tempered by concern over more withdrawals from participation in the Kyoto Protocol.

Groups of delegates and observers seemed far apart on many key issues, and expectations for a successful outcome were limited. Led by HE Abdullah bin Hamad Al-Attiyah, President of COP18/CMP8, the hosting delegation from the State of Qatar worked tirelessly to bring the sides together and negotiate an agreement. The patience and determination of the delegates and observers paid off when in an over-time session, a full package of agreements known as the Doha Climate Gateway was adopted by the conference. Opening the door for progress towards a universal agreement in 2015, the Doha Climate Gateway included agreement on a second commitment period for the Kyoto Protocol, a timetable for reaching the universal climate agreement, and agreement on raising the ambition of current mitigation efforts. Parties also endorsed the establishment of new institutions, and agreed ways to deliver more finance and technology to developing countries.

Building from the Doha Climate Gateway, COP19 in Warsaw, Poland and COP20 in Lima, Peru, are set to chart the course for the adoption of the first-ever universal agreement on addressing climate change in 2015 at COP21 in Paris, France.

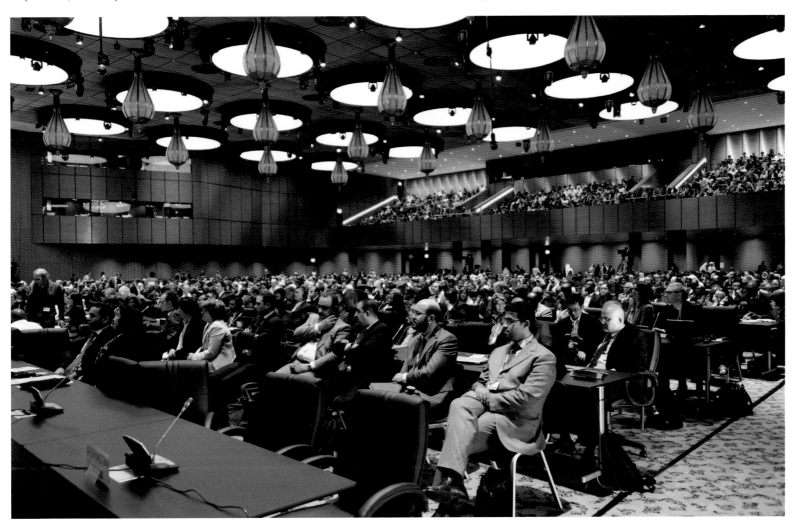

Organising the Annual Conference

The region of the world where the next Conference of the Parties (COP) will take place is always known well in advance — the mystery is which country, and which city. This involves a lot of politics and diplomacy, as well as financial and environmental commitment. Confirmation often comes late or, to be more precise, in the early hours of the morning, on the last day of the previous conference.

The timing is awkward, given that the end of the COP is already a time of mixed emotions. There is the closing of the conference; and saying goodbye to a place and a group of people you have spent many months working with — often day and night in what is usually the longest and largest event the host city has ever held. This sadness is then mixed with the exciting anticipation of a new start at the announcement of the next venue. Exhaustion is mixed with relief and happiness. It is a bit like announcing that you are pregnant; and from that moment you have about nine months to deliver the next 'most beautiful baby in the world'. I have had the privilege of experiencing many such moments in the past two decades, and the honour to have on my side an almost unchanged group of wonderful people — a truly professional team.

New COP, New Country

The new conference always begins with a fact-finding mission. When I first arrived in Doha, I still had fresh memories of the last COP, in Durban, South Africa. I have had the privilege of experiencing 16 COPs but, like babies, every one is unique, a totally different experience.

On arrival I am met by a group of absolute strangers; it is all new, but very welcoming. Deep in my heart I yearn for the familiarity of the previous national team I just left behind; a team I spent nine months with, preparing and delivering what all who are involved describe as a most memorable and rewarding experience, and one where they never worked so hard before.

Déjà vu rescues me when I talk to the new team and hear their aspirations, concerns and questions: they intend to make the conference a complete success and exceed the achievements of the last one. There are familiar questions, though in a different setting and climate. Experience helps me recognise the need to shake off my nostalgia and focus on the new task — and on the clock.

In May 2013 in Bonn, a brainstorming workshop, entitled 'How to COP', for the first time brought together representatives from 11 previous host country governments, senior UN staff and the UNFCCC secretariat, *right*. The workshop offered the opportunity to reflect on experiences, exchange lessons learned and provide strategic inputs; sought to develop good practices and policies for future COP hosts.

Hopes and Fears

I hide the fact that my fears and anxiety are equal to theirs. Yes, I have done this before — many, many times — but not here, and not with them and not in this language. It is like entering into a relationship with a stranger. Yes, I have lived through success, but I have also experienced failure. My apprehension of danger is overcome by the excitement of another chance — yet another chance — to enter an empty space and mould it. There are basic requirements, but a lot of room for creativity; for experimenting; for using new materials, new colours, new shapes; and for pushing environmental awareness a couple of steps further.

My hopes have to be balanced against the familiar realities. There are the sceptics, the thrifty, the race against time, the lawyers, the merchants looking for ultra-profits, the administrators imposing rules, the bankers worried about funding models, the security team questioning extra-territoriality, the ministers working in silos until the principle reminds them that this is a national undertaking.

There is the world's media; there are the more than 1,200 non-governmental organisations and delegations from 179 countries — among them the Holy See — including presidents, ministers and senior officials. All of this, and focused on Doha! Where? What? How? Who? Can they? Will they? The realisation that it is a curse, yet also an opportunity to shine if well grasped, is not missed.

Two Teams Become One

Danger and fear and the sheer amount of time spent together acts as a wonderful catalyst for bonding and melding the new group to the point of transcending differences. That fleeting moment when this happens is neither measurable nor graspable, but it is everlasting. The international and the national lawyers, administrators and security officers begin to share the same interest and speak the same language, driven by the need to deliver the child healthy and bouncy to the waiting world. Before long the two teams — now one — discover many common passions; an opportunity for the international to pass on experience and for the national to deliver something new, by introducing their land, their food, their habits, their clothes,

Ms Salwa Dallalah, *left*. Famous for never losing her composure, no matter what the stresses are around her, Ms Dallalah always manages a smile.

their customs, their message to the world, and their conference outcome. Their way of doing the work. Mutual respect is born; its name is COP.

The days, nights and long hours are rewarded by the arrival of everyone from around the world; the stunts of the protesters to peacefully raise awareness of the plight of Mother Earth; the chance for many to get a platform to make their passionate pleas, and be heard; the hundreds of cameras and members of the media capturing the moments; the experts preaching their points; the Nobel laureates, the officials and ministers rolling up their sleeves and showing commitment; the intense dialogue among decision-makers; the engagement of people and personalities at the highest level, transcending boundaries; the irresistible feeling of the team that, for this period, this is the centre of the universe.

The superlative Doha experience is my latest in a series of wonderful deliveries. The photographs in this book capture the moments beyond any words.

Ms Salwa Dallalah
COORDINATOR FOR CONFERENCE AFFAIRS SERVICES,
UNITED NATIONS FRAMEWORK CONVENTION
ON CLIMATE CHANGE (UNFCCC)

COP Timeline
Starting in 1995, the UN climate change conference has become an annual event visiting seventeen host cities worldwide

1995	**COP1**	Berlin
1996	**COP2**	Geneva
1997	**COP3**	Kyoto
1998	**COP4**	Buenos Aires
1999	**COP5**	Bonn
2000	**COP6**	Kyoto
2001	**COP7**	Marrakech
2002	**COP8**	New Delhi
2003	**COP9**	Milan
2004	**COP10**	Buenos Aires
2005	**COP11/CMP1**	Montreal
2006	**COP12/CMP2**	Nairobi
2007	**COP13/CMP3**	Bali
2008	**COP14/CMP4**	Poznan
2009	**COP15/CMP5**	Copenhagen
2010	**COP16/CMP6**	Cancun
2011	**COP17/CMP7**	Durban
2012	**COP18/CMP8**	Doha
2013	**COP19/CMP9**	Warsaw
2014	**COP20/CMP10**	Lima
2015	**COP21/CMP11**	Paris

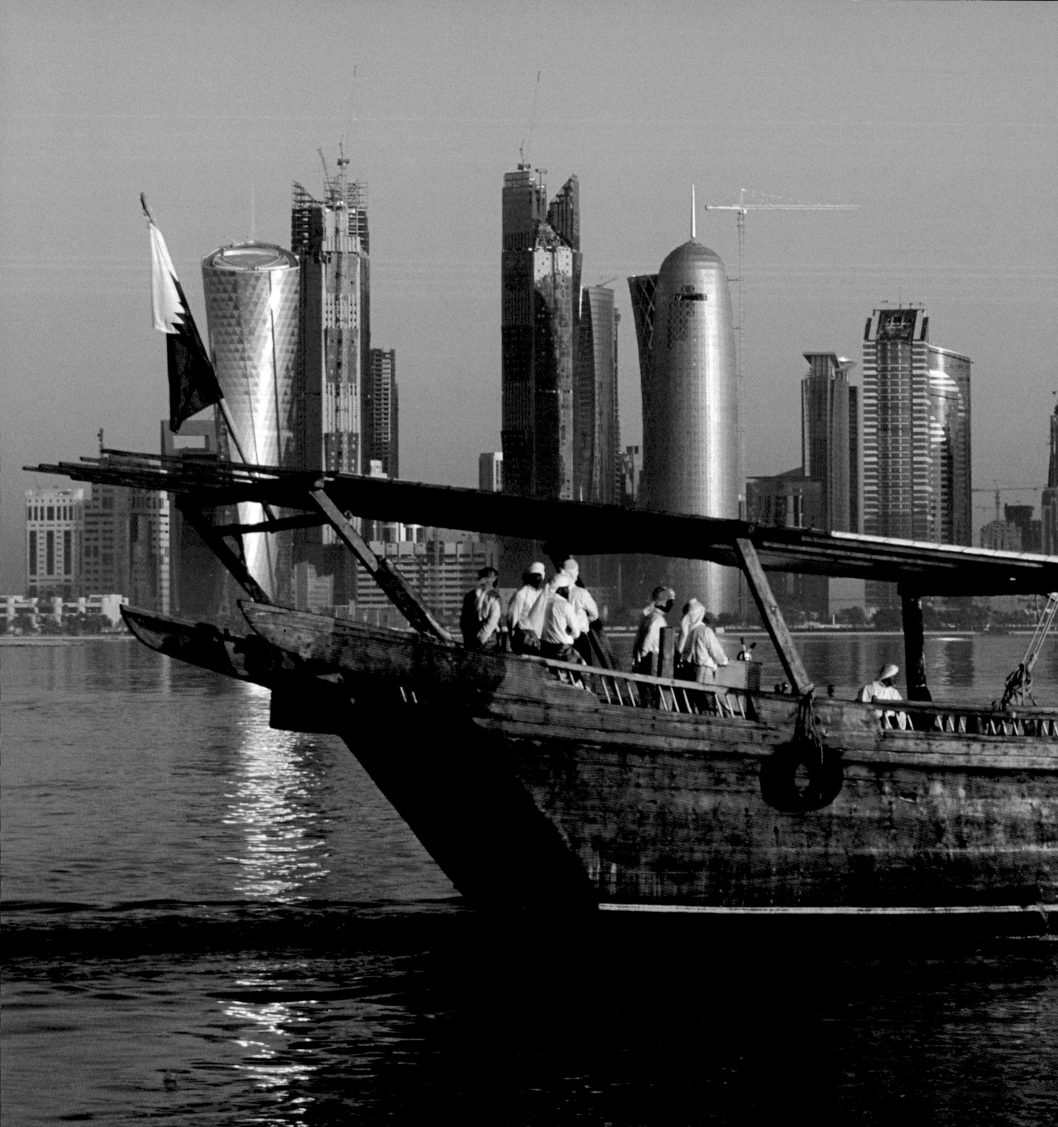

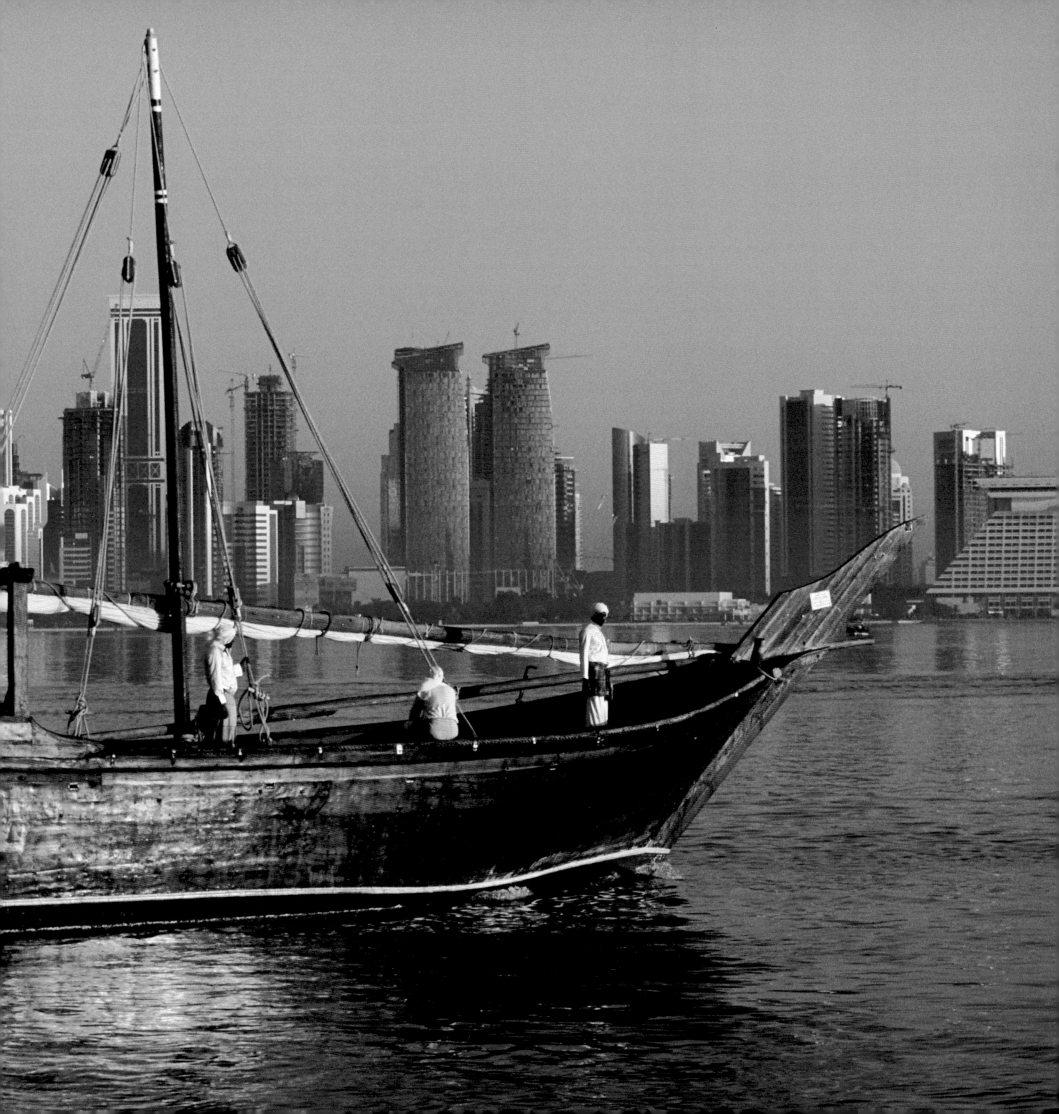

Preparations to host the prestigious international event need to be meticulous, and extend beyond typical conference facilities. An example is the sweeping Arabic-tent styled area at COP18/ CMP8, where participants could withdraw for a quick meal and gather their thoughts before the drama ahead.

Logistics

Participants enjoy a break from proceedings outside one of the refreshment areas. With negotiations taking place 24 hours a day, participants make good use of the areas, where they can order hot food, hold informal discussions, find space to work or just catch up on some sleep.

Let's build a city, a city for 16,000 people, with its own 24-hour transport network, restaurants and healthcare facilities. Let's connect it to the world — in fact, bring the world to the city, through modern communications and media presence, with fast internet connections, websites, apps and social media. Additionally, there must be those things that are vital to a society but taken for granted — like road signs, maps, bus timetables, planned accommodation, security and public information. Moreover, let's do this, not over several years — but a few months. Two weeks later, we will remove all physical trace, yet leave a powerful legacy for the world, along with rich memories.

This is the logistical challenge of creating a United Nations climate change conference. Yet such an ambitious physical undertaking is only the beginning. For this new settlement must know how to host presidents and kings, political campaigners and teenage activists; it must organise more than 2,000 meetings in two weeks and provide a multitude of daily cultural entertainment for guests.

Despite the enormous scale and pressure, no decision must be taken without first measuring its environmental impact, and every gramme of carbon emission must be recorded. Yet there is more, for all of this must be achieved with no margin for error. The world will not wait. Everything must be prepared and delivered on time, and events planned literally to the second. This must be a venue where the world can negotiate its future, and tackle the most crucial issues confronting mankind.

Such a challenge is the stuff of civic planner's dreams — or nightmares — but it is also the basic logistics checklist for those hosting the conference.

When the State of Qatar was selected by the delegates of COP17/CMP7 to host the 2012 event, this was the task ahead. Teams were created, specialists in every aspect of this vast undertaking were found and brought together to do the best work that they had ever done: more than 300 experts in protocol, communications, events management, transport, accommodation, advertising, IT, branding, conference planning, catering and many other fields. They had one task ahead of them. And the clock was ticking.

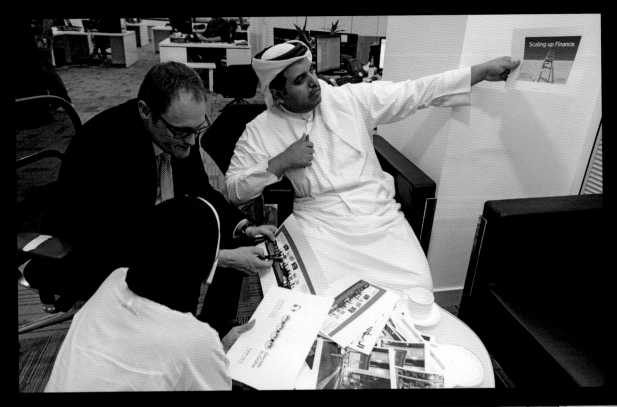

In the countdown to the event, senior organisers work through the detailed logistics. They know that success at such a vast and important conference requires detailed, painstaking planning, and they work with a team of more than 300 people to prepare the event.

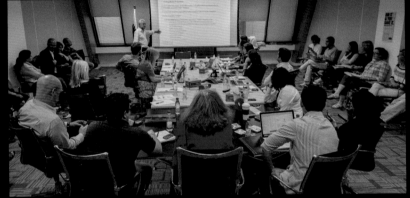

The organising committee works to ensure seamless liaison with the city and national government. Other critical meetings bring together specialists and representatives from UNFCCC to discuss transport, security, catering, accommodation and communications.

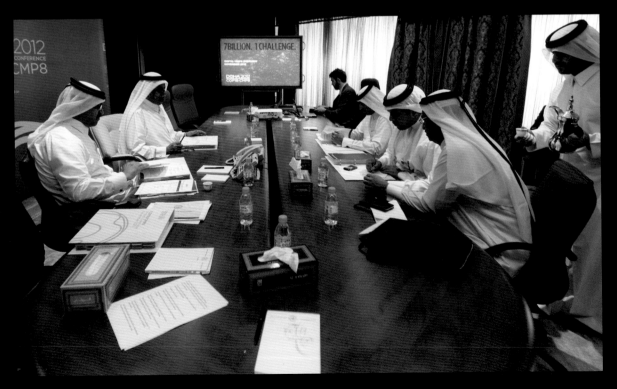

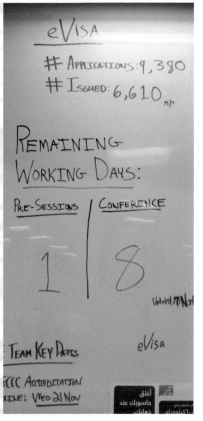

eVisa

Applications: 9,380
Issued: 6,610

REMAINING
WORKING DAYS:

PRE-SESSIONS | CONFERENCE

1 | 8

Updated 17 Nov 71

TEAM KEY DATES eVisa

FCCC Accreditation
xive: Wed 21 Nov

HE Abdulaziz bin Ahmed Al-Malki, *top left*, Chairman of Executive Organising Committee of COP18/CMP8, and Mr Fahad bin Mohammed Al-Attiya, Chairman of Organising Sub–Committee, are two critical figures on which the conference depends.

Coordination also extends from one conference leader to the next, with HE Maite Nkoana-Mashabane, *left*, President of COP17/CMP7 in Durban in 2011, arriving for talks ahead of the 2012 conference with HE Abdullah bin Hamad Al-Attiyah, who will become President at COP18/CMP8 Doha.

23

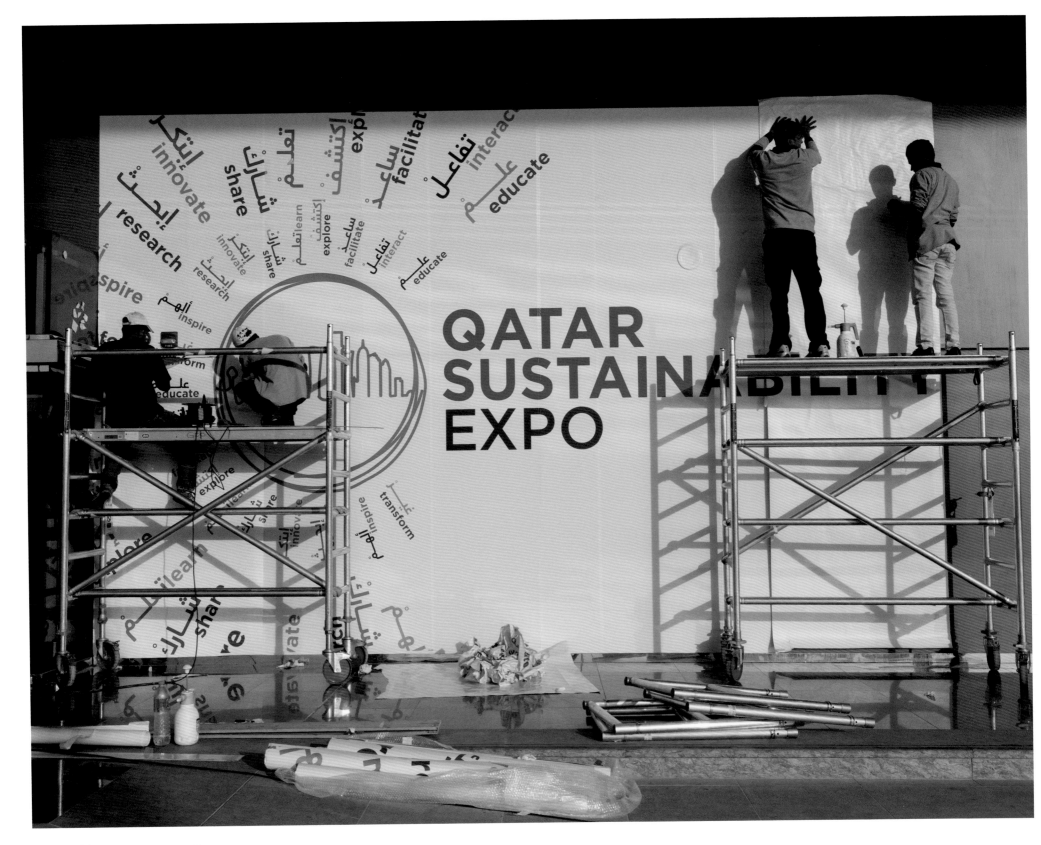

A sustainability expo ran concurrently with COP18, showcasing the brightest ideas in sustainability from the region and the wider world — from new ways to recycle to solar-powered vehicles. A total of 94 organisations took part, and 12,000 visitors attended.

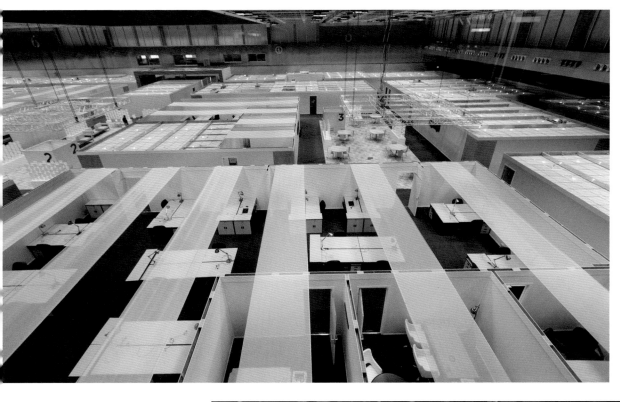

Preparing the Qatar National Convention Centre (QNCC) to host 16,000 participants is a mammoth constructional operation.

Information pods, *below left*, appear in shopping malls and throughout the city to raise awareness among residents about the conference — and what they can do to reduce their own carbon emissions. Technicians, *left*, in the conference centre, meanwhile lay about 30km of copper cable and almost 4km of fibre-optic cable. They expect up to 35,000 data connections during the event, and the venue information technology team alone is increased approximately ten-fold to 189 people.

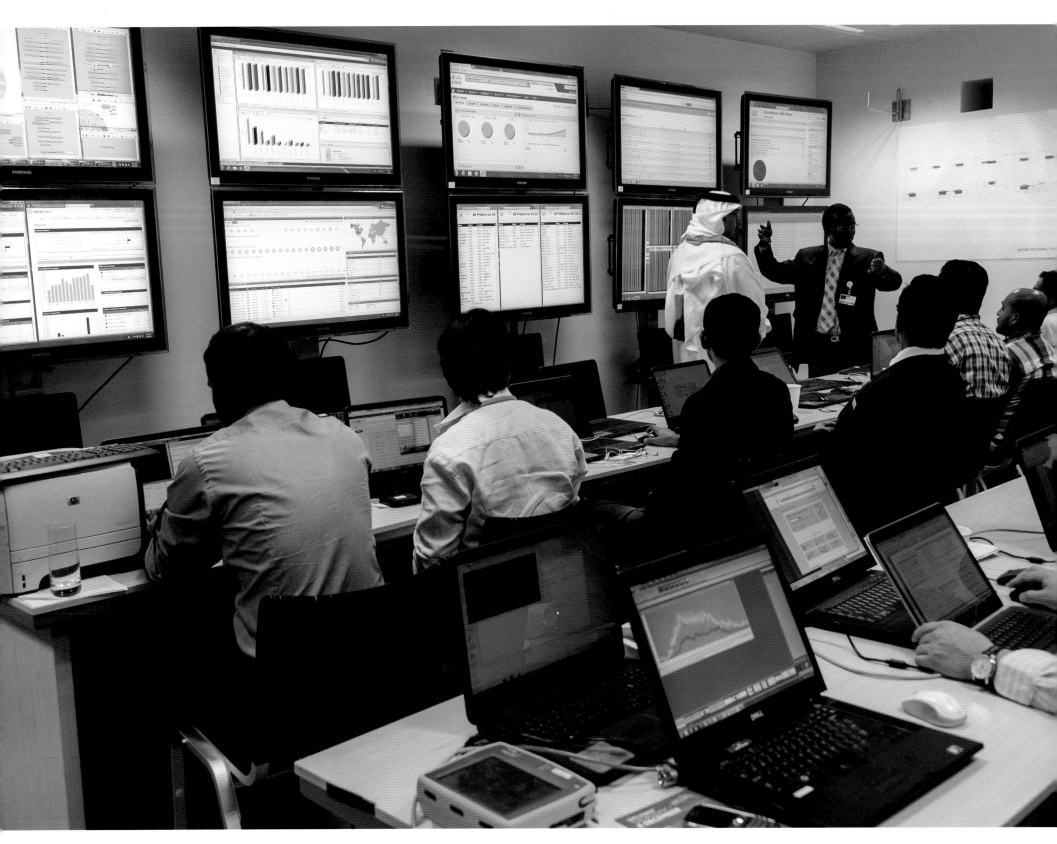

Coordinating such a massive event is a vast logistical undertaking, and at the main operations room technical staff work 24 hours a day to monitor everything from the flow of people around the building to the use of internet facilities.

COP 18
Operations Room

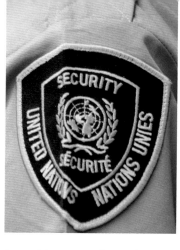

Beyond the teams of specialists brought in to plan, organise and manage the event, the beating heart of the conference is a force of 1,145 volunteers, *left*, recruited from across the country, who dedicated their time and effort to help make the conference a success — from greeting dignitaries at the airport, to manning information booths, to coordinating transport.

With so many dignitaries in one place, a very visible and professional UN security team, recognisable by their uniform, *above*, is present to provide peace of mind for participants but is rarely called upon.

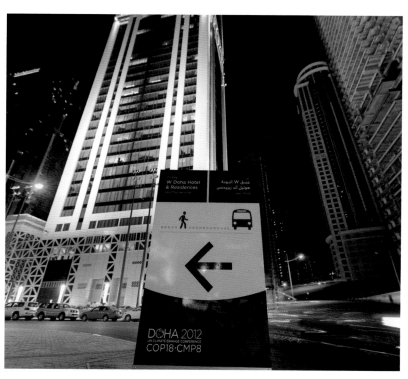

The 16,000 conference participants are staying in hotels around the city, and transporting them to the venues and home again is a colossal operation. From scratch, organisers create a bus network that any city would be proud of, with more than 400 buses, monitored by satellite and live mapping running a 24-hour service to every major hotel, mall and destination across the city.

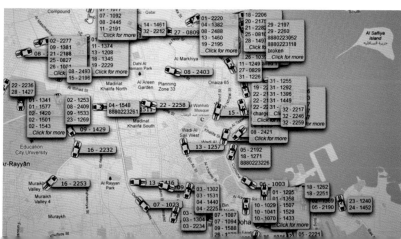

Collaboration, *above*, between the host nation, the organising committee and the venue is key to a smooth-running conference. Preparation is everything, from the cleanliness of the centre to the branding. The equivalent of six football fields of branded backdrops are produced for COP18/CMP8, and after the event, all are recycled into carrier bags, in keeping with the spirit of the conference.

The emphasis on recycling runs through every aspect of the event, from measuring the exact carbon footprint of the conference to only printing meeting documents, *right*, that are actually required by delegates. Using this UN 'PaperSmart' initiative, only 264,000 pages of documents are produced at COP18/CMP8 Doha—about one-tenth of the 2.4 million produced at the previous year's event.

Technology plays a key role in keeping the carbon emissions of the conference low. For example, QNCC, *opposite*, draws a large part of all its energy from 3,500 square metres of solar panels on the building, and makes extensive use of daylight for lighting, as well as having features such as highly efficient water management facilities.

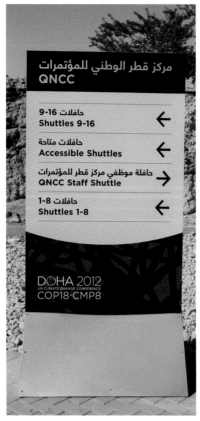

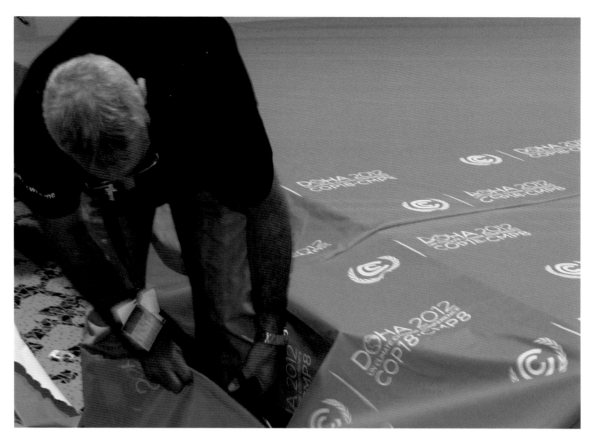

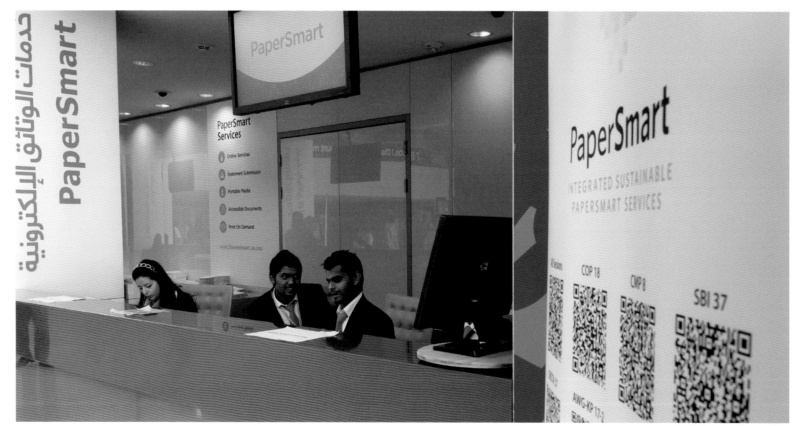

Catering staff prepare lunch for some of the 16,000 participants. Negotiating climate treaties is hungry work, and a team of 128 chefs and 750 serving staff prepare and serve 33,400 meals — all made using food from environmentally sustainable sources. Even the cutlery is designed to be recycled.

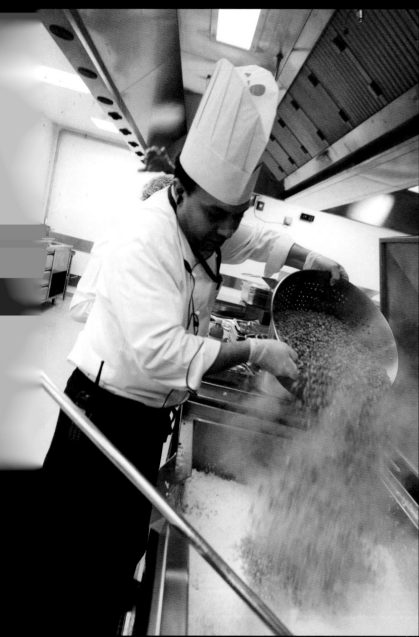

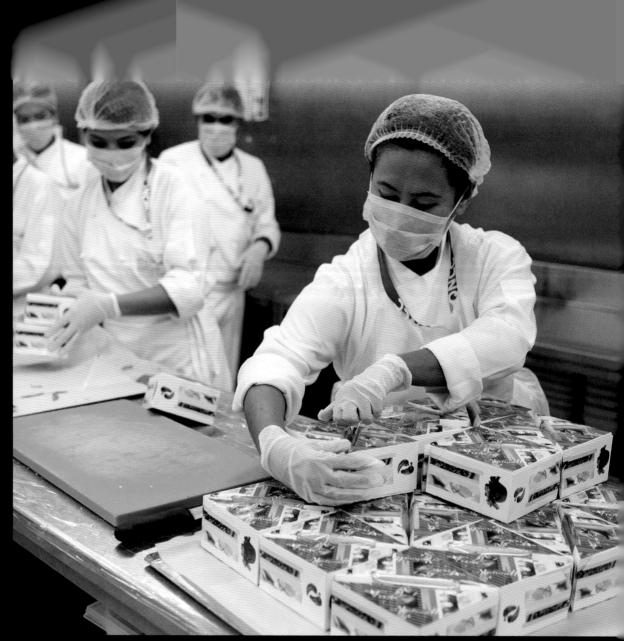

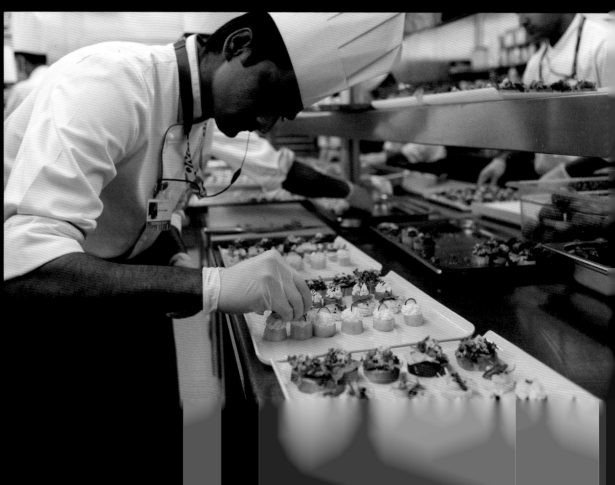

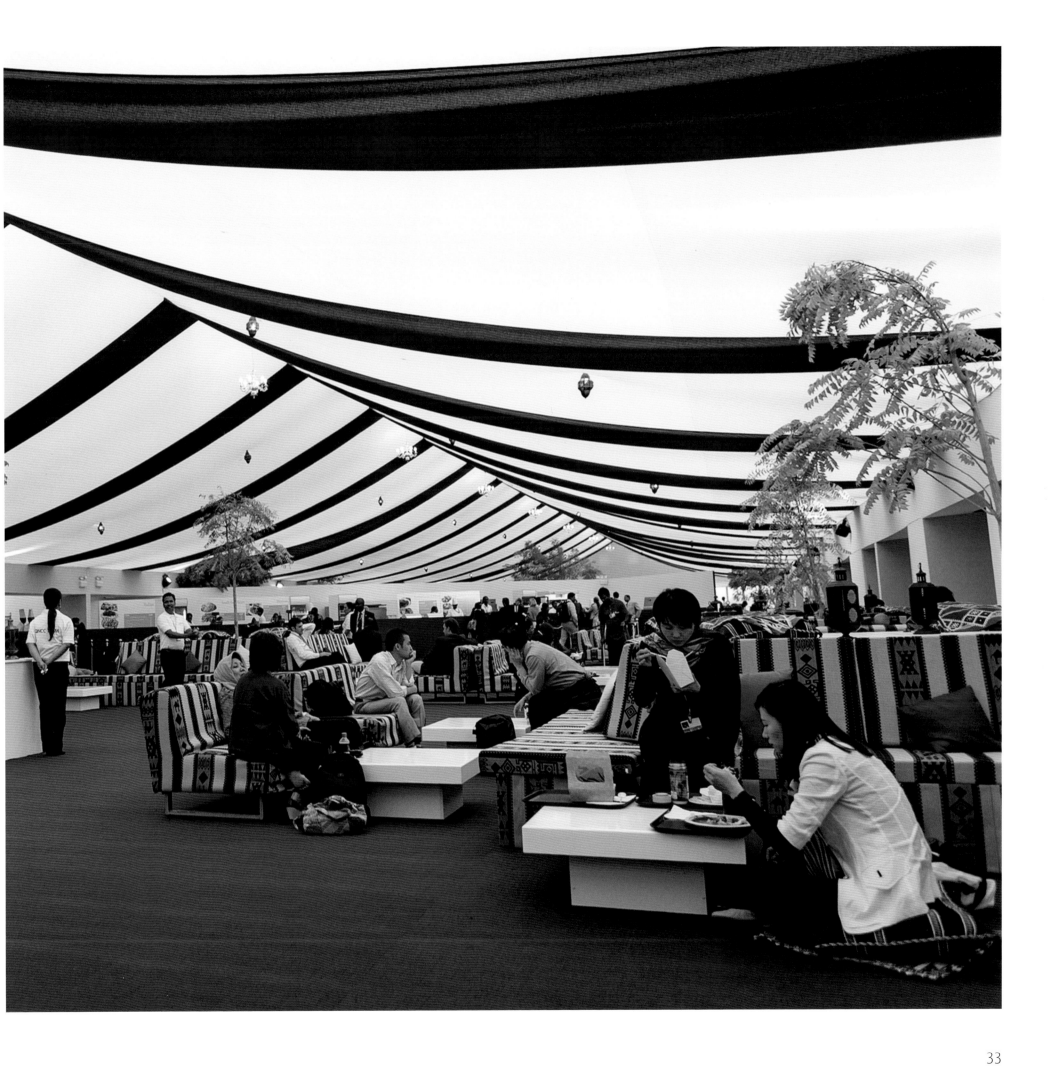

Managing the flow of people around such an expansive event is challenging. Some areas, such as UN offices, have restricted access, but others, such as NGO events, are open to all. Security staff, *right*, have to be well briefed and vigilant.

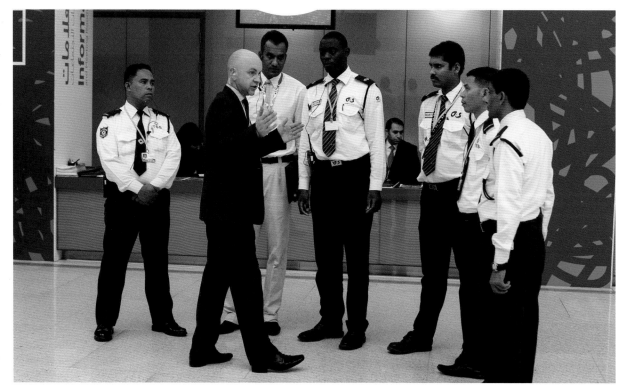

The key to the system is the use of an extensive coloured-badge system, *right*, where each participant — whether delegate, observer, media or technical staff — carries a badge signifying where they are permitted to go. At the UN conference, it's all about your badge.

كافتيريا
Cafeteria

فريق المفاوضات القطري
الافطار: ٧:٣٠ ص – ٩:٠٠ ص
الغذاء: ١١:٣٠ ص – ٢:٠٠ م
العشاء: ٧:٠٠ م – ٨:٣٠ م

Qatar Negotiation Team Only

Breakfast: 7:30AM - 9:00AM

Lunch: 11:30AM - 2:00PM

Dinner: 7:00PM - 8:30PM

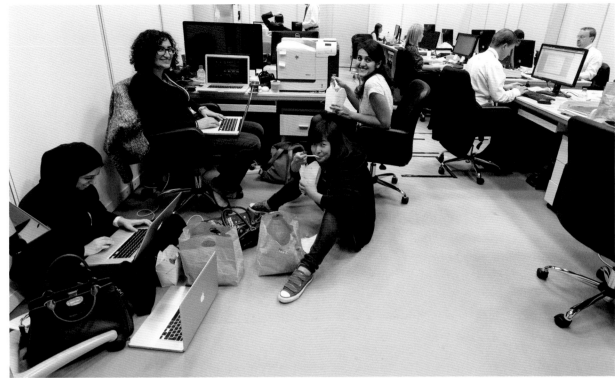

The public information office, *left*, is the nerve centre of media operations, providing live news to participants, local and international journalists and the wider world through a website, smartphone app and twitter feed, charting every meeting and every decision as it happens.

With so many delegations from so many countries, logistics and planning is key to ensuring participants have access to everything they need, from secure post facilities for each country to a traffic system, *below*, to ensure that the heads of delegations can get to their vital meetings on time and unflustered.

From delegates expressing the positions of their governments to observer groups finding innovative ways to get their message across to delegates, the essence of a climate change conference is communication. As part of the UN climate change conference process, thousands of civil society groups attend the event to offer information and lobby delegates.

Chairs, *right*, made from recycled cardboard, invite passers-by to take a seat. Climate change conferences are a great venue for innovators to showcase new energy-efficient and low-carbon technology and products.

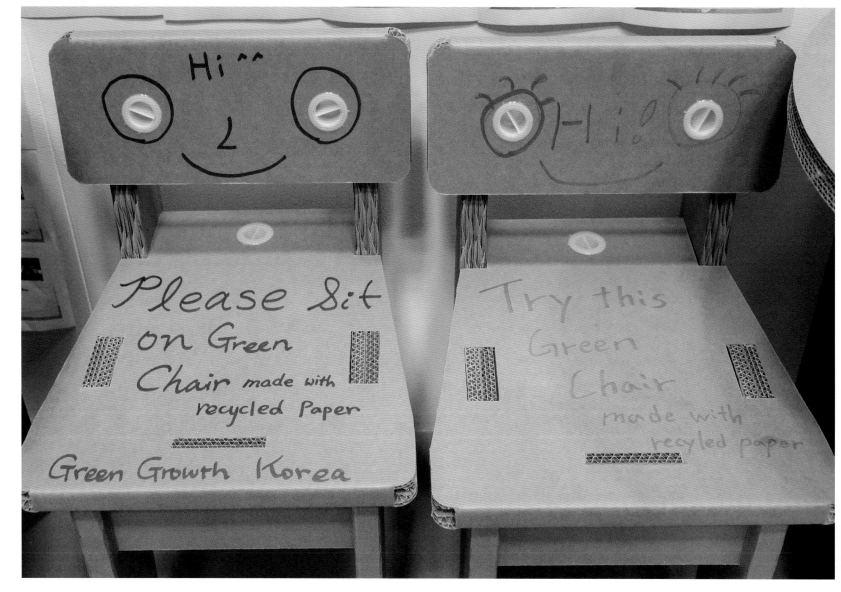

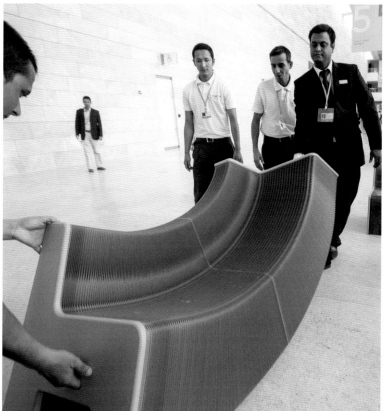

Conference organisers also work to make the best use of recycled materials, such as seating made from recycled paper, which is used extensively across the centre and is surprisingly comfortable.

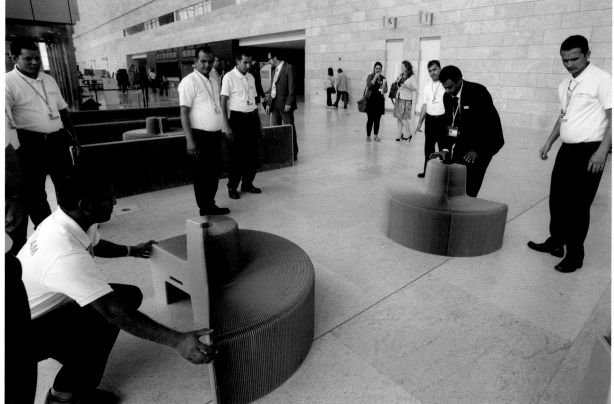

A TV cameraman, *right*, records the words of Ms Christiana Figueres, Executive Secretary of the United Nations Framework Convention on Climate Change, at the opening of the conference. There is huge media interest in the event, with almost 800 journalists attending and hundreds of thousands more monitoring events from back home. Every session is recorded and made available on-demand through the UNFCCC website, along with translations of all speeches.

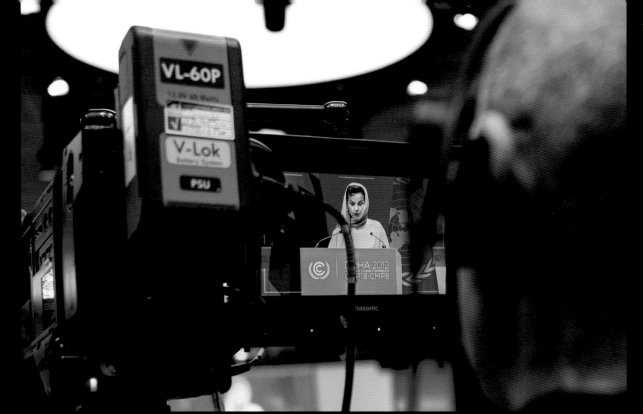

A broadcast 'stand-up' position, *right*, for the international television news network Al Jazeera, where dignitaries will be interviewed about their views on progress. The conference is a significant news event in the world, with every major international news station providing updates. The global interest in the issue of climate change is reflected in the wall-to-wall coverage.

Conveying the vast array of TV, radio, print and digital media from the conference to the world, as well as relaying the live images from every session around the building, is a formidable task. Almost 35km of new cables are laid down, *right*, for the conference, and that is just around the building.

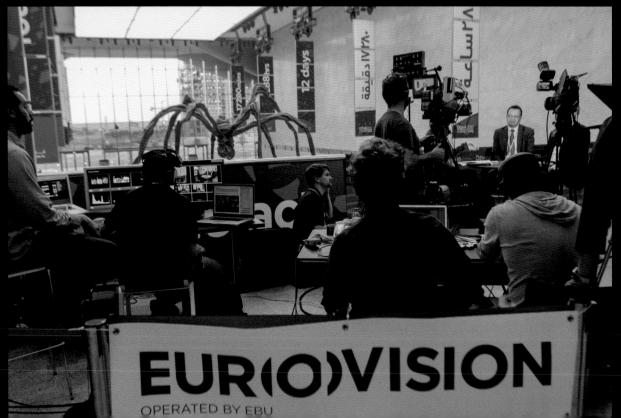

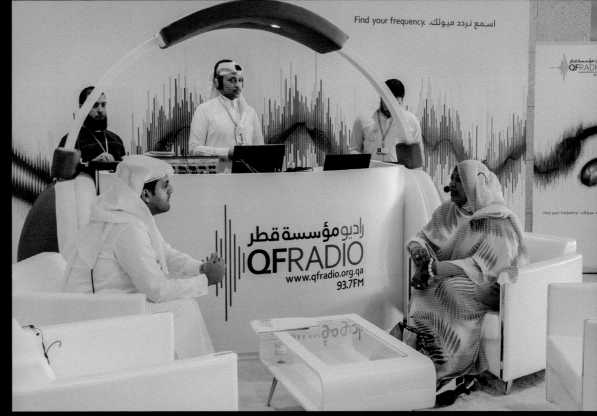

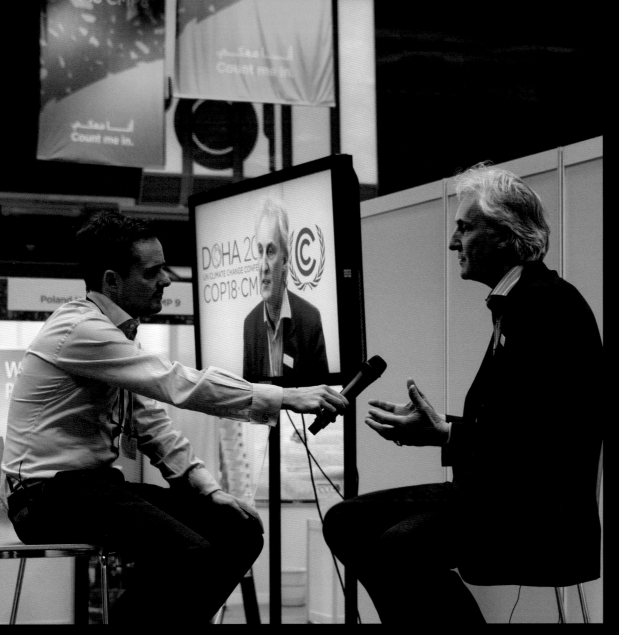

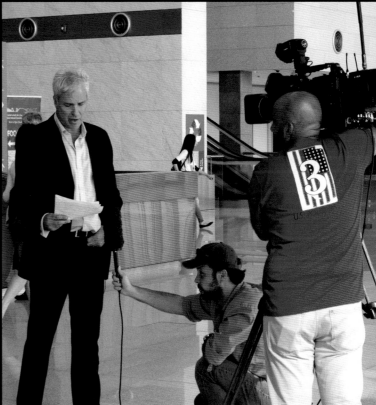

Mr Andrew Mitchell, *left*, Executive Director of Global Canopy Programme, an environmental group that focuses on forests, is interviewed live at the event. Many stations anchor their main news of the day from the conference, as well as having regular daily talk shows and live interviews based from the venue.

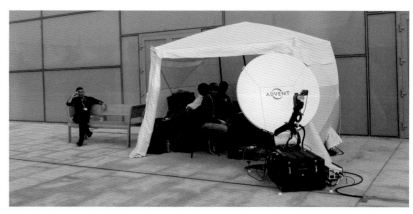

Technical facilities available to participants and broadcasters include 'charging stations', *above*, for mobile phones, to conference rooms equipped with screens to watch the live feed from the plenary sessions.

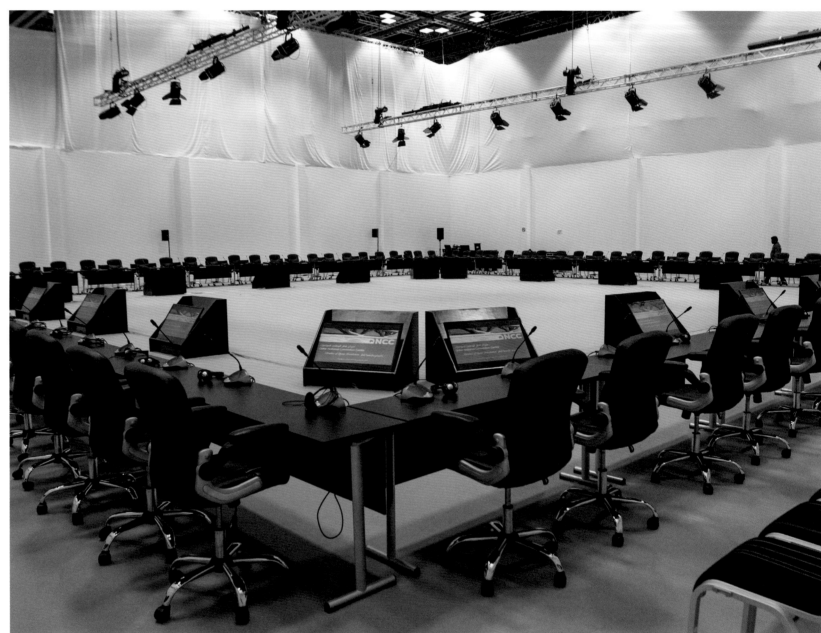

Participants enjoy simultaneous translation, *right*, of all proceedings. Arriving at a plenary session, delegates are handed a headset with multiple language feeds, allowing one to monitor events closely, whatever language is being spoken on the floor of the meeting.

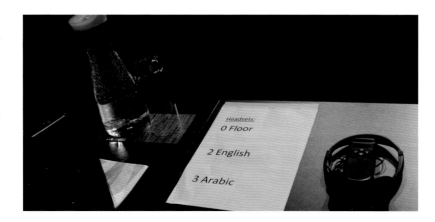

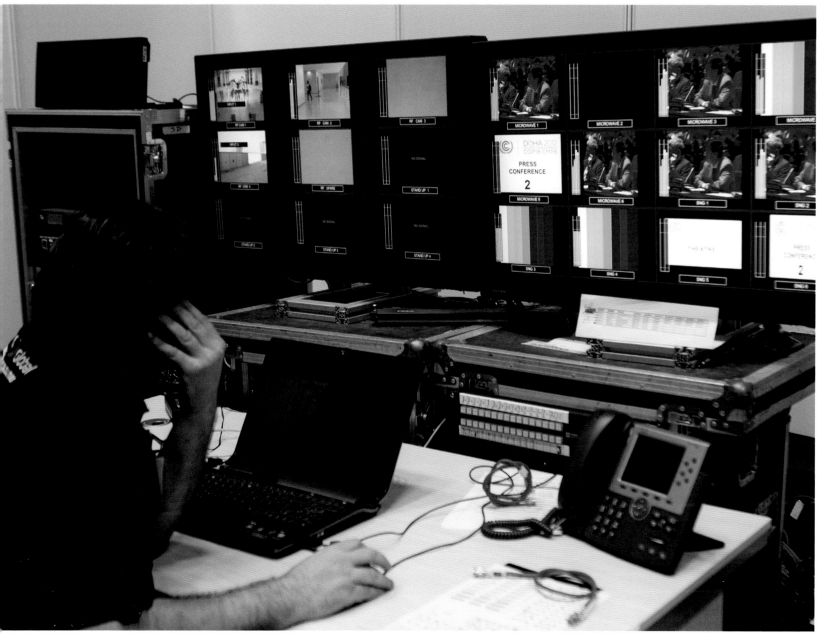

Logistical support ranges from 'wayfinding', explaining the location of all events and facilities, from anywhere to anywhere, *top picture*, to specialist facilities that provide support for international broadcasters to mix and upload their video news feeds.

Coordinating the meetings and movement of 16,000 people and helping them communicate through live interpreters is an immense duty, especially when the future of the world is being analysed. Every morning at 8am, the most powerful heads of every department and agency meet for a quickfire exchange to work rapidly through the challenges of the day ahead. With so much at stake, the atmosphere is electric.

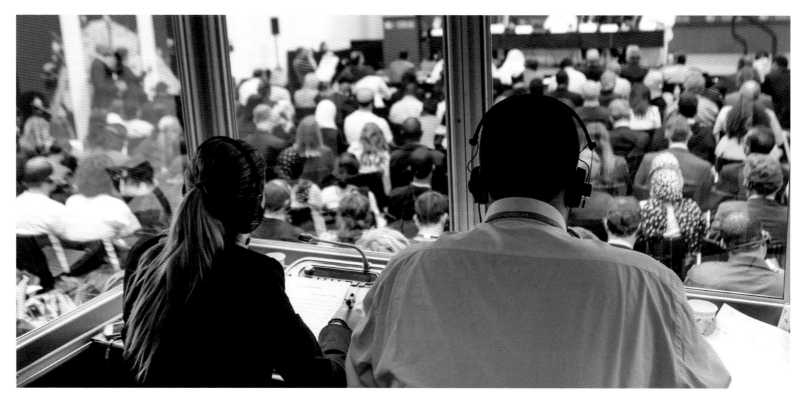

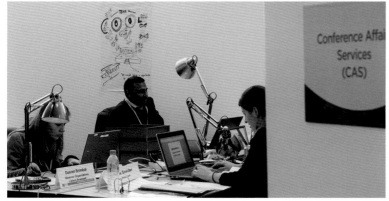

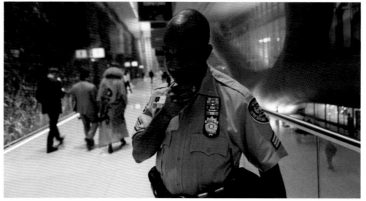

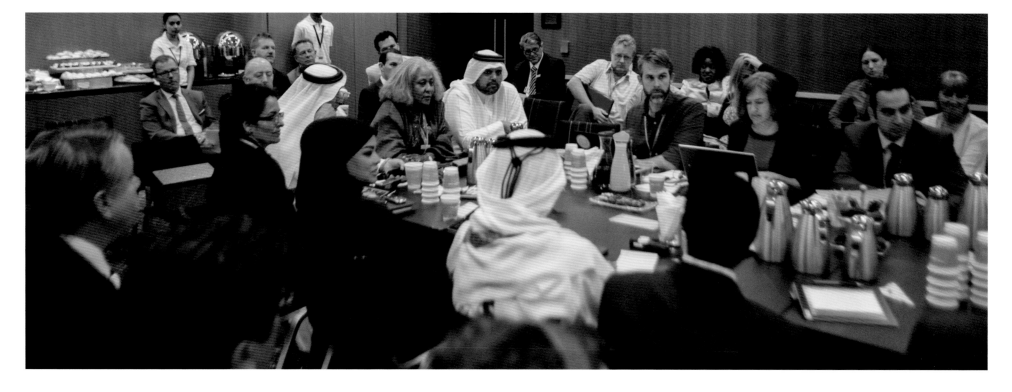

When you are hosting a meeting as big as a city, the provision of services needs to be comprehensive. At the venue, a fully equipped medical centre is established, with a team of doctors and nurses as well as specialised medical facilities.

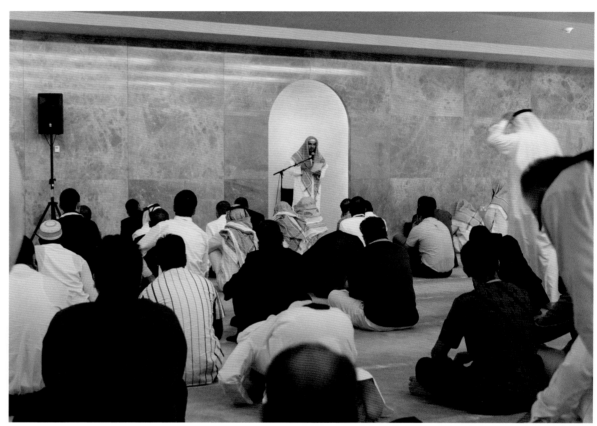

Facilities are also provided, *above*, to allow participants of all faiths and traditions to find time away from the demands of the conference.

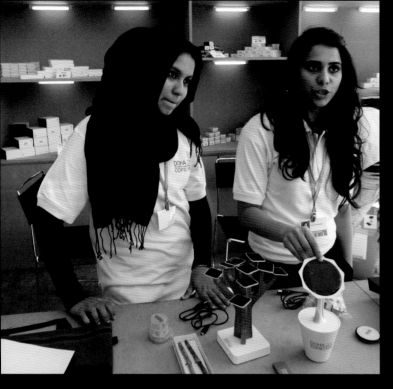

At the conference, participants also get to test the principles of energy-saving technology, *right*, with solar-powered devices available from a pop-up shop, as well as personal gifts made from sustainable sources, including a bamboo pen in a wooden presentation box.

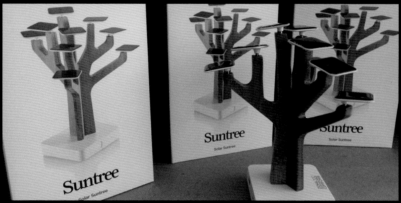

Conferences produce thousands of pages of paper, but at the UN climate change conference, every effort is made to prevent the needless waste of materials. The daily statistics for PaperSmart — the UN system where only documents that are absolutely required are printed — are displayed, *right*, so that participants can view the ongoing effort to conserve resources.

United Nations
Framework Convention on
Climate Change

DOHA 2012
UN CLIMATE CHANGE CONFERENCE
COP18·CMP8

PaperSmart
INTEGRATED SUSTAINABLE
PAPERSMART SERVICES

Sustainability at COP 18/CMP 8:
Tree Counter

A cooperation between the **Government of the State of Qatar**, the **UNFCCC secretariat** and the **UN Integrated Sustainable PaperSmart Services (ISPS) secretariat**

At COP 18/CMP 8, so far approximately 217 trees* have been saved through paper-reduction measures targeting official documents.

No. of sheets* saved: 1,820,329

This represents a reduction of approximately 94% in comparison to the same day at COP 17/CMP 7.

* The above numbers are based on actual paper usage for official documents at COP 18/CMP 8. Additional sustainability measures are in place, such as actions to reduce the wastage of paper as well as shipment restrictions for participants and staff. However, currently no statistics relating to these measures are available.

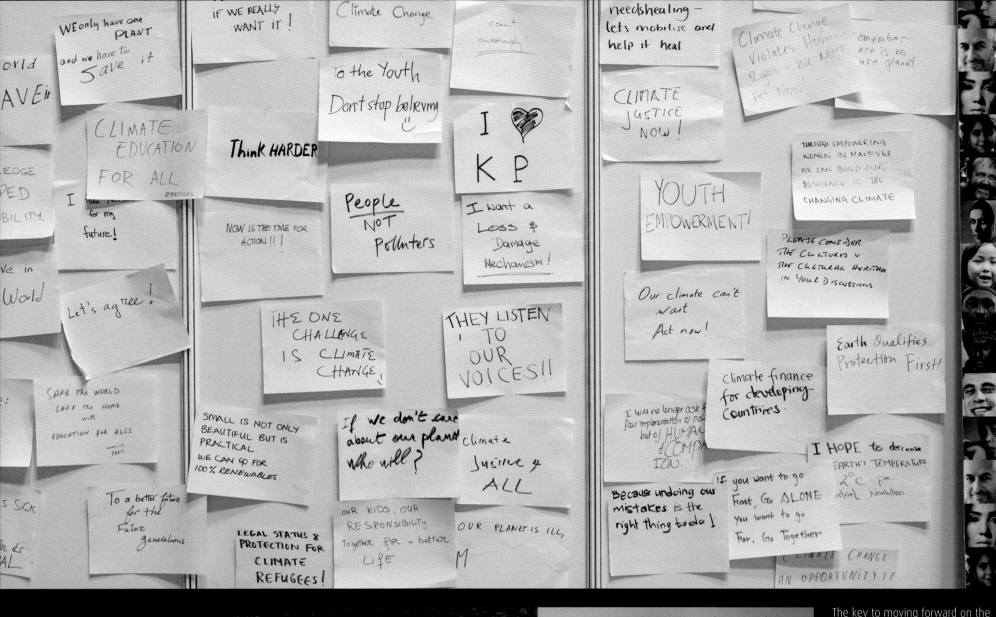

The key to moving forward on the global challenge of climate change is communication, and it does not have to be confined to ministers and delegates. All participants at the conference have a message that they want to share. Informal noticeboards allow interaction between those who are at the conference, so participants can get their own message across.

Organisers also set up 40 'Grab & Go' healthy food stalls directly outside meeting rooms, thereby ensuring that hunger pangs would not get between delegates and their important decisions.

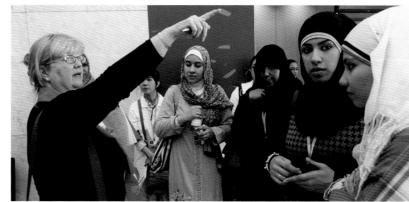

Coffee, *right* and *below*, is the friend of those working long hours on intractable problems around the world. Towards the end of each climate change conference, participants always forgo sleep and work through the night. A generous supply of caffeine — in both western and Arabic varieties — is credited with helping to reach a number of the more difficult resolutions. At the Doha conference, organisers estimate that 200,000 cups were served.

There is a profound feeling of community and camaraderie at a climate change conference. Whatever their positions on the various issues, all participants — whether delegates or observers — are focused on making progress, addressing what many see as the greatest challenge to human civilisation. 'Count Me In', *far right*, sums up much of this feeling, and is the slogan of the 2012 conference.

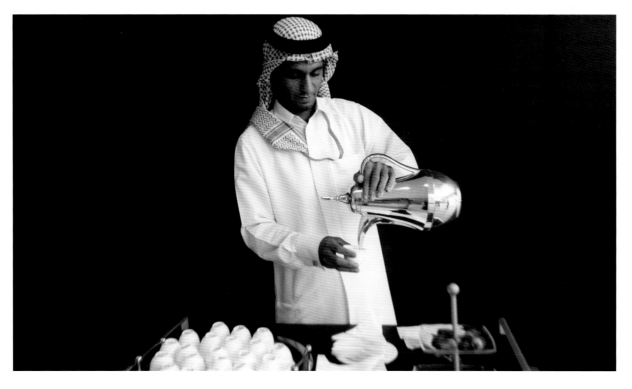

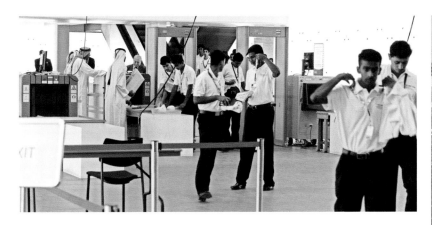

Day and night, the conference keeps going. After every meeting, notes have to be typed up, *above*, agendas prepared for the next event, delegations contacted and statements issued.

Keeping the show on the road is a force of almost 1,000 workers, *left*, doing everything from handing out translation headsets, to moving boxes, files and stands around the vast 40,000 square metre centre, to support the work of the organisers.

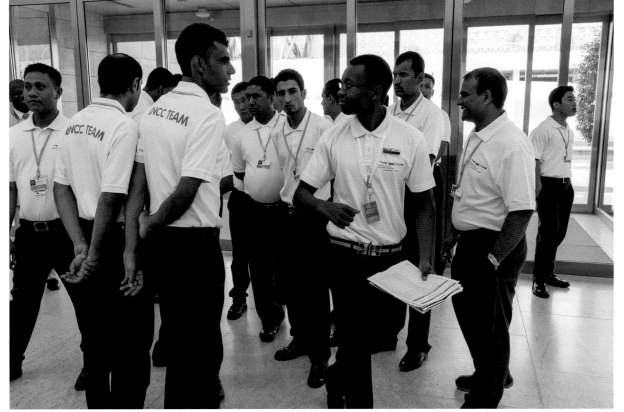

There is no more welcome sight at the end of a hard day at a climate change conference than members of the transport team, *right*, directing you to your shuttle bus home. A fleet of more than 400 buses is brought in to create an instant transport network to reduce emissions and increase efficiency, moving the 16,000 conference participants between their hotels to the venues, every 30 minutes or less, 24 hours a day, free of charge.

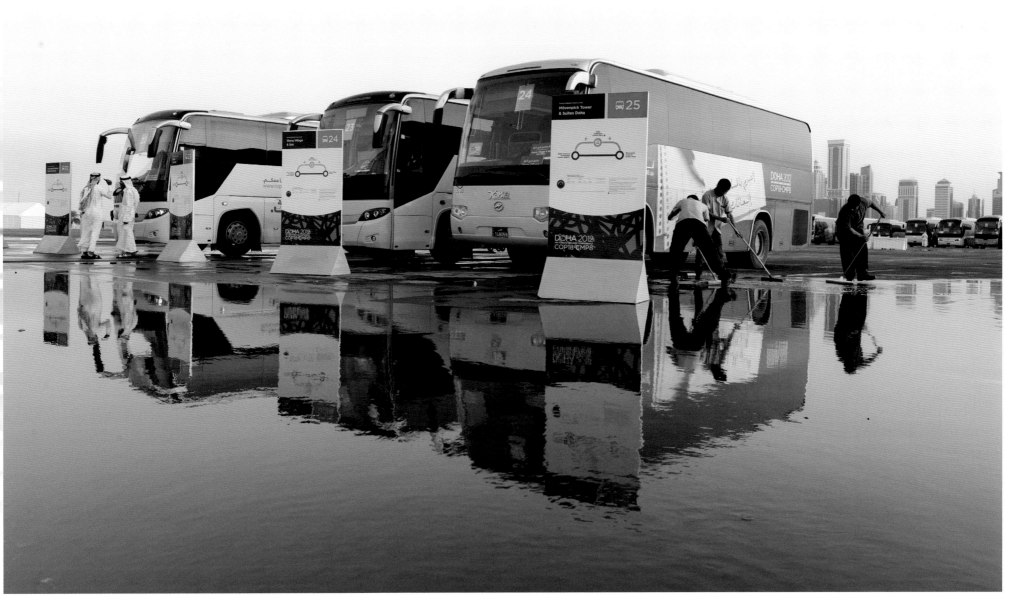

Seasonal downpours happen from time to time and are very welcome. The clean-up operation was swift and efficient.

The bus network is created especially for the conference. It provides a door-to-door service from hubs at or near every major hotel in the city, a logistical feat that not only manages to collect and deliver its passengers day and night, but also works to a tightly choreographed timetable.

When the conference ends, for some the work starts again. In the public events industry, the final stage is called the 'tear down'. It involves another mammoth logistical endeavour, removing and either re-using or recycling thousands of tonnes of stands, seats, machines, tabling, desks and everything else that goes with a conference, all in a matter of days. For those who participate in the conference, the tear-down can lead to a few tears of their own.

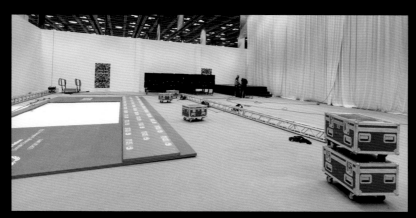

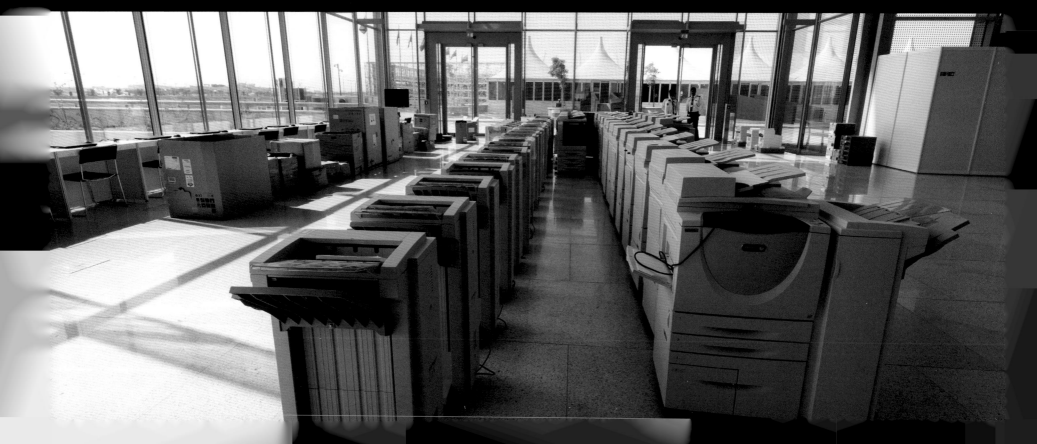

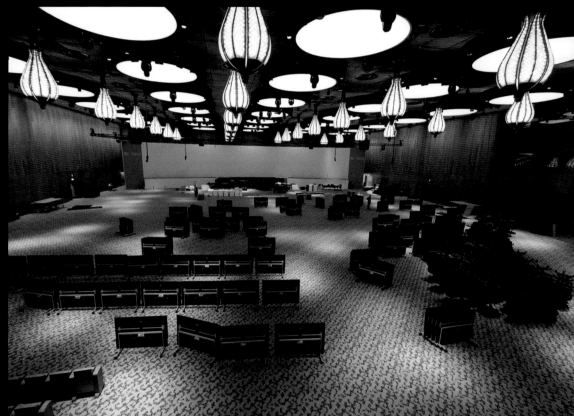

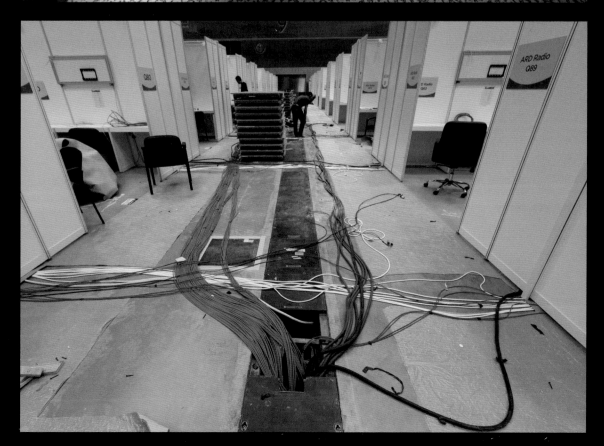

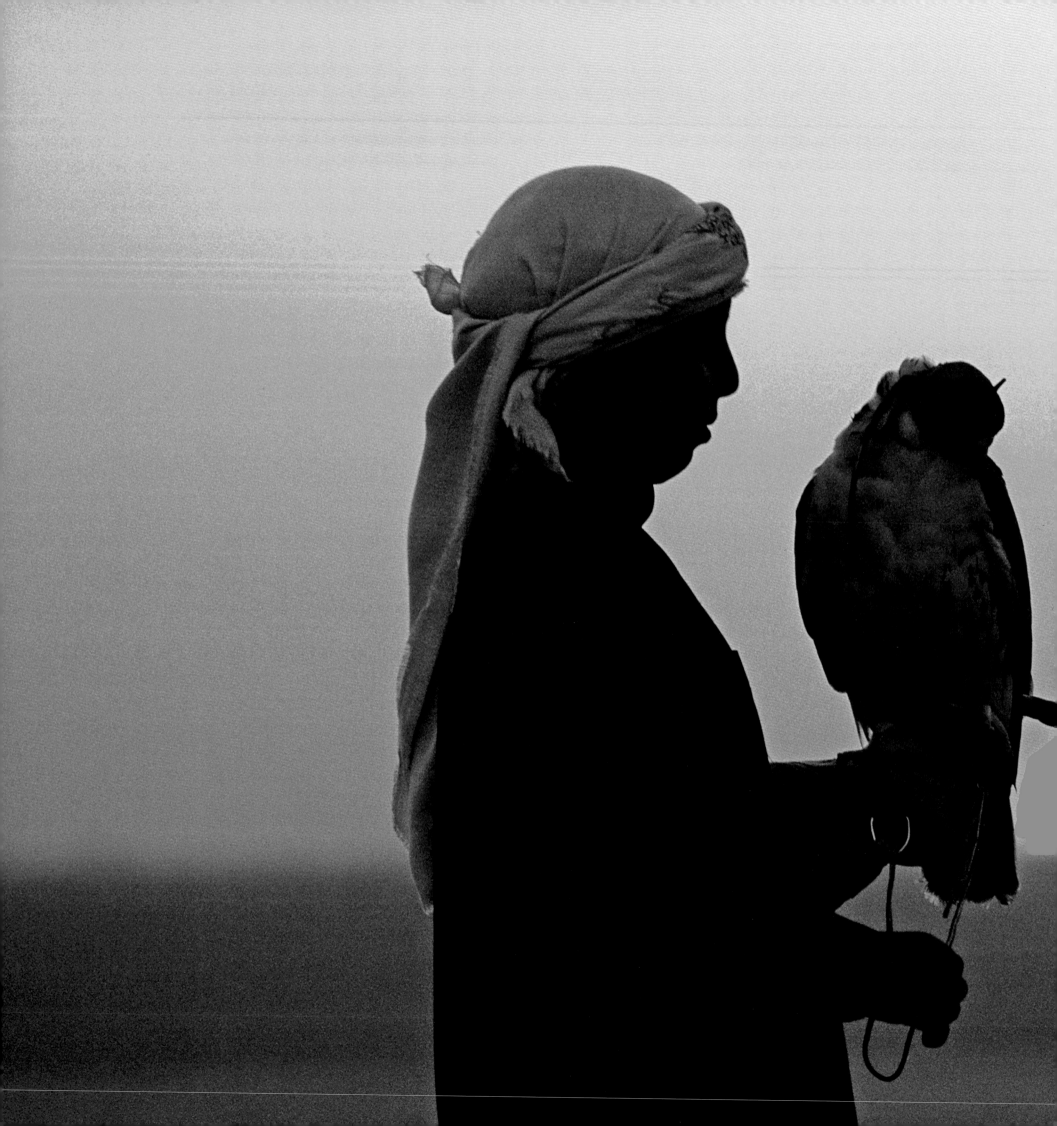

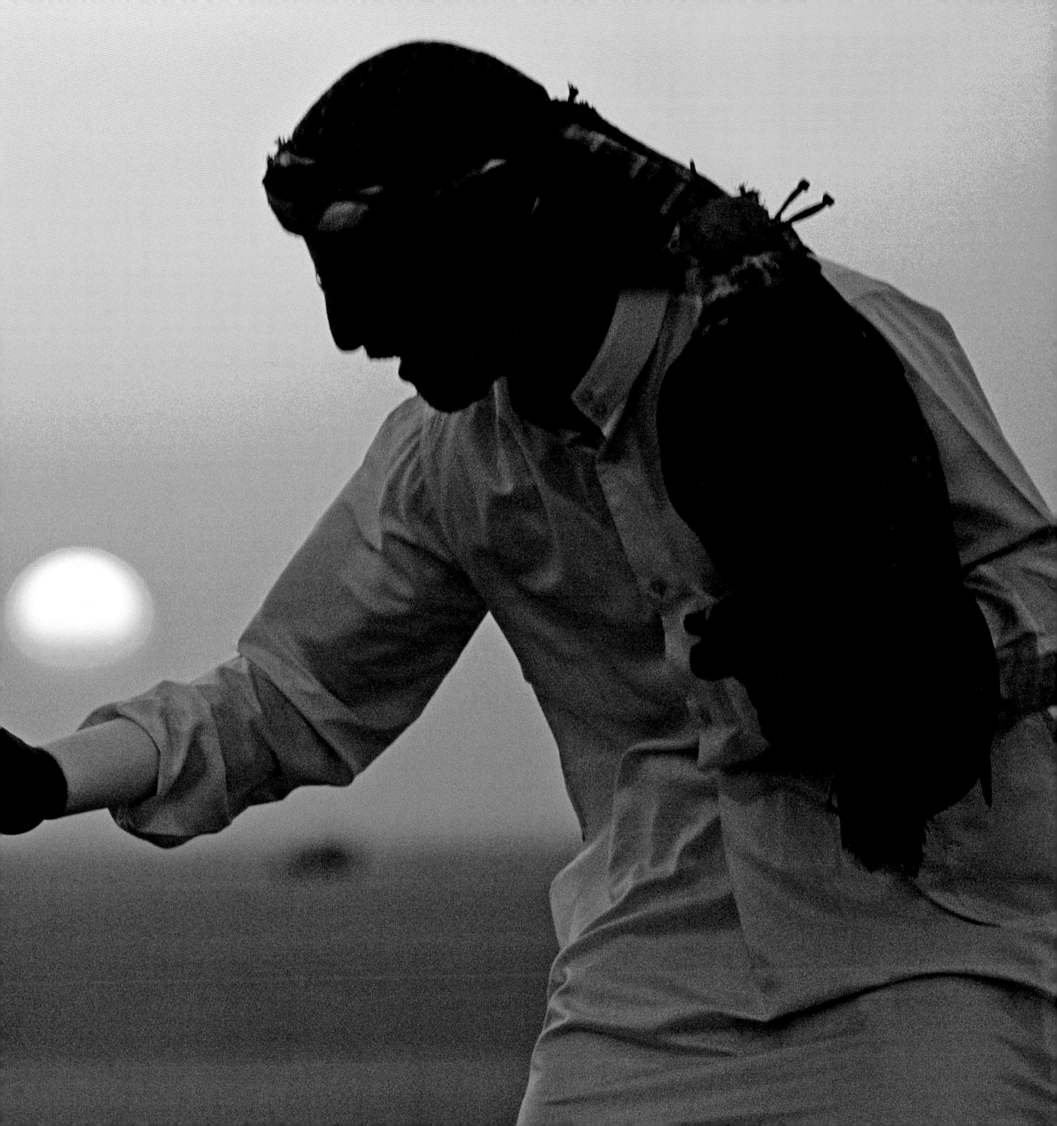

The Host City

The Qatar National Convention Centre is one of the world's most efficient 'green' conference buildings, making extensive use of natural light with large glassed areas as well as drawing on solar power and other technologies to reduce its carbon footprint. It was therefore an obvious venue for the 2012 conference, allowing the host city to showcase its commitment towards sustainability, and for participants to experience cutting-edge facilities.

Inviting the world to your home is an honour that is shared from time to time by leading international cities. These are the places that have etched their names on the world of politics, culture, education and sport. And for good reason. Because hosting the world can be an exacting challenge requiring features that stretch the resources of even the most advanced cities, from first-class infrastructure to a citywide sense of hospitality and openness; from low crime figures to good healthcare and world class services.

Hosting a United Nations climate change conference is a unique opportunity for a city to play an important role in a critical global process, open itself fully to the world, and declare its commitment to meet the challenges of our future. It is an opportunity to showcase cultural heritage, natural wonders, natural beauty and state-of-the art facilities.

However, such opportunities can also present challenges. With many thousands of people attending, a city must ensure it has sufficient facilities, from quality accommodation for guests to public spaces, transport links, even an airport that is sufficiently big. And with so many representatives of the world's media in your home — there were more than 800 in Doha — leaders must be prepared for a high degree of scrutiny. Little can be hidden from the world's media. In this respect, of all the international events that a city can host, the United Nations climate change conference is perhaps the most exacting. Not only must the city have good infrastructure, but it must be authentically working to deliver environmental responsibilties across all fronts from waste management and renewable energy, to ecosystem protection and efficient use of resources. For those cities that have made such a commitment, hosting the conference is an opportunity to demonstrate a progressive vision to the world.

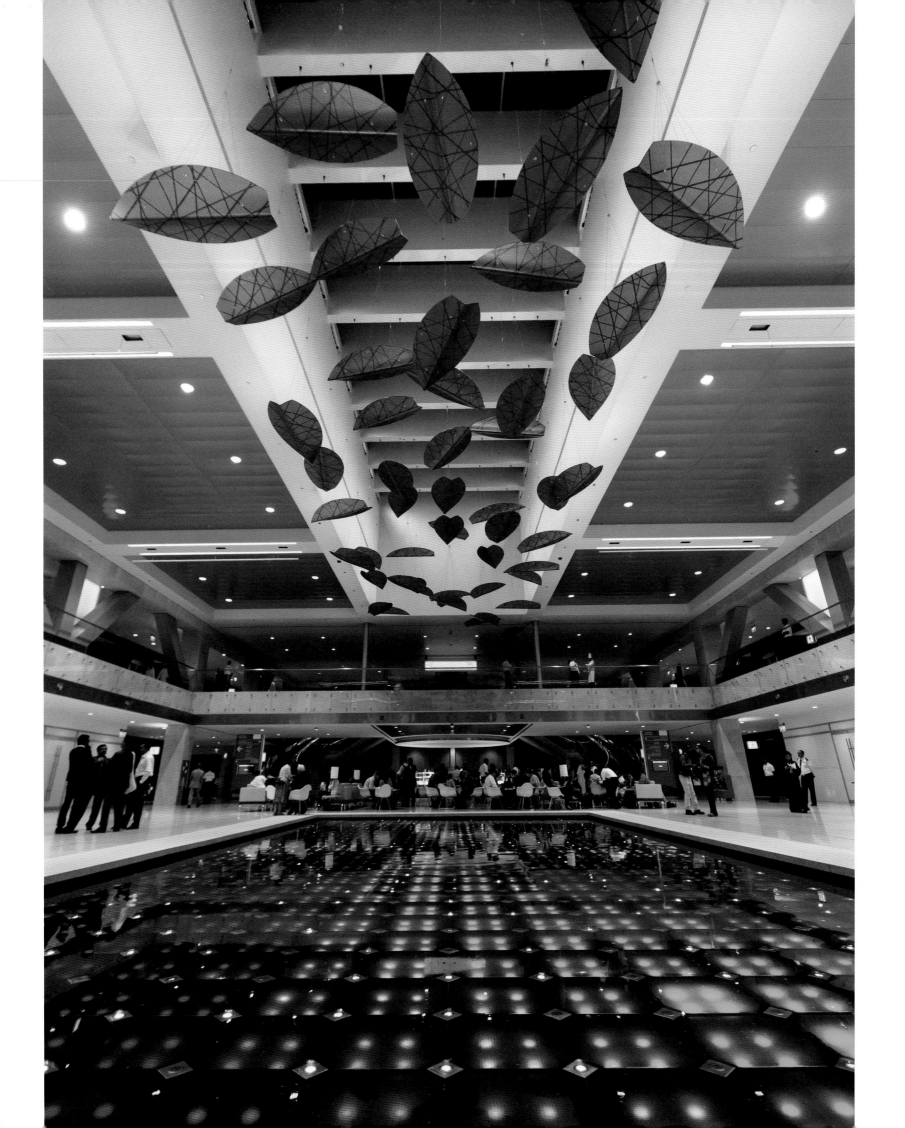

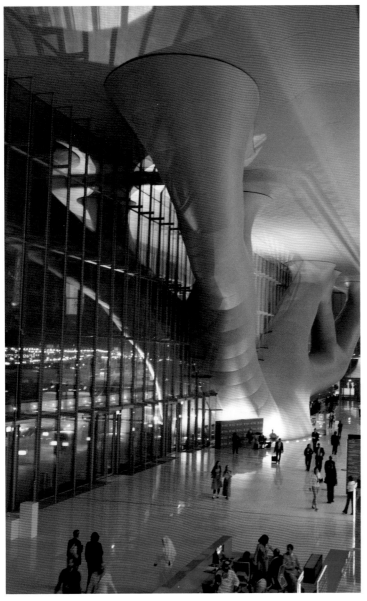

Conference participants take time out to enjoy a coffee in the venue, which is both modern in design and intrinsically connected to its natural setting, with a replica of an expansive Sidra tree — the national symbol of the country — in its cavernous entrance hall, and conference decorations to show the connection with our natural world.

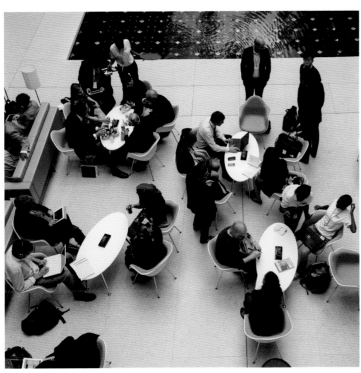

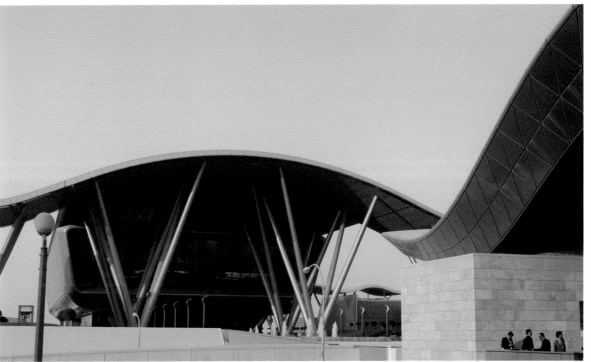

The Qatar National Conference Centre, *right*, was designed with a focus on sustainability, and built to the high 'gold standard' of the American green building certification system known as Leadership in Energy and Environment Design (LEED).

Using recycled materials, pop-up information pods, *right*, are staffed by volunteers, and are used to inform participants about the conference and how they can make a difference by reducing their own carbon footprint.

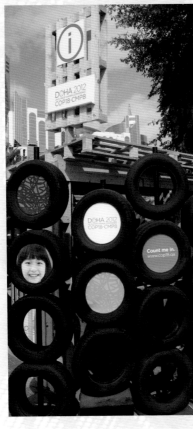

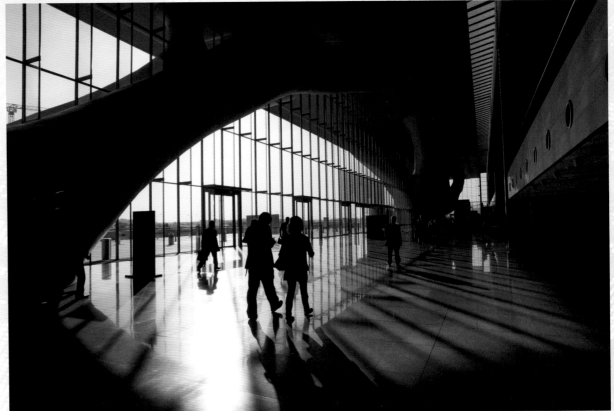

The Centre is designed to be very efficient in its use of energy, water and materials. The venue also features furniture made from sustainable products.

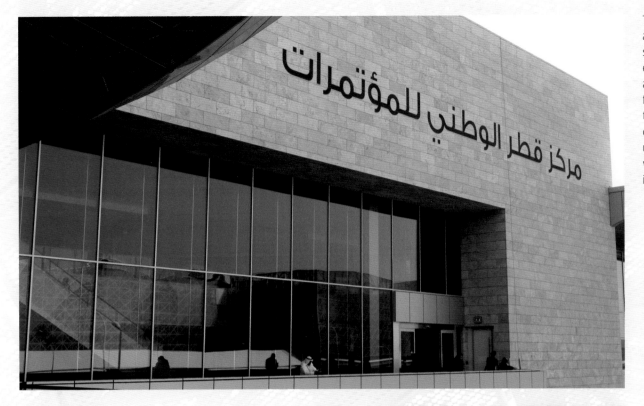

The building has been certified as 32 per cent more efficient than similar structures that do not feature environmentally sustainable designs and technology. Its solar panels, for example, contribute greatly to the power requirements over the duration of the conference. Water use is 40 per cent below what would be expected for a centre of its size, thanks to efficiency designs.

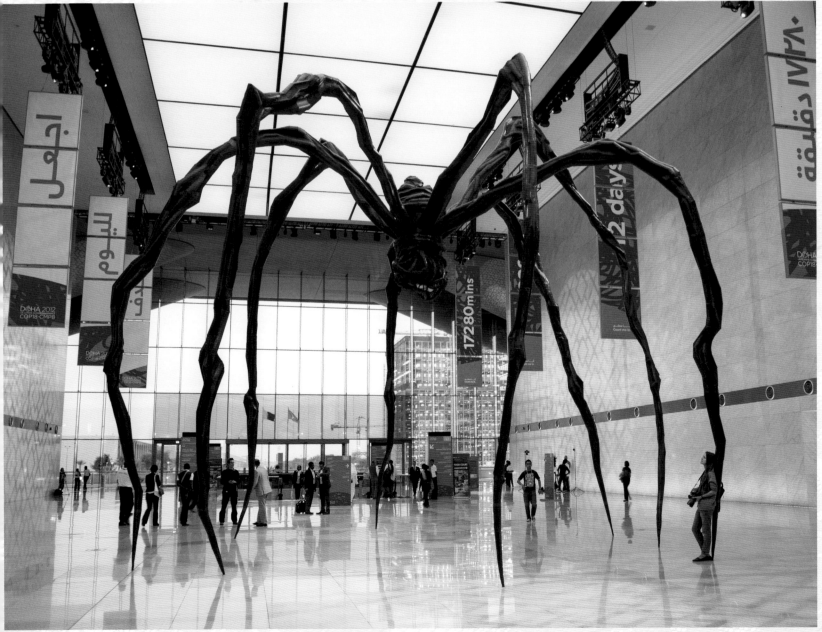

In the middle of the venue a towering bronze cast of a spider, more than nine metres high and wide, dominates the space. Created by the French-American sculptor Louise Bourgeois, entitled 'Maman'.

Welcoming the world to the UN Climate Change Conference allowed the host city to showcase its rich cultural diversity, with performances across Doha, including a festival of local and international green films, and musical performances by the Qatar Philharmonic Orchestra.

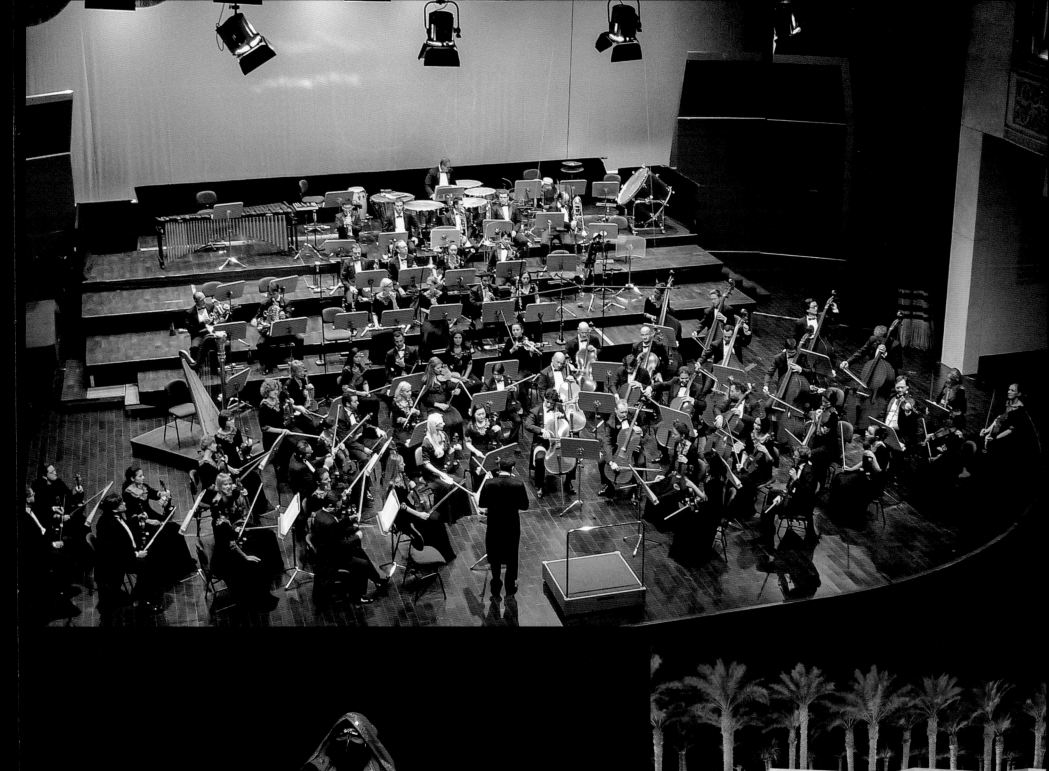

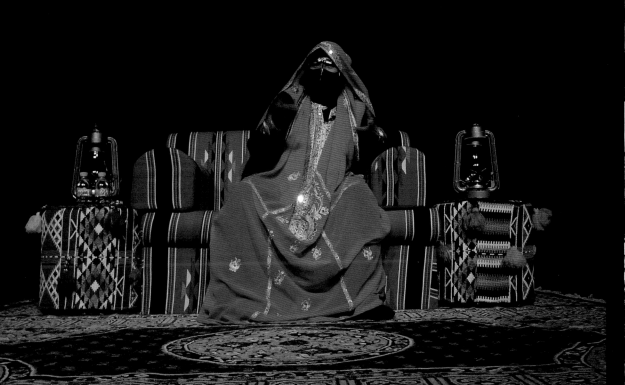

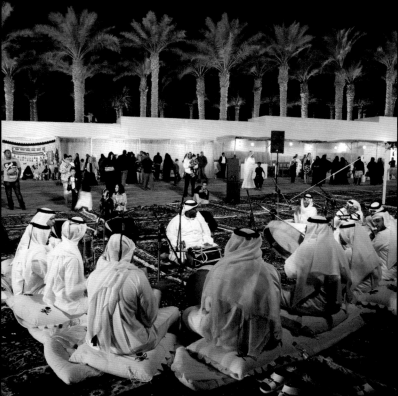

Music played on the oud, *above*, a traditional Arabic musical instrument, resonates with the soul. Those attending the conference are able to experience a range of traditional and modern music concerts as part of hundreds of city events, arranged to coincide with the conference, which showcase the rich culture of the host city.

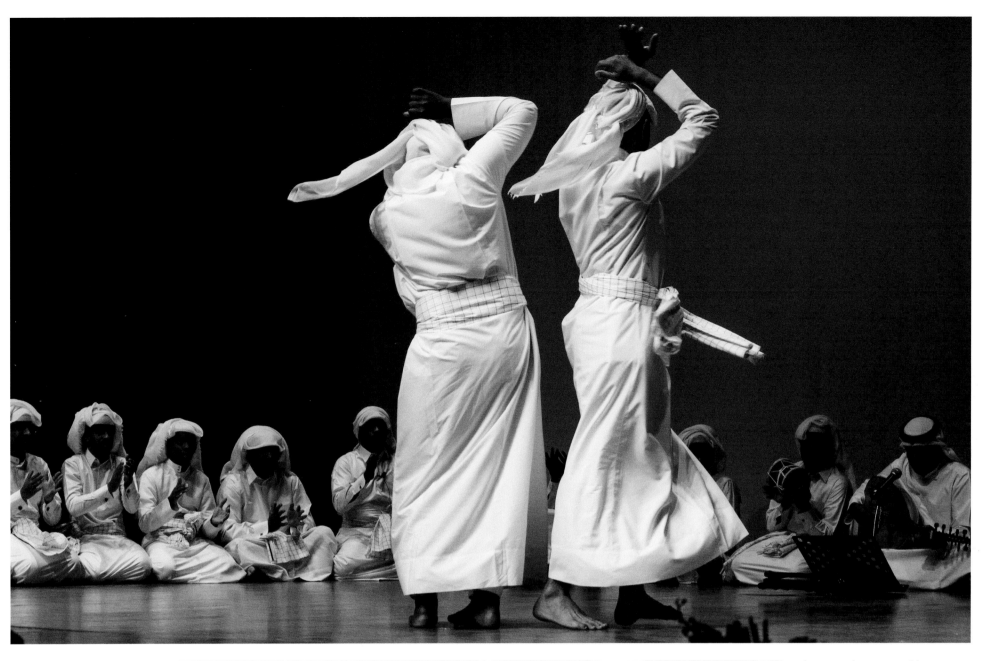

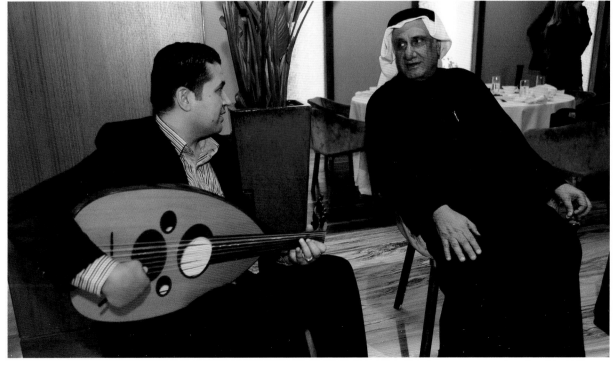

There are also opportunities to see traditional dance, *above*, and attend other cultural events specific to the city, such as readings set to music by Dr Hassan Ali Al Nimah, a Qatari poet, *left*.

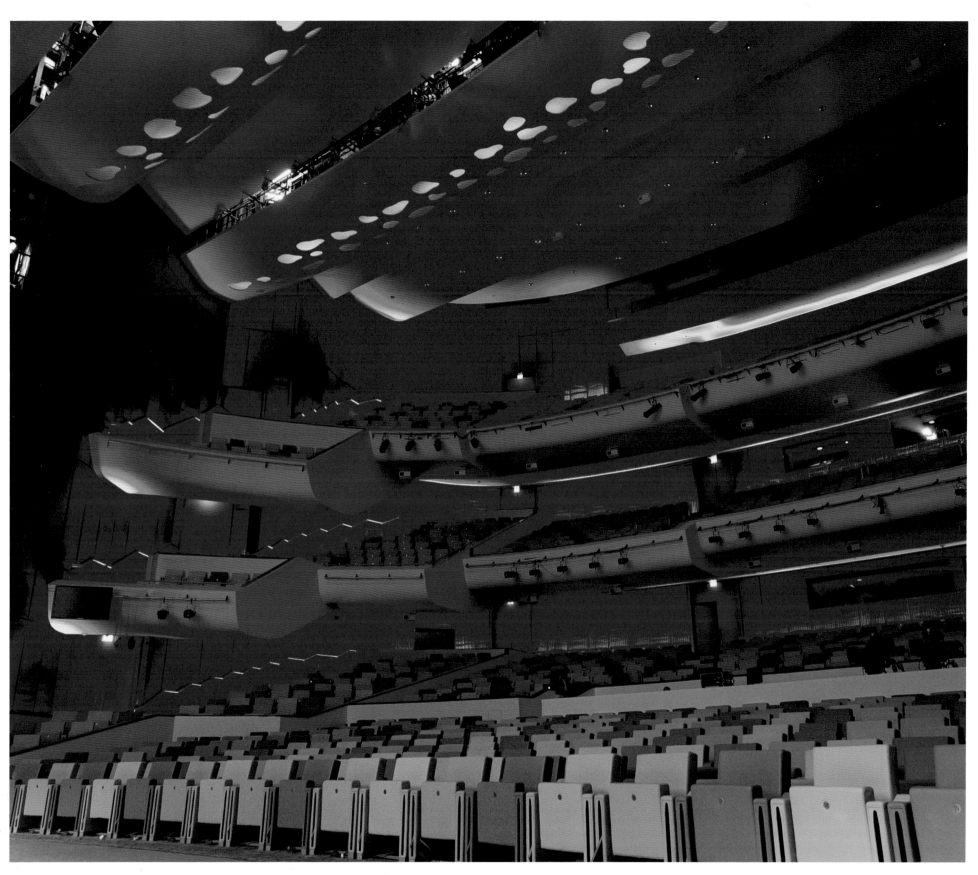

Cultural performances bring music, dance and drama, but also colour. The performance spaces and other venues used during the conference have a contemporary vibrancy and grace that for many lingers as an abiding image long after the conference has ended.

In a venue lit predominantly by natural light, surrounded by organic forms and symbols, delegates can find inspiration for how advanced civilisations can live in harmony with the natural world.

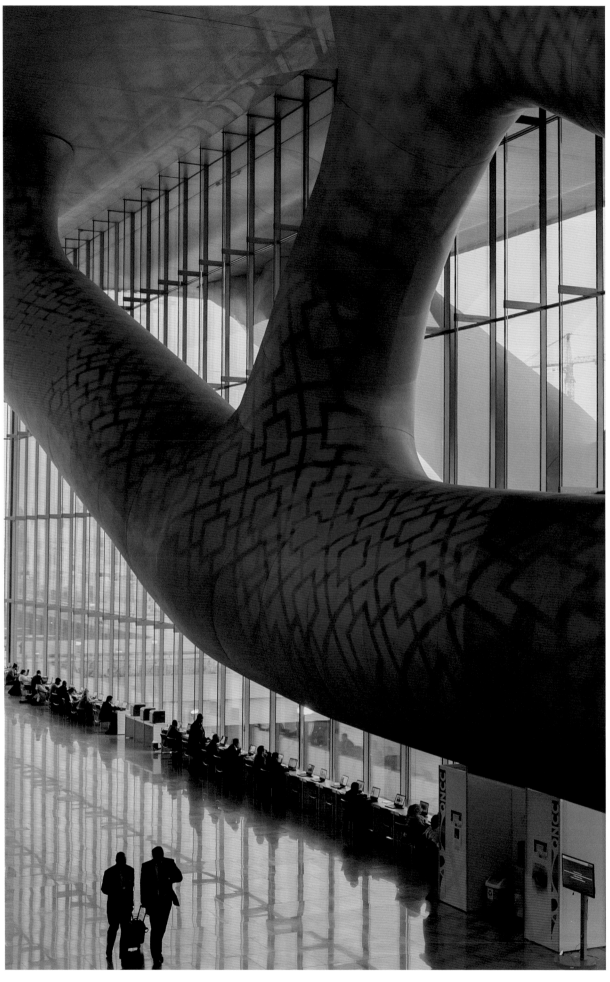

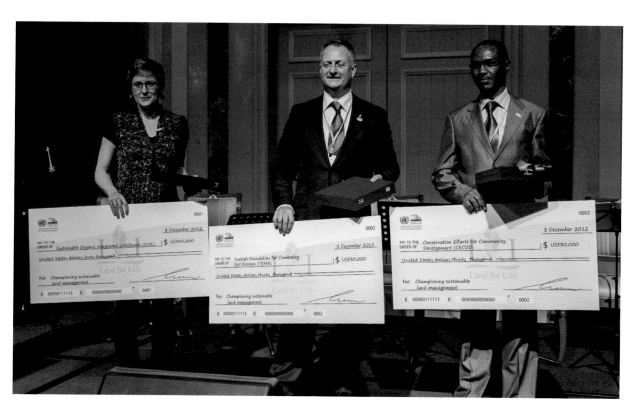

The conference is an opportunity to announce the winners of the annual 'Land for Life' awards created by the United Nations Convention to Combat Desertification and supported by the State of Qatar to recognise excellence in sustainable land management. The 2012 award was presented to Sustainable Organic Integrated Livelihoods (SOIL), a charity working in Haiti, with runners up CECOD, working in Uganda, and TEMA, working in Turkey.

Sustainable Organic Integrated Livelihoods provides a system to improve sanitation in Haiti and produce organic compost. Ms Leah Nevada Page, *above*, its Development Director, explains the organisation's work and collects the winning cheque for $40,000, (seen *top left*, alongside the runners up) towards its programme.

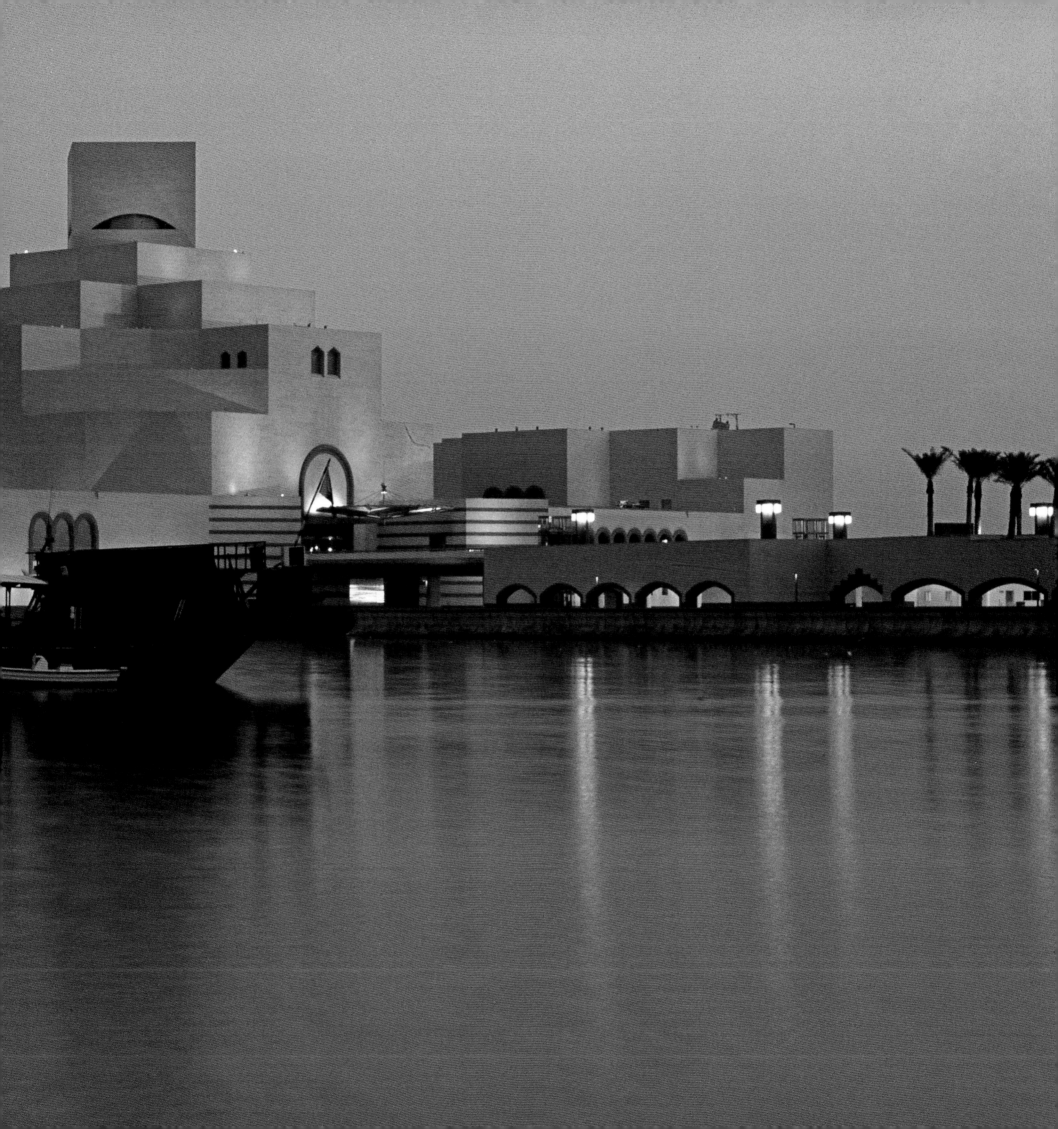

The Emir (now Father Emir) of
Qatar HH Sheikh Hamad bin Khalifa
Al-Thani, invites guests to a special
banquet. It is an auspicious occasion,
taking place at the beautiful Museum
of Islamic Art, *opposite*, providing
an opportunity for world leaders to
meet and discuss key issues.

HE Sheikha Al-Mayassa bint
Hamad bin Khalifa Al-Thani,
right, Chair of Qatar Museums,
speaks to the assembled
dignitaries about the importance
of addressing climate change.

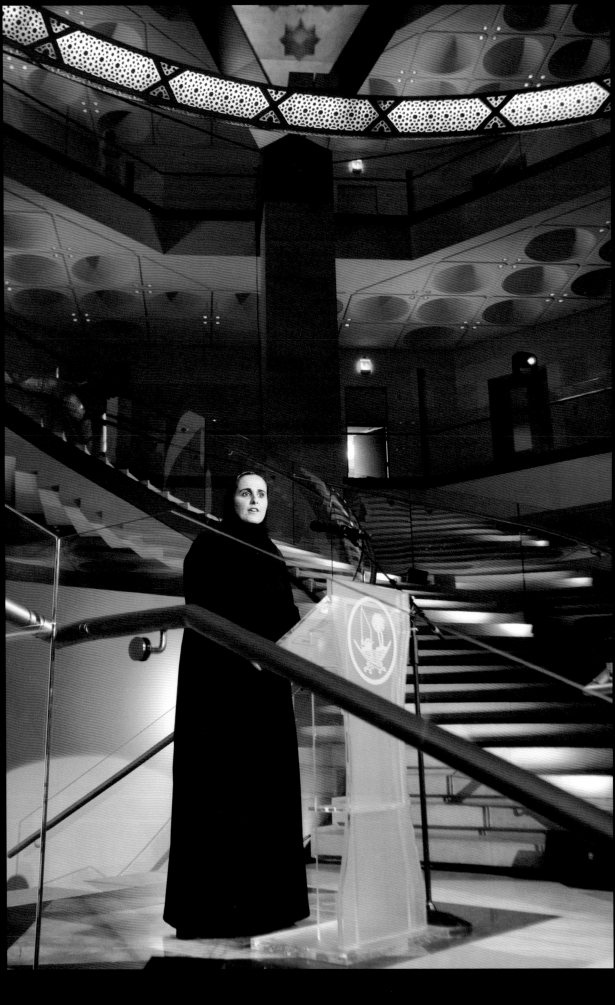

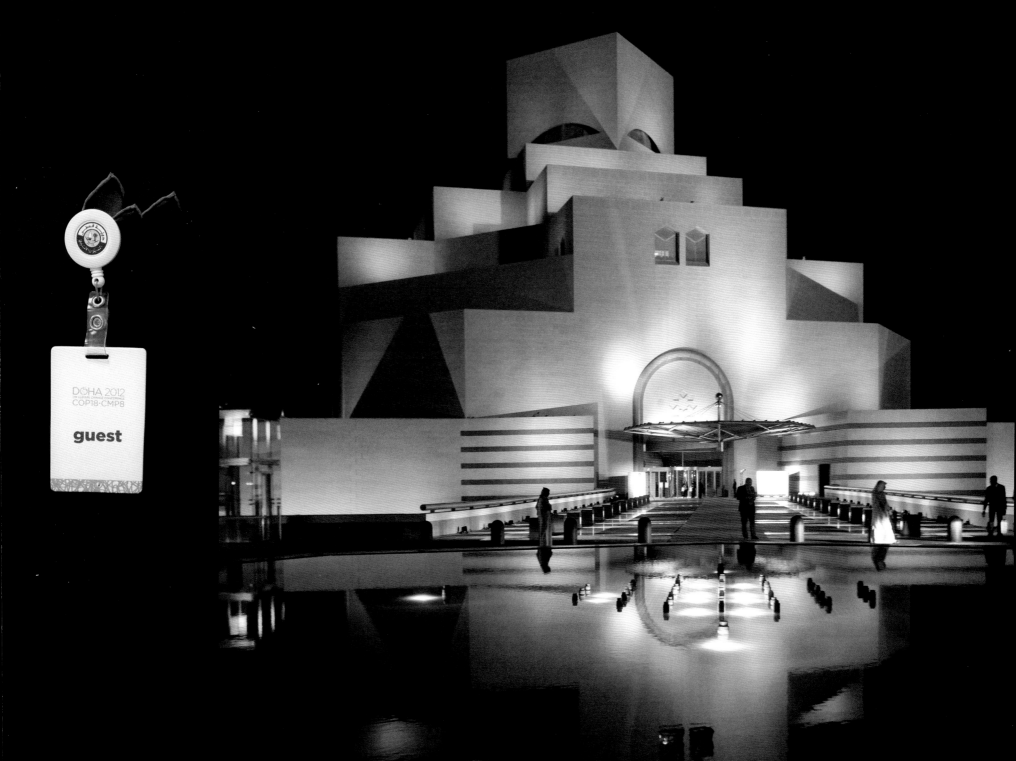

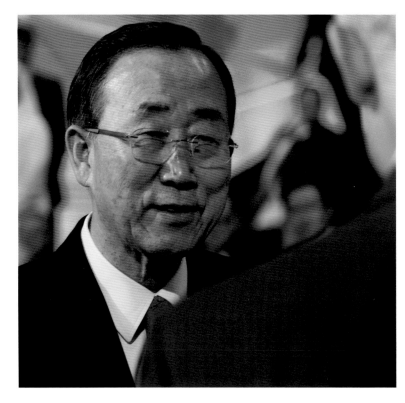

The occasion is an opportunity
for delegates to meet informally,
and perhaps talk about the tough
negotiations ahead — as well as to
sample some exceptional food.

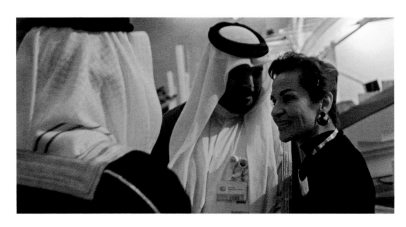

Ms Christiana Figueres, *above*,
Executive Secretary of UNFCCC,
takes the opportunity to meet
key figures.

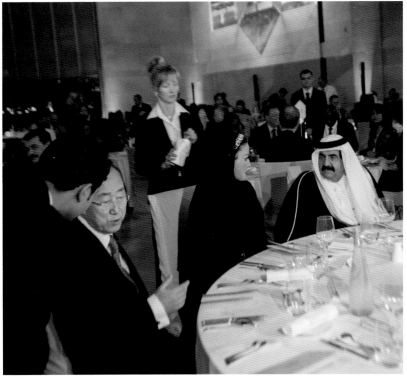

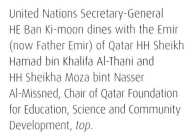
United Nations Secretary-General HE Ban Ki-moon dines with the Emir (now Father Emir) of Qatar HH Sheikh Hamad bin Khalifa Al-Thani and HH Sheikha Moza bint Nasser Al-Missned, Chair of Qatar Foundation for Education, Science and Community Development, *top*.

" *Don't ask what global climate protection can do for your country; ask what your country can do for climate protection…* "

Hans Joachim Schellnhuber, Director of the Potsdam Institute for Climate Impact Research (PIK), paraphrased former US President John F Kennedy's famous words during his address to the highest-ranking representatives of states in Doha.

The distinguished guests listen to speeches by some of the world's leading figures on climate change.

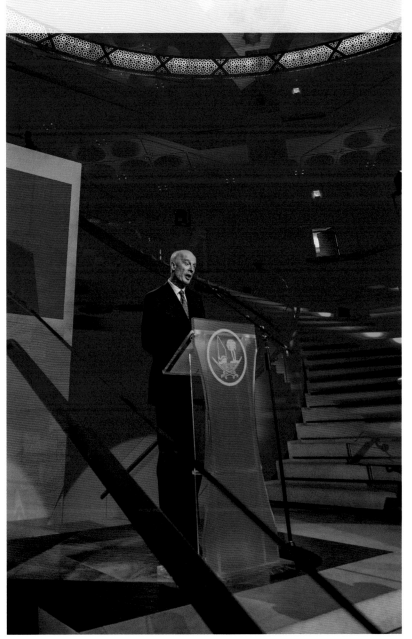

Far left, HE Mohammadi Zadeh, (pictured centre), Vice-President of the Islamic Republic of Iran and Head of the Department of the Environment, and a member of his delegation, (pictured left), talk with United Nations Secretary-General HE Ban Ki-moon.

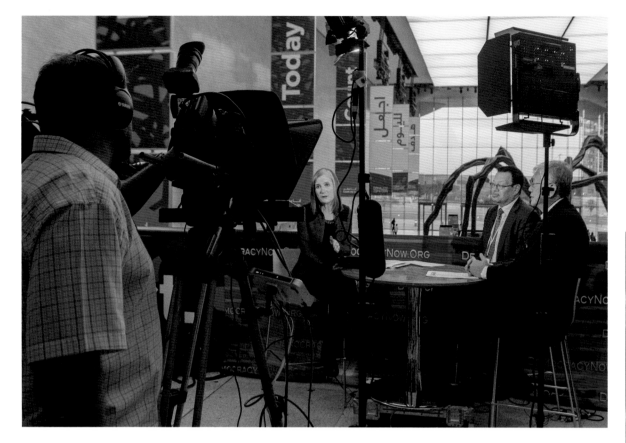

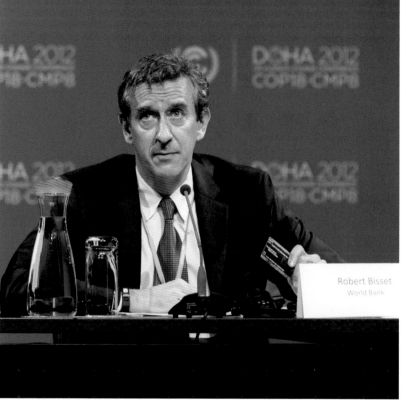

Real progress on addressing climate change can only be achieved when all stakeholders are fully engaged, including civil society groups, *right*, non-government organisations, the private sector and the media, *above*. Enormous efforts are made during the conference to draw in and engage all groups to reach consensus.

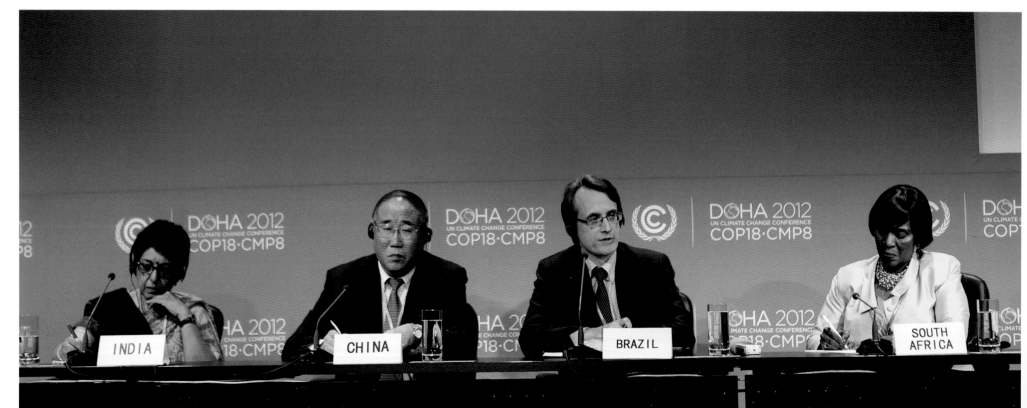

Engagement

There can be no agreement without consensus; and trying to build consensus on a global stage may seem an impossible task. Yet this is the standard that United Nations climate change conferences set for themselves. They reach out to the nations of the world; they engage. Collective ambitions extend beyond States, governments, businesses and global organisations to reach a much broader community — voices that are heard more rarely. These range from climate-change activists to members of indigenous societies, women's organisations and youth groups: those representing the next generations, the stakeholders of the future. A true consensus, which is essential to build a sustainable future – requires efforts to engage on this much wider level.

This effort to engage begins months before the annual conference. Delegates from nations and representatives ranging from local environmental groups and activists to global youth leaders and international civil society organisations meet to discuss priorities and chart a path forward. Conference organisers sit with these groups and coalitions to hear their views, and take note of their positions. This engagement serves as one of the core pillars for planning the conference, from arranging events and gatherings for civil society observers to creating opportunities to meet delegates, and take part in one-on-one meetings with the most senior figures.

When the UN climate change conference begins, it is easy to judge the success of this engagement strategy. There are of course the delegates who represent the nations of the world. However, if the conference has really connected with the wider world, there will be thousands of representatives from youth groups, civil society organisations, protesters and indigenous peoples. For every figure in a business suit, there will be another in traditional dress, or in a T-shirt with a provocative slogan. This is the constituency; these are the stakeholders of the future — and these are among the voices that the conference must include, perhaps most of all. It is this engagement that makes the UN climate change conference so vibrant, so vital and so colourful, and one of the few places on earth where you can feel that the world — the whole world — is truly represented.

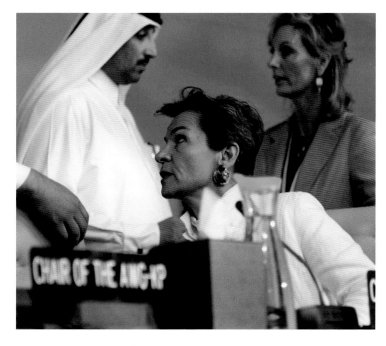

Ms Christiana Figueres, *above*, Executive Secretary of UNFCCC, has repeatedly emphasised that meaningful change can only be achieved through global collaboration.

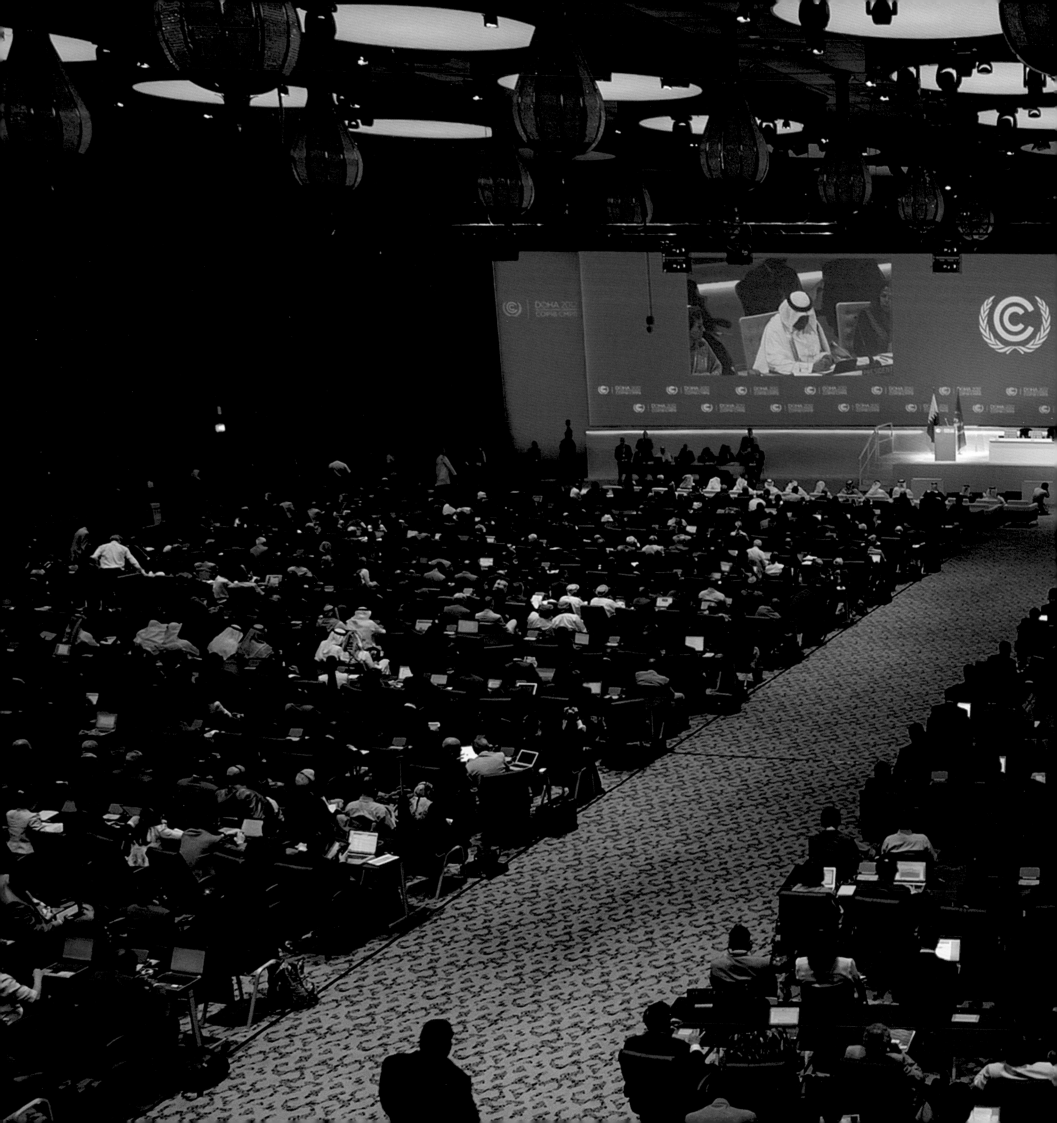

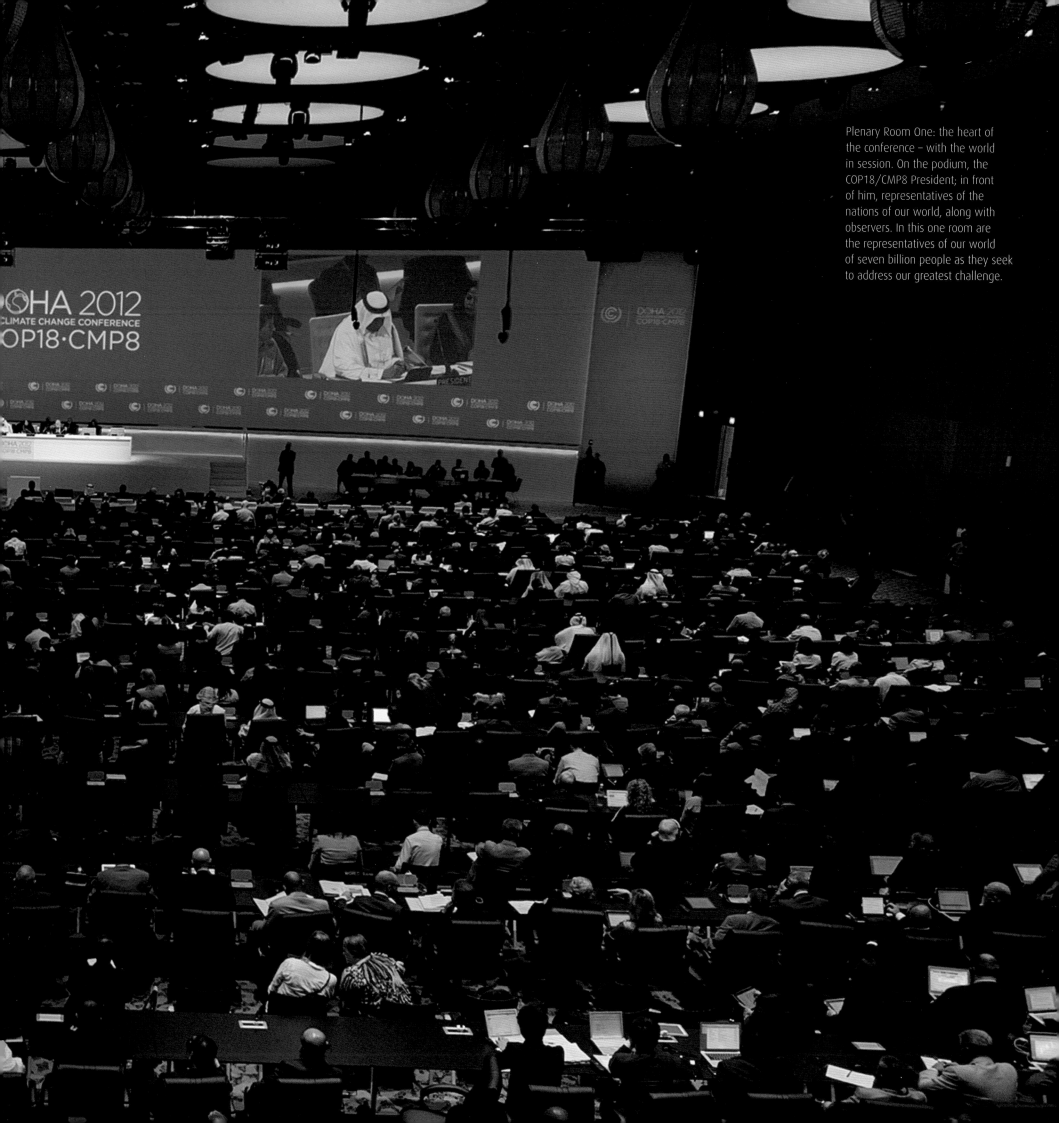

Plenary Room One: the heart of
the conference – with the world
in session. On the podium, the
COP18/CMP8 President; in front
of him, representatives of the
nations of our world, along with
observers. In this one room are
the representatives of our world
of seven billion people as they seek
to address our greatest challenge.

Engagement begins from the first moment of the conference, with the appointment of a new conference president. This opens a door to new regions of the world, new governments and peoples, and helps to spread the responsibility of addressing climate change.

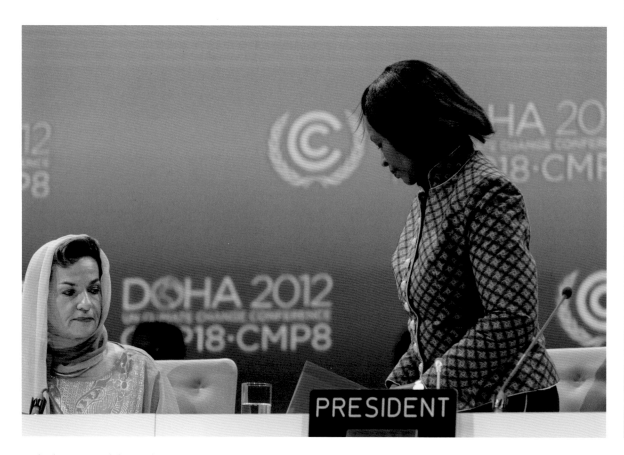

At the beginning of the Conference, Ms Figueres, Executive Secretary of UNFCCC, presides over the transition of the presidency. HE Maite Nkoana-Mashabane, President since COP17/CMP7 Durban in November 2011, completes her term.

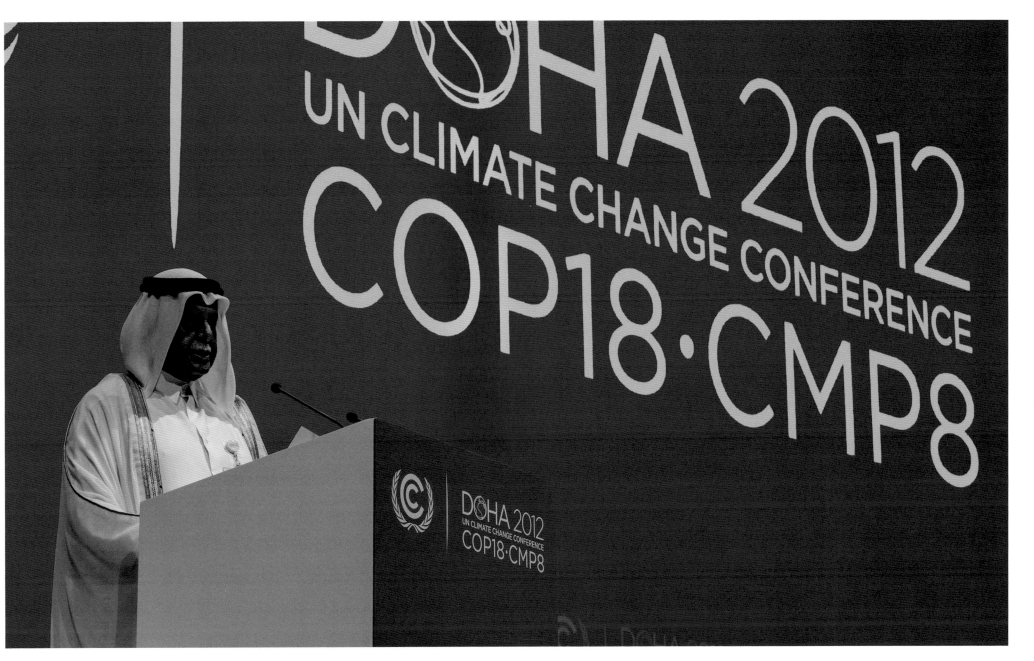

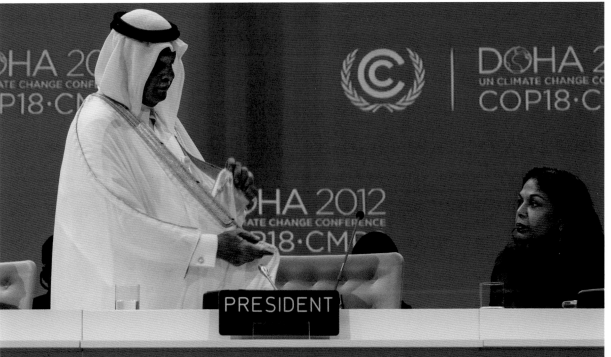

HE Abdullah bin Hamad Al-Attiyah, former Deputy Prime Minister of Qatar, takes over as President. The veteran politician facilitated the discussions among the delegates with disparate views, towards agreement during the conference. He remained as President until COP19/CMP9 in Poland in November 2013.

Unlike other high-level international meetings, UN climate change conferences are marked by their vibrancy — and this comes from the wide participation from diverse countries, cultures (and ages).

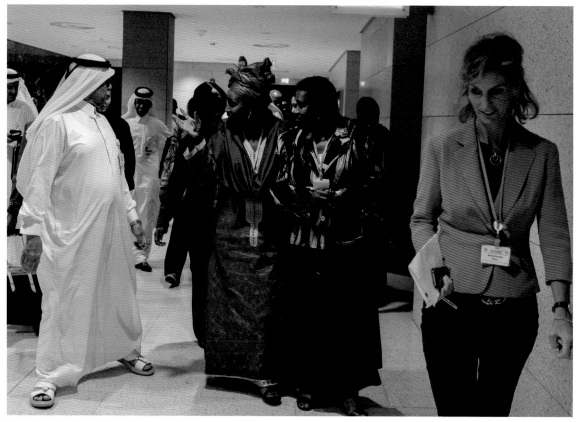

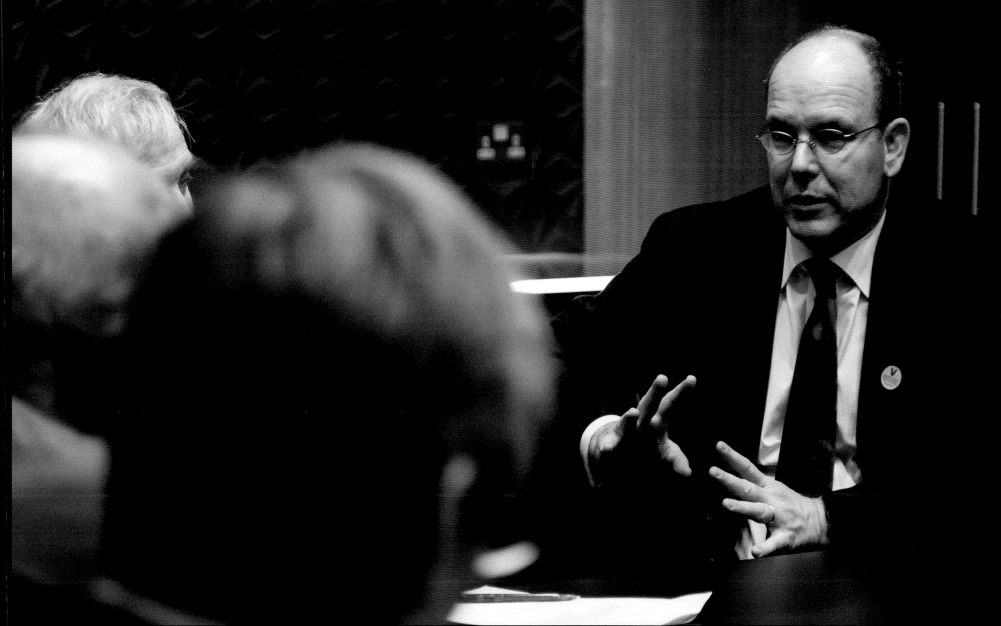

HSH Prince Albert of Monaco, *below*, works passionately to raise awareness of environment and climate change issues and encourages sustainable development through his foundation. He speaks at a meeting on how the world needs a clearer vision of how to tackle climate change.

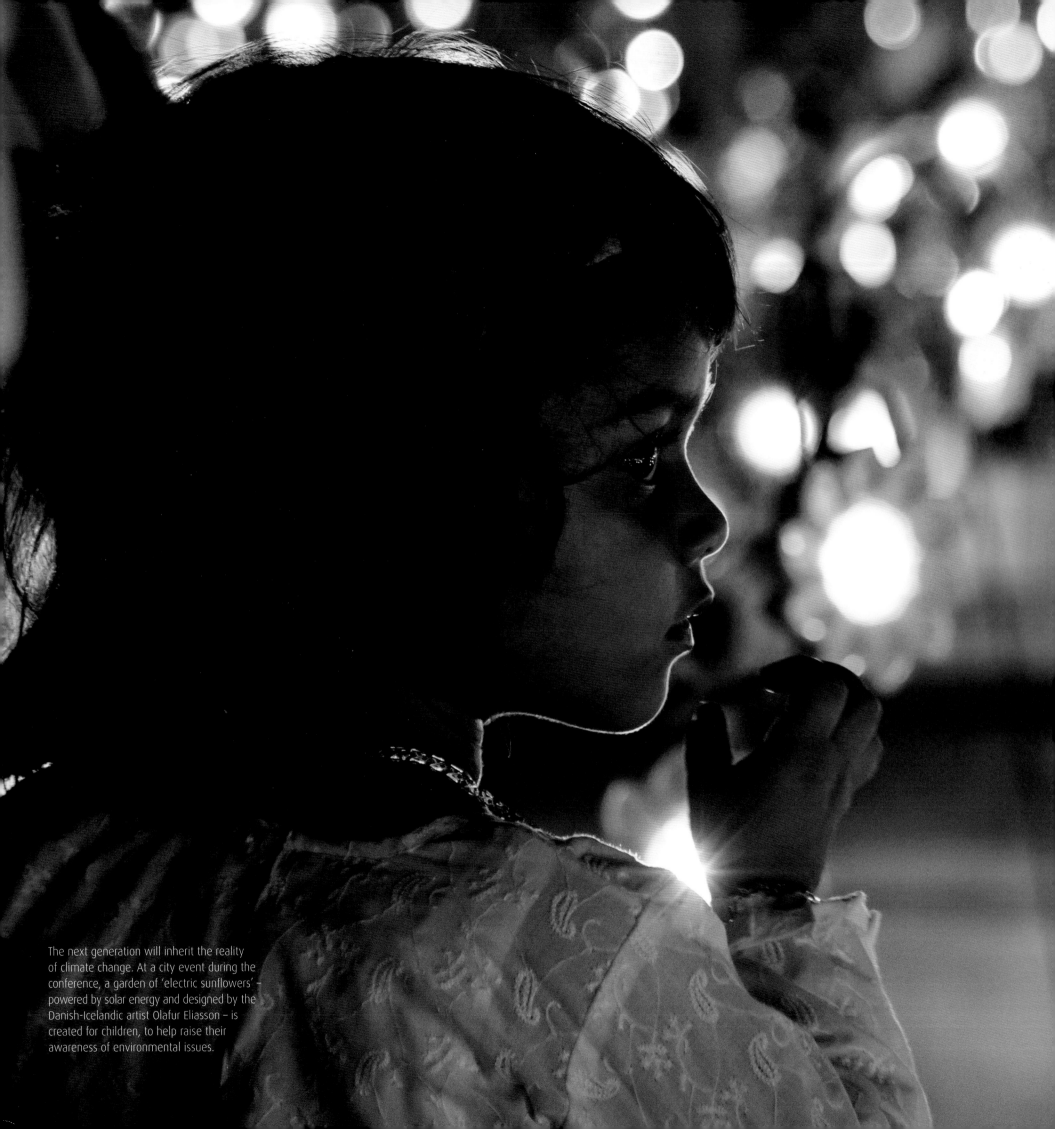

The next generation will inherit the reality of climate change. At a city event during the conference, a garden of 'electric sunflowers' – powered by solar energy and designed by the Danish-Icelandic artist Olafur Eliasson – is created for children, to help raise their awareness of environmental issues.

'7 Billion. 1 Challenge.': the complex issues addressed by the conference of carbon emissions, mitigation, adaptation, sustainable development and diplomacy, and all the hopes and fears of those working on the issues can be summed up in just these four words, which remind all at the event of the importance of their work.

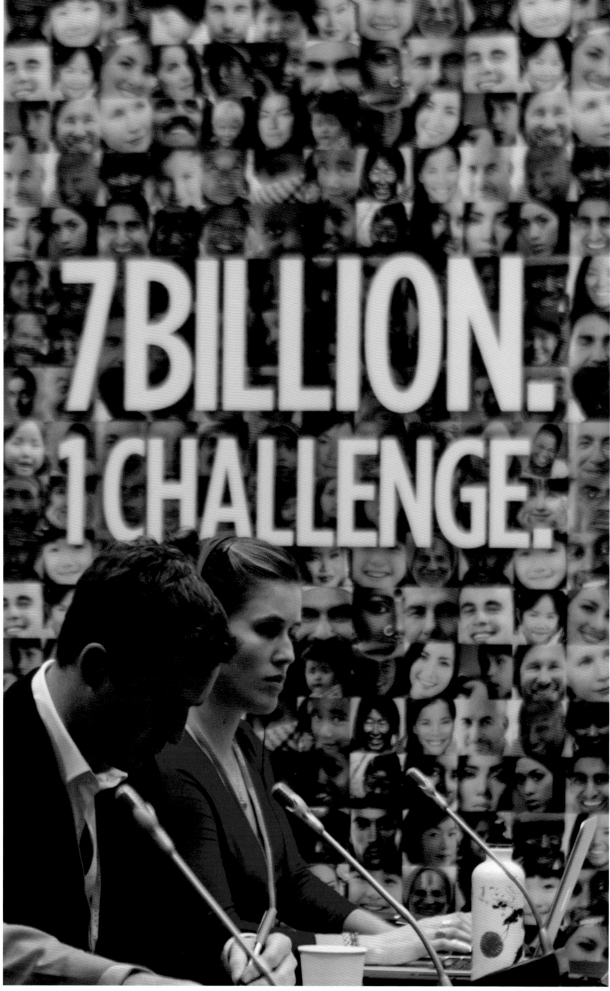

7BILLION. 1CHALLENGE.

In many parts of the world, women are in the front line of climate change because of their role in managing food and water resources for families. Every year, the conference offers women's groups a platform to outline gender issues linked to climate change, so that they can continue to shape these key areas of global policy.

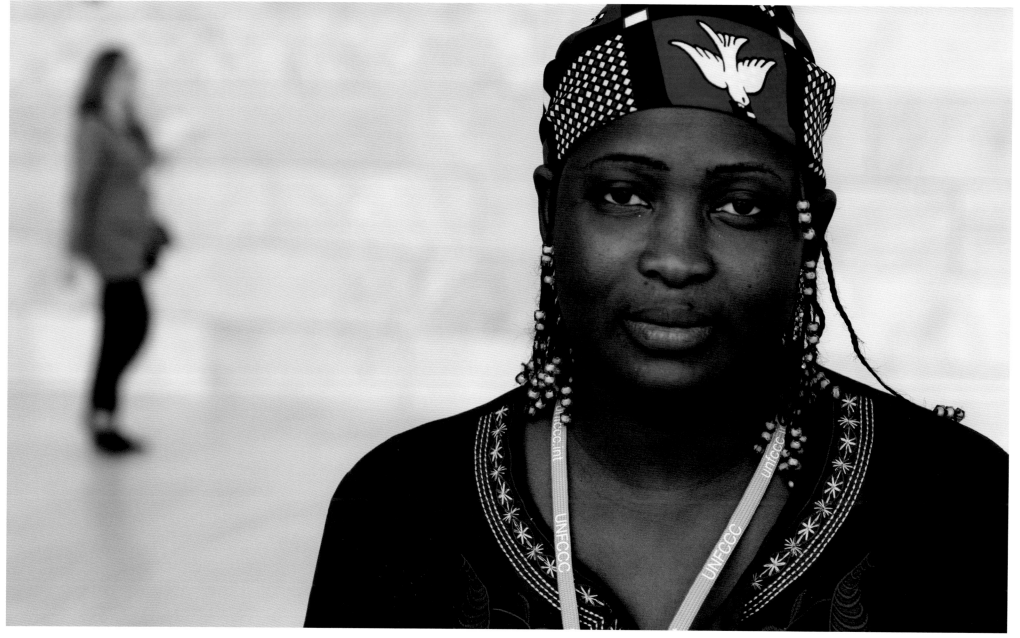

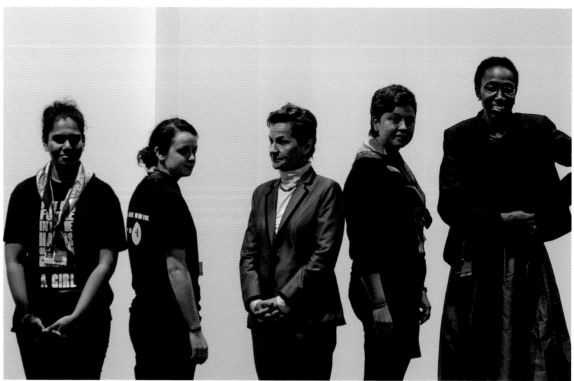

Perhaps the most obvious constituency that will be directly affected by climate change is our youth, the generations of tomorrow. At the conference, they are represented at all levels, given platforms to express their views and a 'Youth Day' to lobby for action.

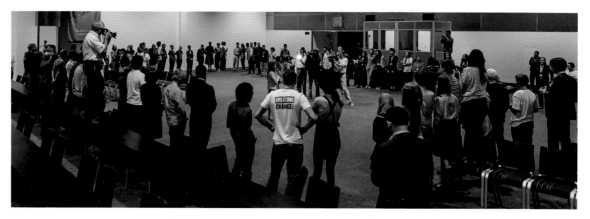

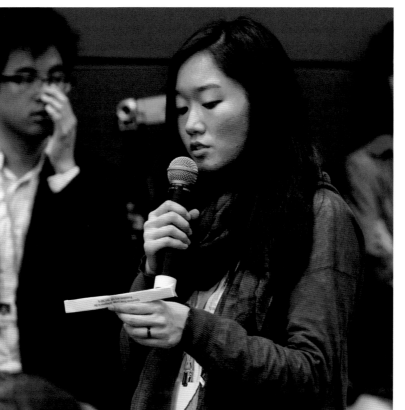

Ms Rachel Kyte, Vice President for Sustainable Development at the World Bank, at the release of a report by the institution, says the key to progress is spreading information about the challenges, especially to the world's youth.

Observers and other youth participants attending are able to put questions directly to senior figures, through question and answer sessions and informal meetings.

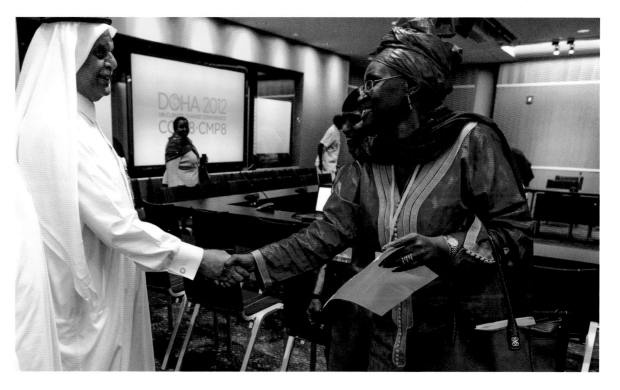

One of the significant political events of the first week is Palestine gaining recognition and a seat at the conference with a voice. South Sudan, which gained independence in 2011, is also formally recognised, and both join the Holy See with the accreditation of observer status.

SOUTH SUDAN

PAL

Formal engagement between activists and policymakers is just one element of the conference. There are also countless opportunities for observer groups to get their message across, such as through impromptu demonstrations to raise awareness of particular issues.

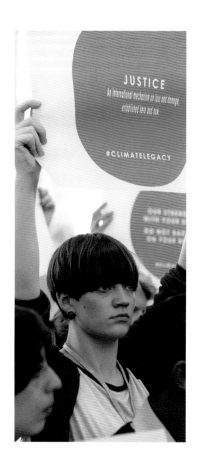

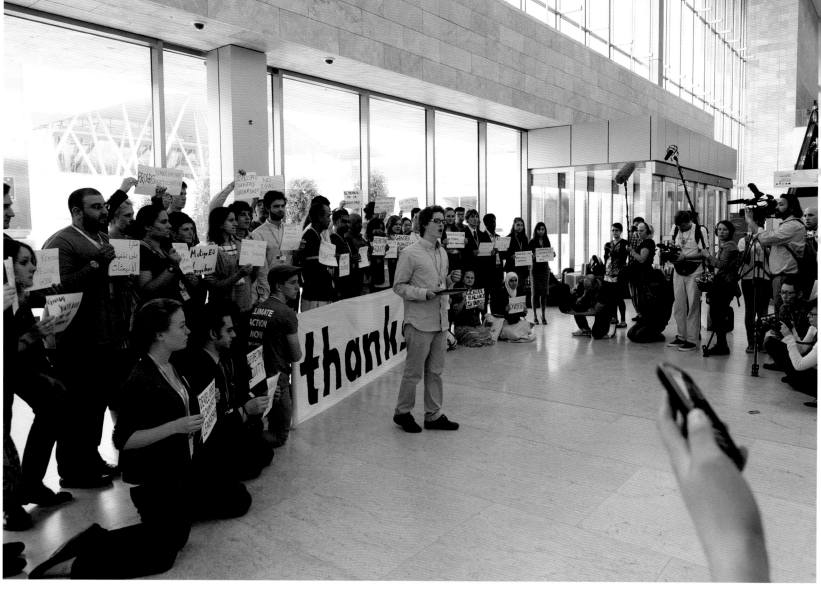

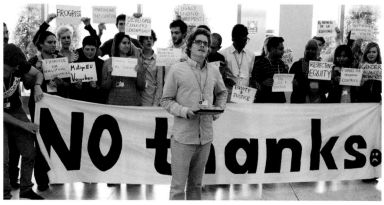

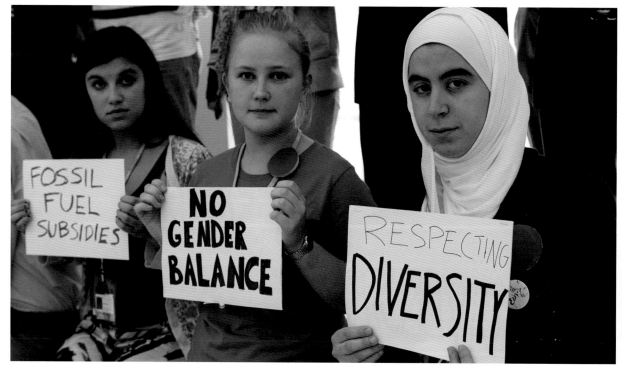

New technology provides another means to engage audiences. COP18/CMP8 Doha served as a benchmark for a technologically integrated climate change conference. Social networking played a huge role through Twitter feeds and blogs from participants, the widespread use of mobile applications and the internet.

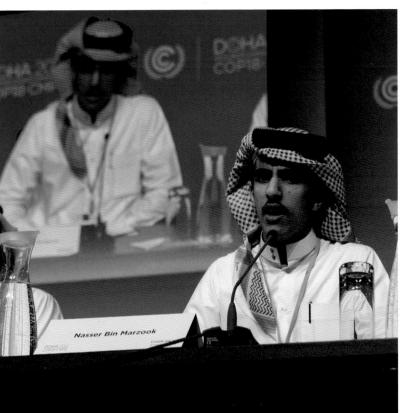

Mr Nasser bin Marzook, *far left*, a Qatari school student, tells the conference how he became aware of the effects of global climate change as part of Qatar Foundation International's 'Ocean for Life' programme. Many students, members of observer groups and other representatives of the world's civil society are given formal platforms to express their views and those of their peers.

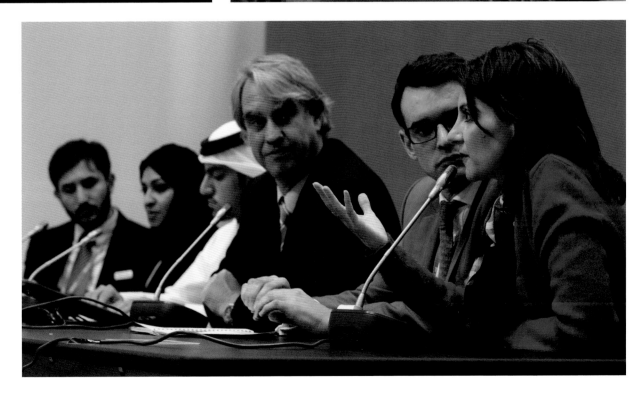

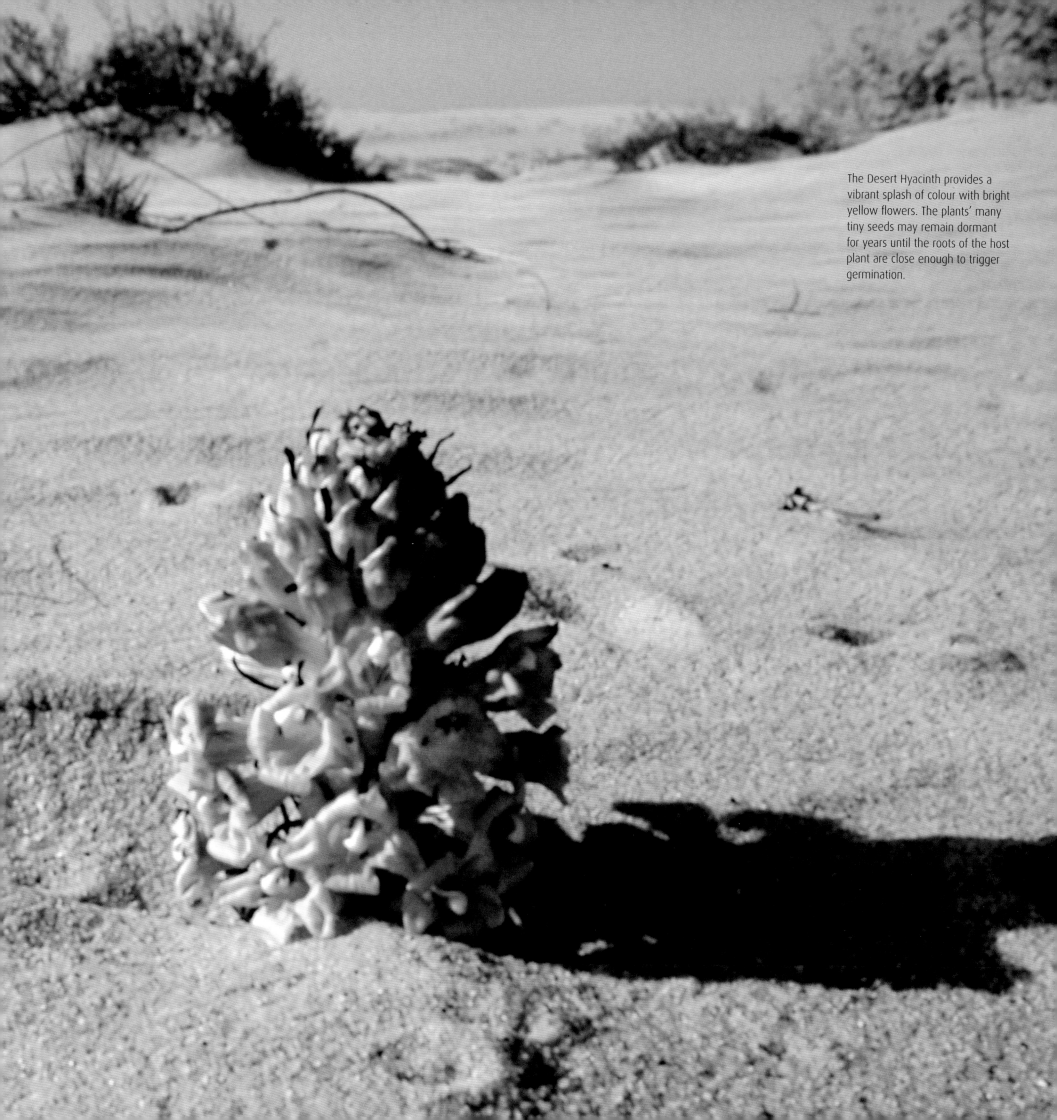

The Desert Hyacinth provides a vibrant splash of colour with bright yellow flowers. The plants' many tiny seeds may remain dormant for years until the roots of the host plant are close enough to trigger germination.

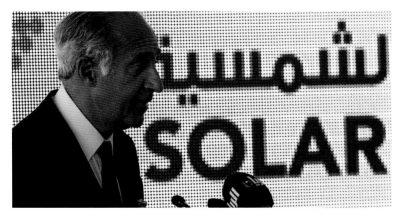

Engaging the private sector is critical to addressing climate change. Renewable energy technology is a critical part of a more sustainable future and on the sidelines of the conference, the Qatar Solar Test Facility in the Qatar Science and Technology Park, is launched, creating the region's first facility dedicated to testing solar technologies in desert climates.

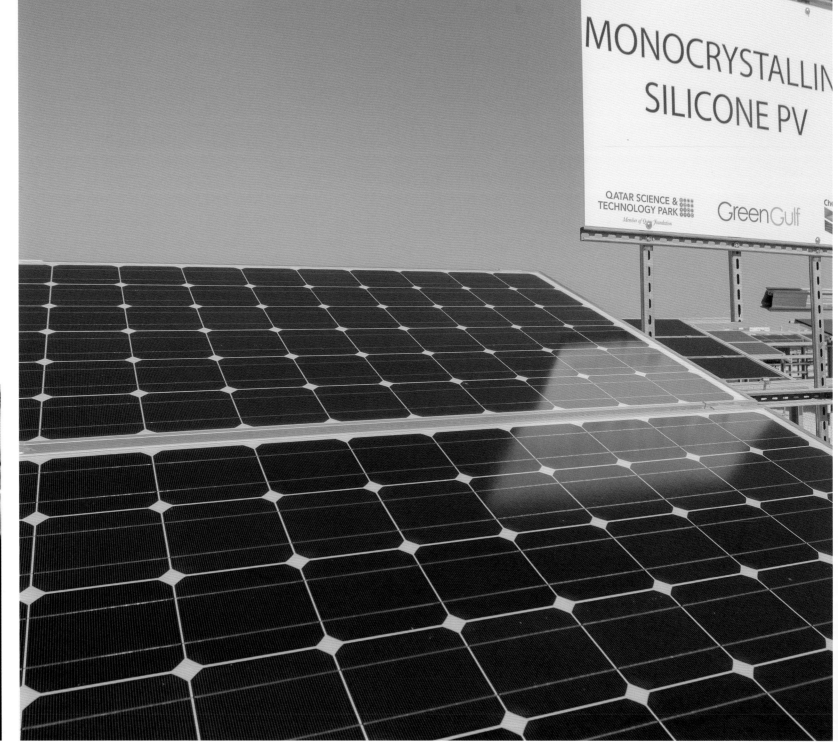

The Doha Film Institute Green Film Festival brought together filmmakers, the local community and conference participants for screening and discussion sessions. French filmmaker Mr Jacques Perrin, *left*, discusses his film 'Winged Migration' with noted architect Abdel-Wahed El-Wakil.

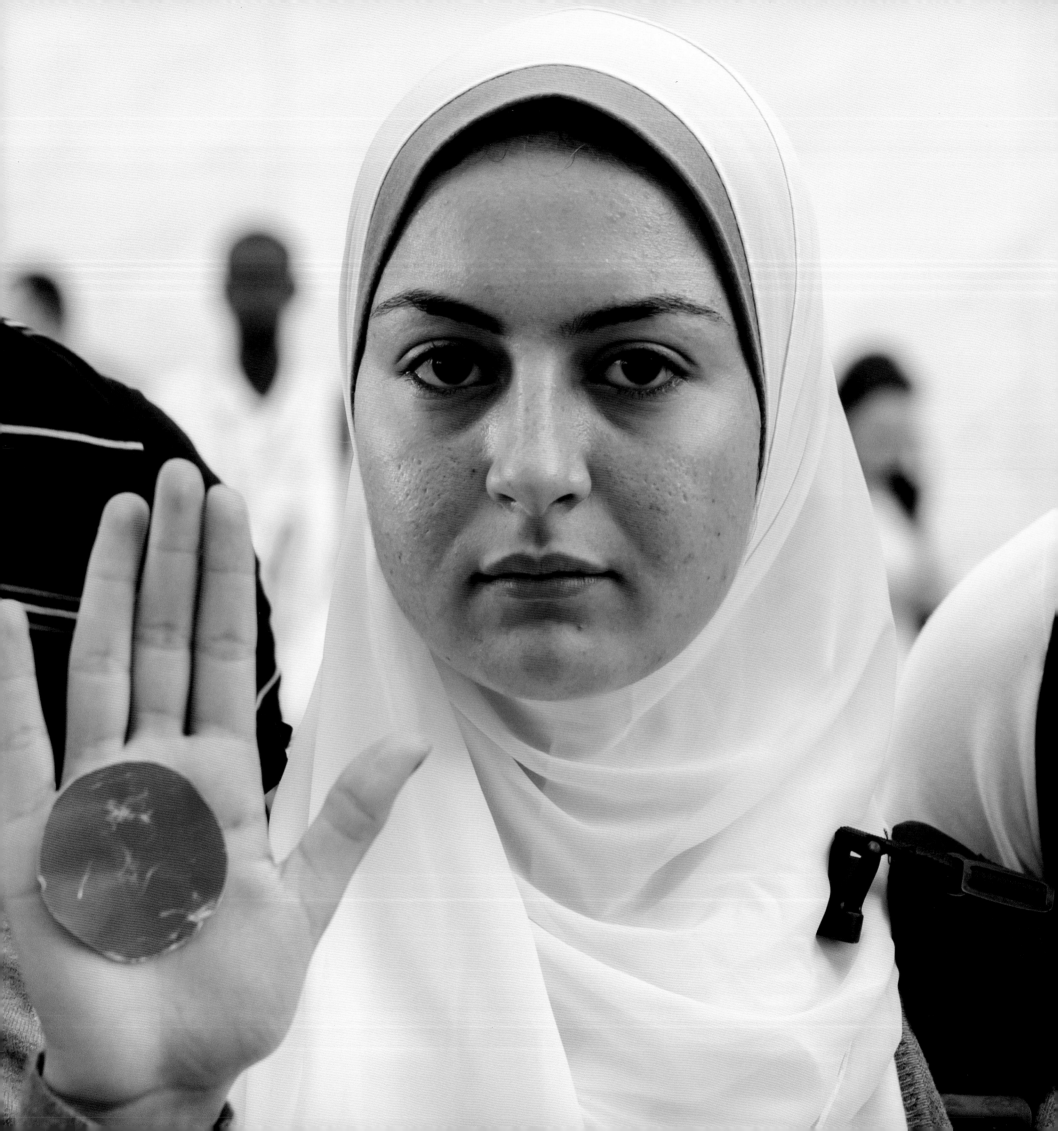

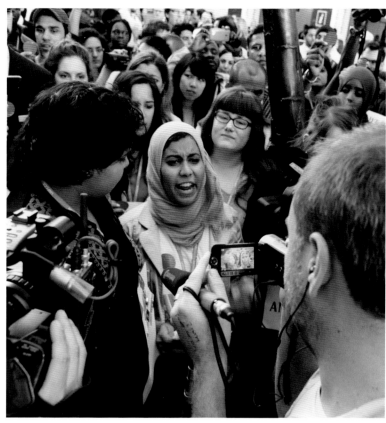

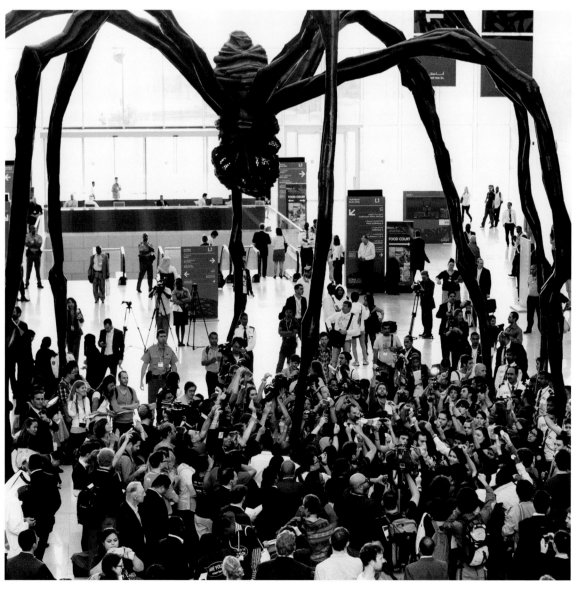

Red dots, *left*, are the symbol of the Climate Legacy Campaign, a civil society organisation that campaigns to raise awareness. It holds a sombre vigil during the conference to get its point across to delegates.

The same symbol is used when another group, Sing For The Climate, organises a 'flashmob' under the giant spider sculpture at the conference centre. Participants come together to 'sing for the planet', urging action 'to build a better future'.

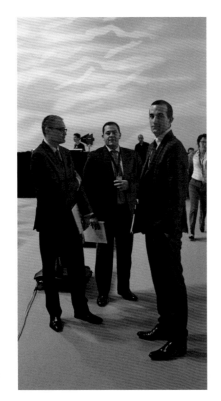

If the average global temperature rises by more than 2°C, scientists predict it will set off a critical chain of events. The target therefore is to limit global warming to 2°C, and posters featuring this goal are present, *below*, throughout the conference.

عالم <2° world

Delegates participate in question and answer sessions, which are central to the conference. Each one represents a country or interest group, and time is set aside for all to make their views known, ensuring a consensus is built behind agreements.

Dr Wajeeha Al Baharna, *left*, the President of Bahrain Women's Association For Human Development, speaks at a 'Hikma Hour' or 'Wisdom Hour' session, a regular feature of the conference that highlights traditional regional responses to climate issues.

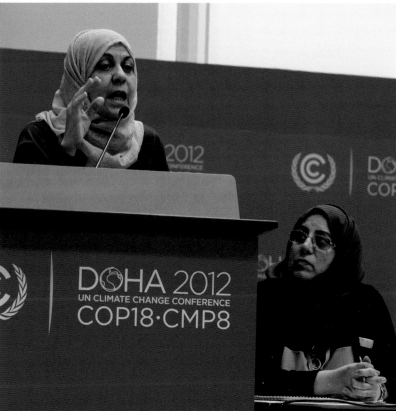

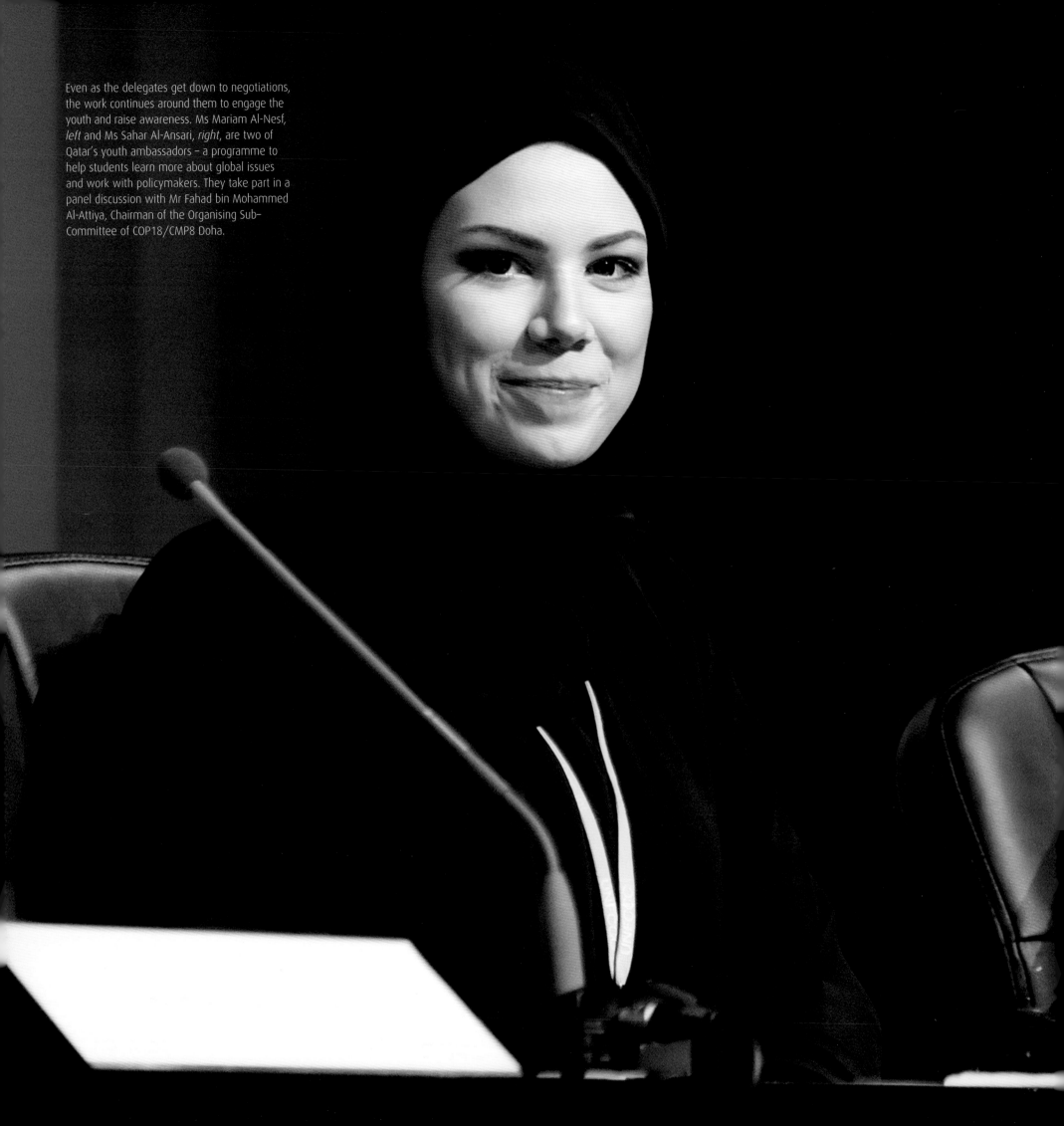

Even as the delegates get down to negotiations, the work continues around them to engage the youth and raise awareness. Ms Mariam Al-Nesf, *left* and Ms Sahar Al-Ansari, *right*, are two of Qatar's youth ambassadors – a programme to help students learn more about global issues and work with policymakers. They take part in a panel discussion with Mr Fahad bin Mohammed Al-Attiya, Chairman of the Organising Sub–Committee of COP18/CMP8 Doha.

Sahar Al-Ansari

Momentum for Change, *right*, is an initiative by UNFCCC, to showcase initiatives across the globe that are moving the world toward a resilient, low-carbon future.

Research groups take advantage of the platform provided by the conference to release new information. Ms Marion Vieweg-Mersmann, *far right*, of Climate Analytics, a Berlin-based group, releases a report on the current international system for the trading of pollution permits.

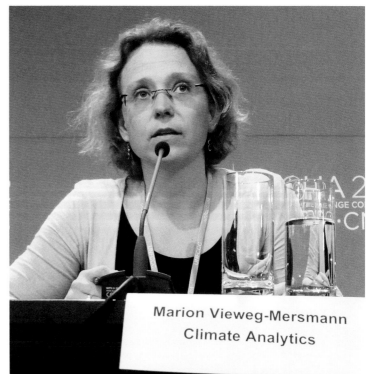

Many of the initiatives highlighted during the conference are publicised through daily press conferences which are led by the UN and the local media team. These provide an opportunity to explain the events of the day and give journalists an opportunity to ask questions. Some individual governments, such as the United States, *far right*, also hold their own press conferences to explain their positions on negotiations.

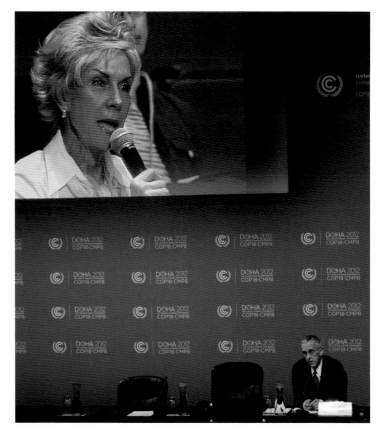

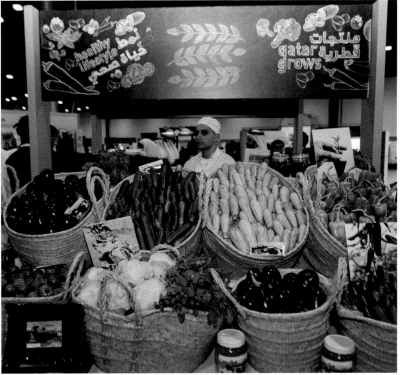

الرئيسية لبرنامج قطر الوطني للأمن
آليات تحقيق الأمن الغذائي في قطر

THE QNFSP MASTER PLAN
THE MECHANICS OF ACHIEVING
FOOD SECURITY IN QATAR

تحلية المياه
WATER
DESALINATION

الزراعة المحلية
LOCAL AGRICULTURE

تصنيع الأغذية
FOOD PROCESSING

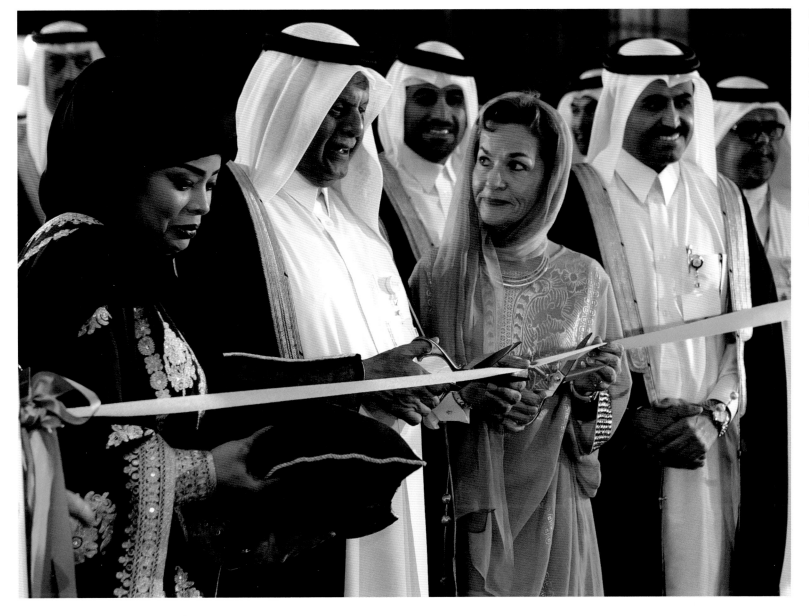

One of the most popular parts of the conference is the Qatar Sustainability Expo, showcasing sustainable initiatives by local, regional and international organisations. These range from solar-powered sports cars to new ways to reduce energy use, and Qatar's emerging local organic agricultural produce. The event is opened by HE Abdullah bin Hamad Al-Attiyah, President of COP18/CMP8, and Ms Christiana Figueres, Executive Secretary of UNFCCC, *left*.

As the official opening of the High-Level Segment of the conference draws closer, staff fine-tune the details, from the massive video presentation that will be seen across the plenary room, to the running order and appearances by notable Qataris including Dr. Noor bint Ahmed Al-Khori.

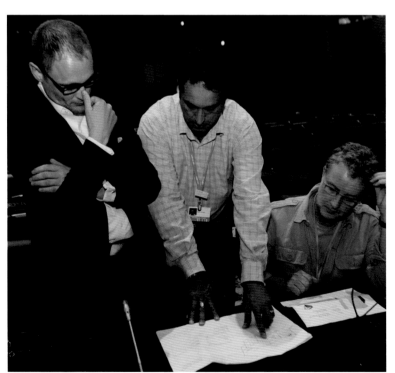

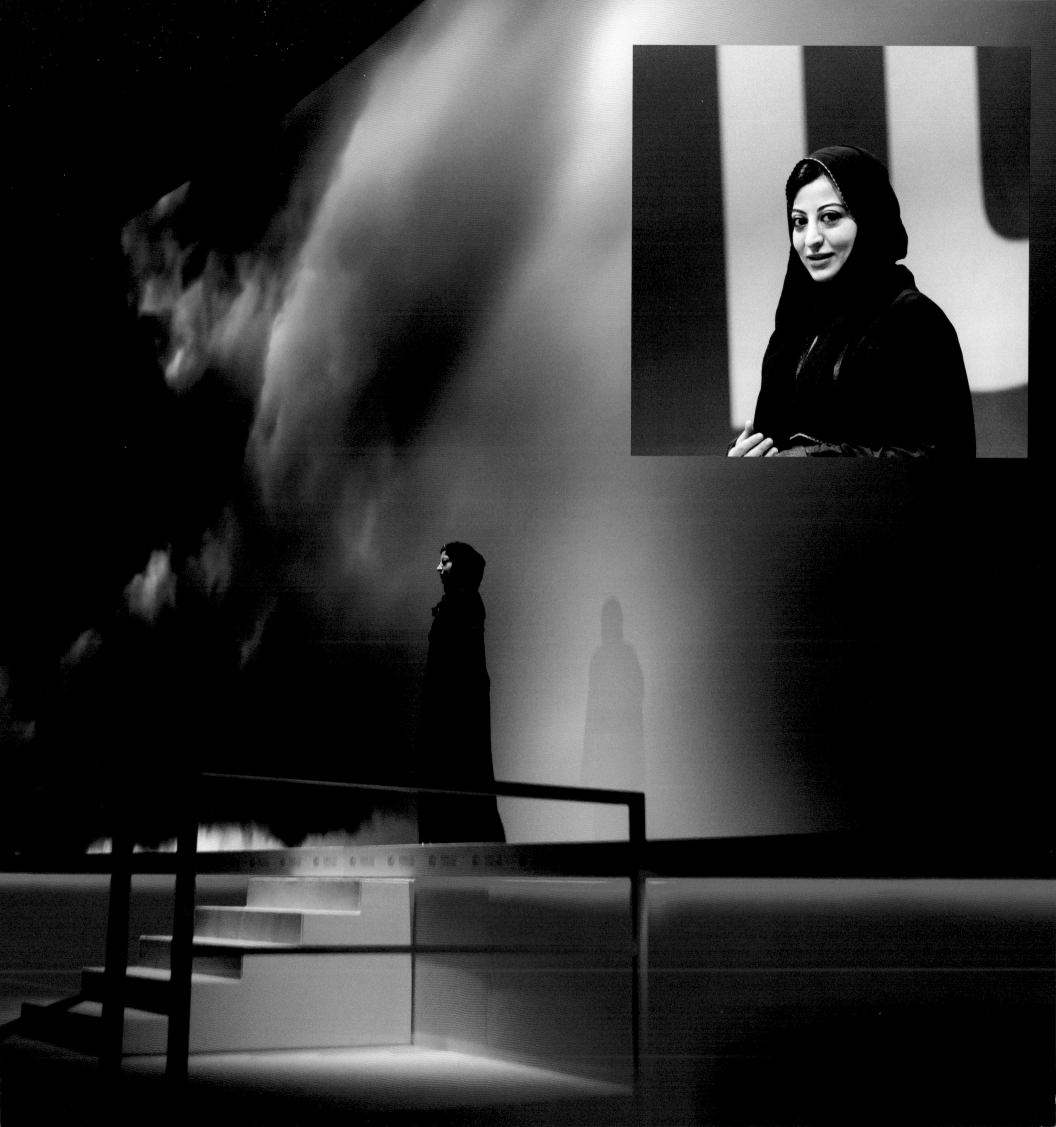

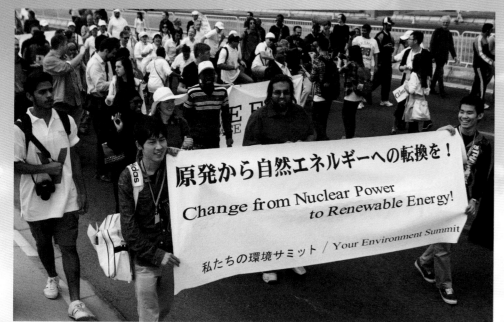

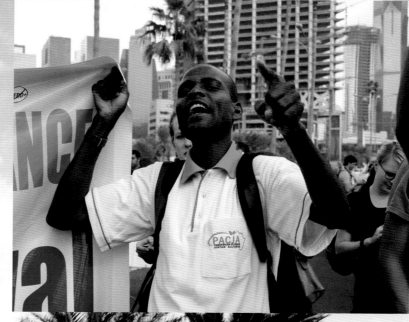

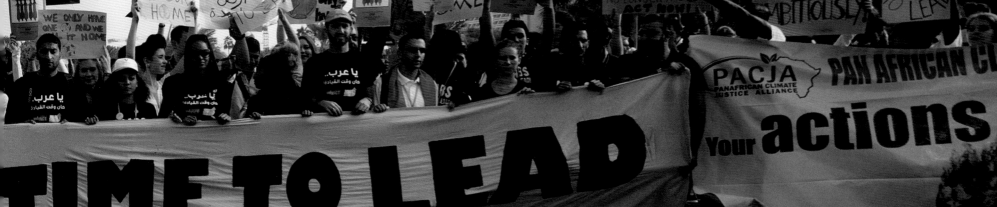

A tradition of every climate change conference is the Global Day of Action. Participants take to the streets of the host city to voice their concerns at the problems of climate change and seek to raise local and international awareness. In Qatar, the event takes place on the first Saturday of the conference, with vast crowds stretching all along the city's Corniche.

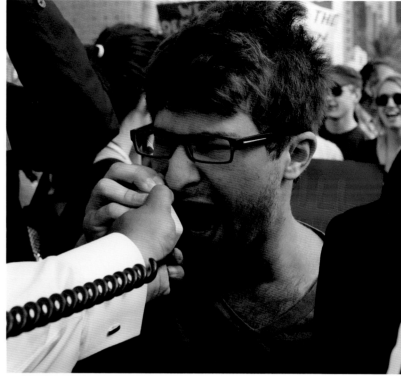

The march is an opportunity for city residents as well as visitors to take part and raise awareness. Those attending range from the senior officials of the COP18/CMP8 Doha organising committee, *above*, to students and activists who have travelled long distances to be at the event.

The world's media, such as the German broadcaster Deutsche Welle, *right*, attend the march, and hear the voices of those who are urging international action. The protesters are colourful and committed in making their voices heard.

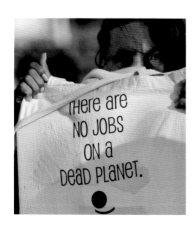

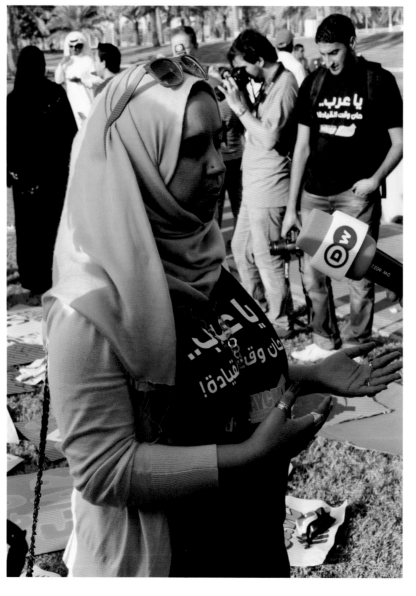

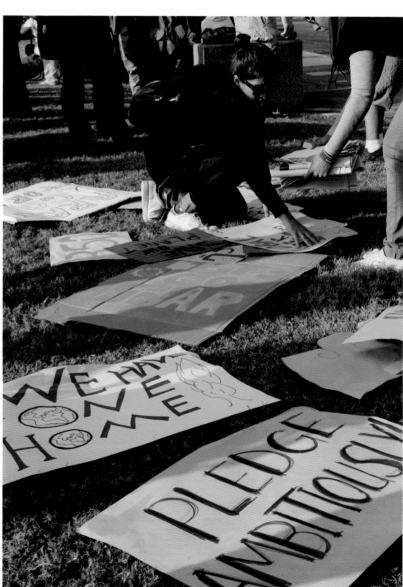

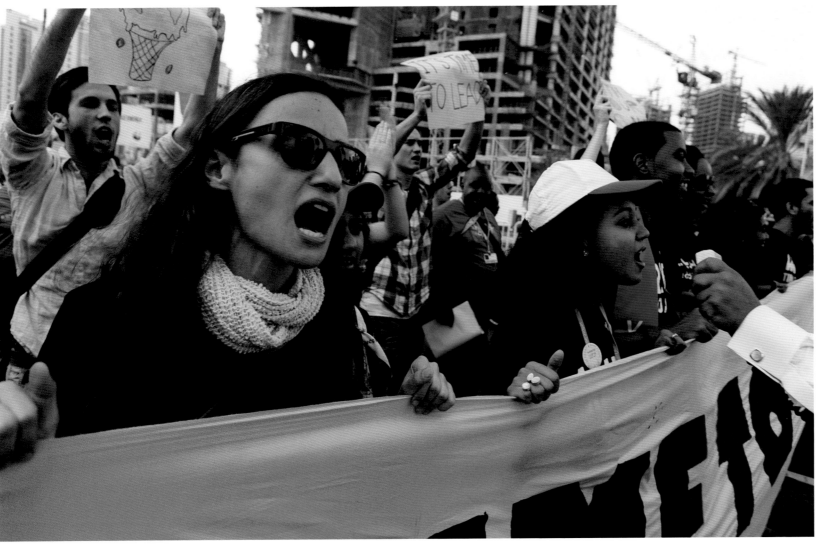

Under the Banner 'One Environment, One People, One Earth', the message of the march is enthusiastically championed by the international activists and Qataris who attend. While the issues at the heart of the demonstration are very serious, the protest day is good humoured. The march draws families as well as activists and has a festival atmosphere.

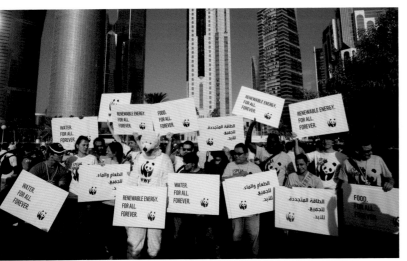

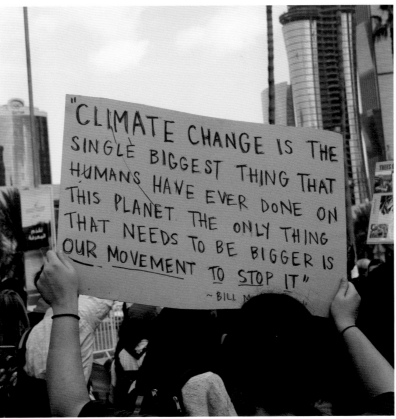

111

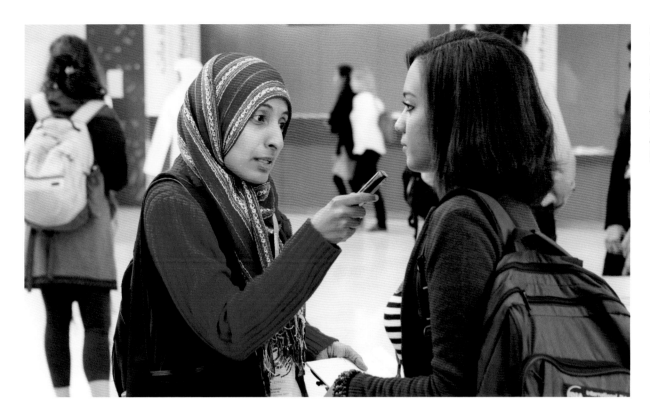

For many of those attending the march, it is their first opportunity to take part in a public protest about climate change. After the event, there is much discussion about what it has achieved, and hopes are raised that it will spur grassroot environmental action, both locally and in the region.

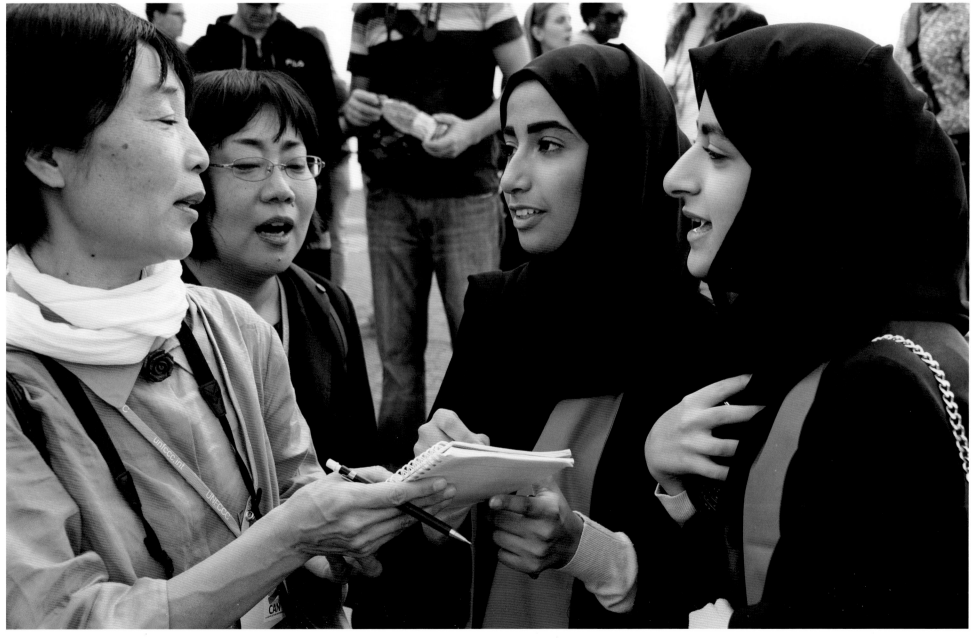

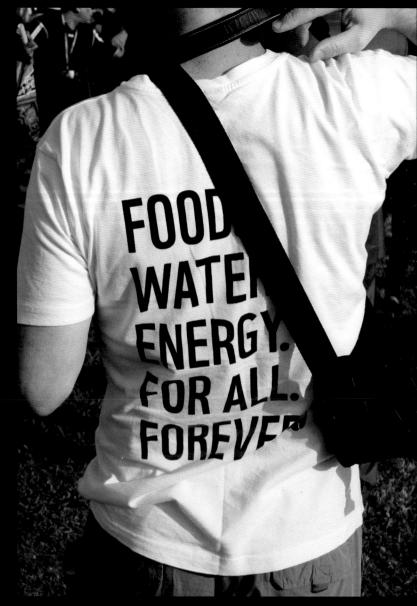

The humble T-shirt is more than a piece of clothing at the climate change conference – it is a billboard. Activists use their clothes to advertise their messages and particular issues. This 'protest chic' comes in a range of colours and styles. But the message is always the same: we need action now.

Some take the concept of wearing the message one stage further, such as this protest, *opposite*, organised by YouThinkGreen, an environmental youth movement. The group invites people to list their thoughts, demands and wishes about the conference, to be written on leaves that the protesters then wear.

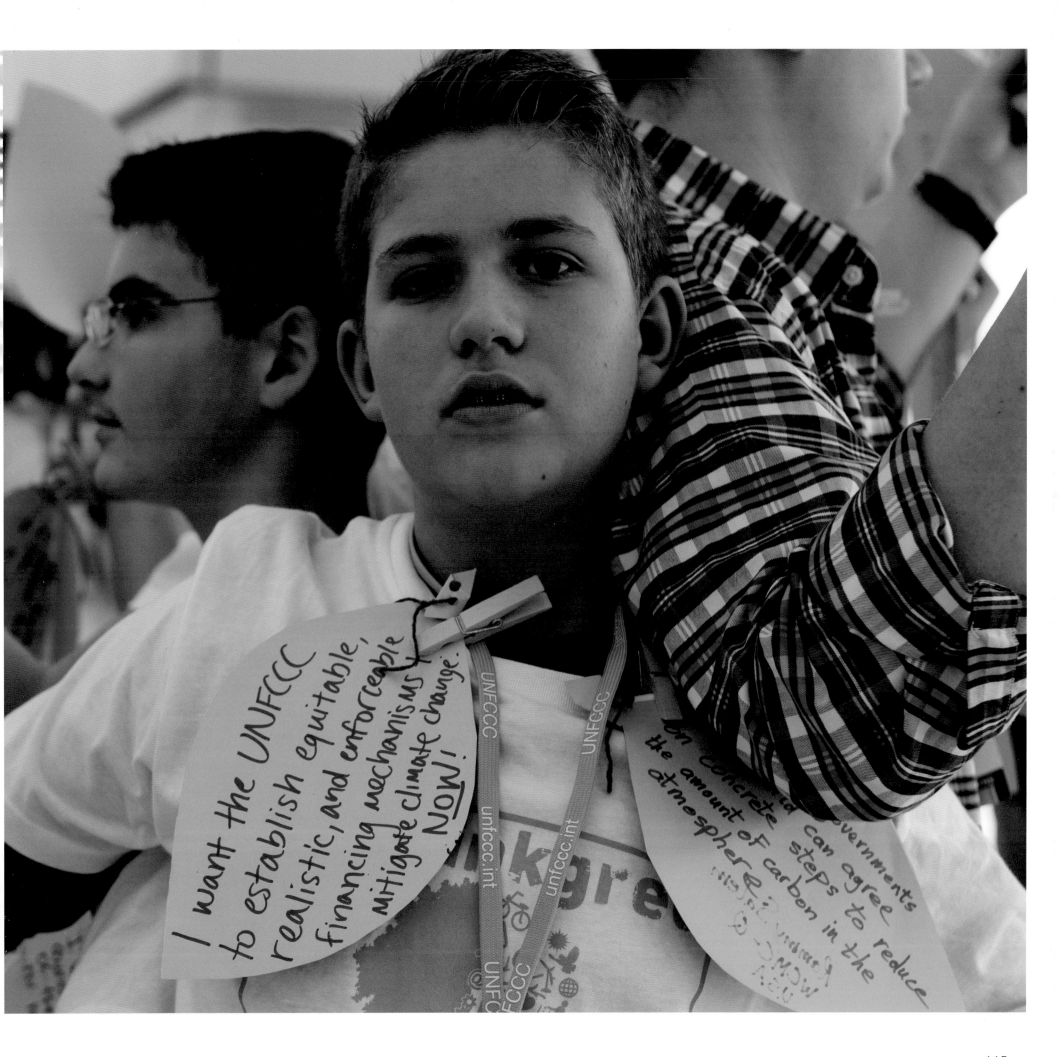

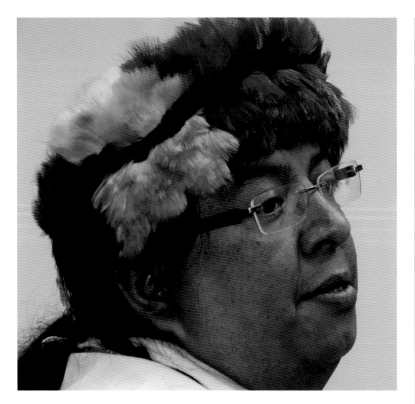

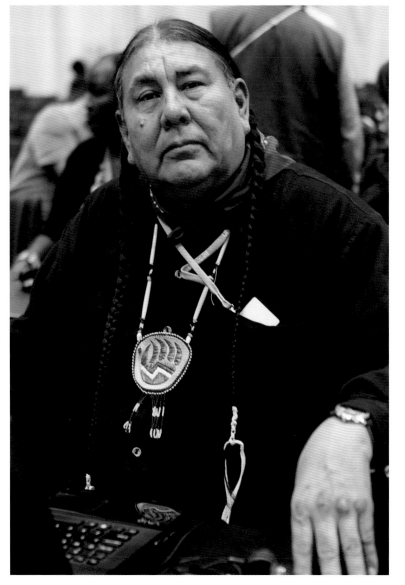

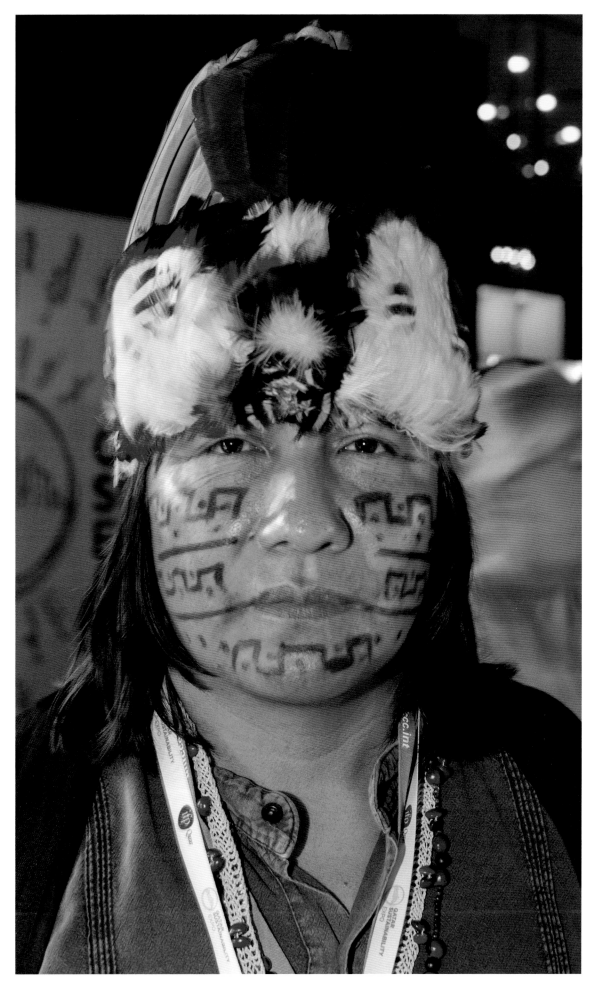

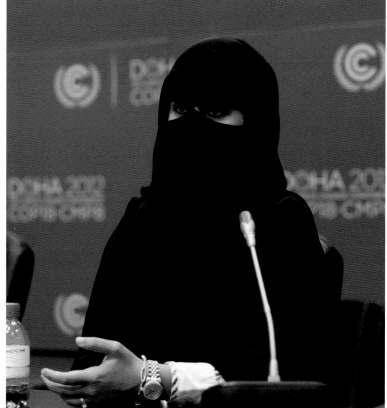

A global conference should represent the world, including all its nations, cultures and age groups. As such, the climate change conference in Doha is a visible success, with participants from around the globe.

Mr Manari Ushigua, *left*, is a representative of the Zapara people of the Amazonian rainforest region, where rising temperatures are already undermining food production.

Along with the Global Day of Action, there are many more small informal protests that take place within the conference. Civil society groups raise banners and hand out leaflets, trying to engage delegates in conversation as they arrive at the conference and as they walk between meetings.

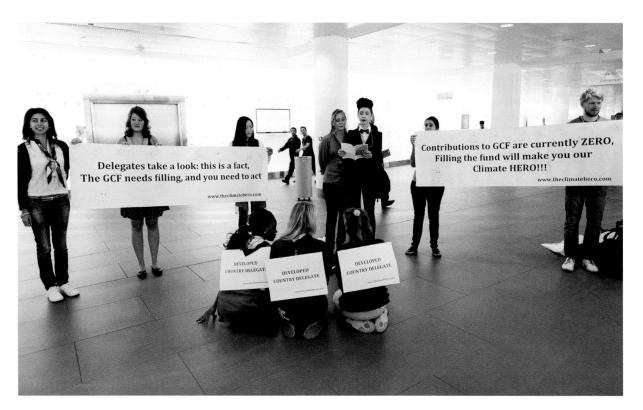

For some, the issues are very focused, such as the need for clean water for the world's poor or the need to protect the forests of the world, as the Earth's lungs.

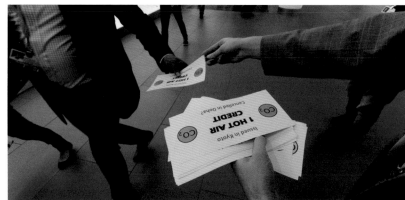

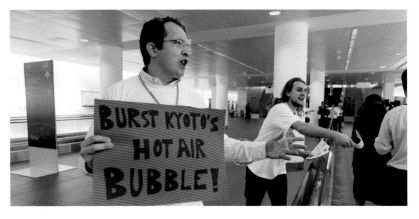

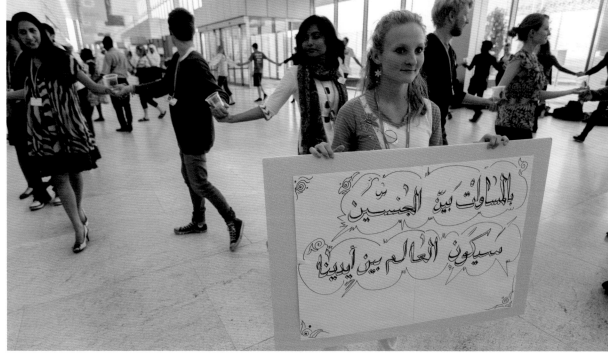

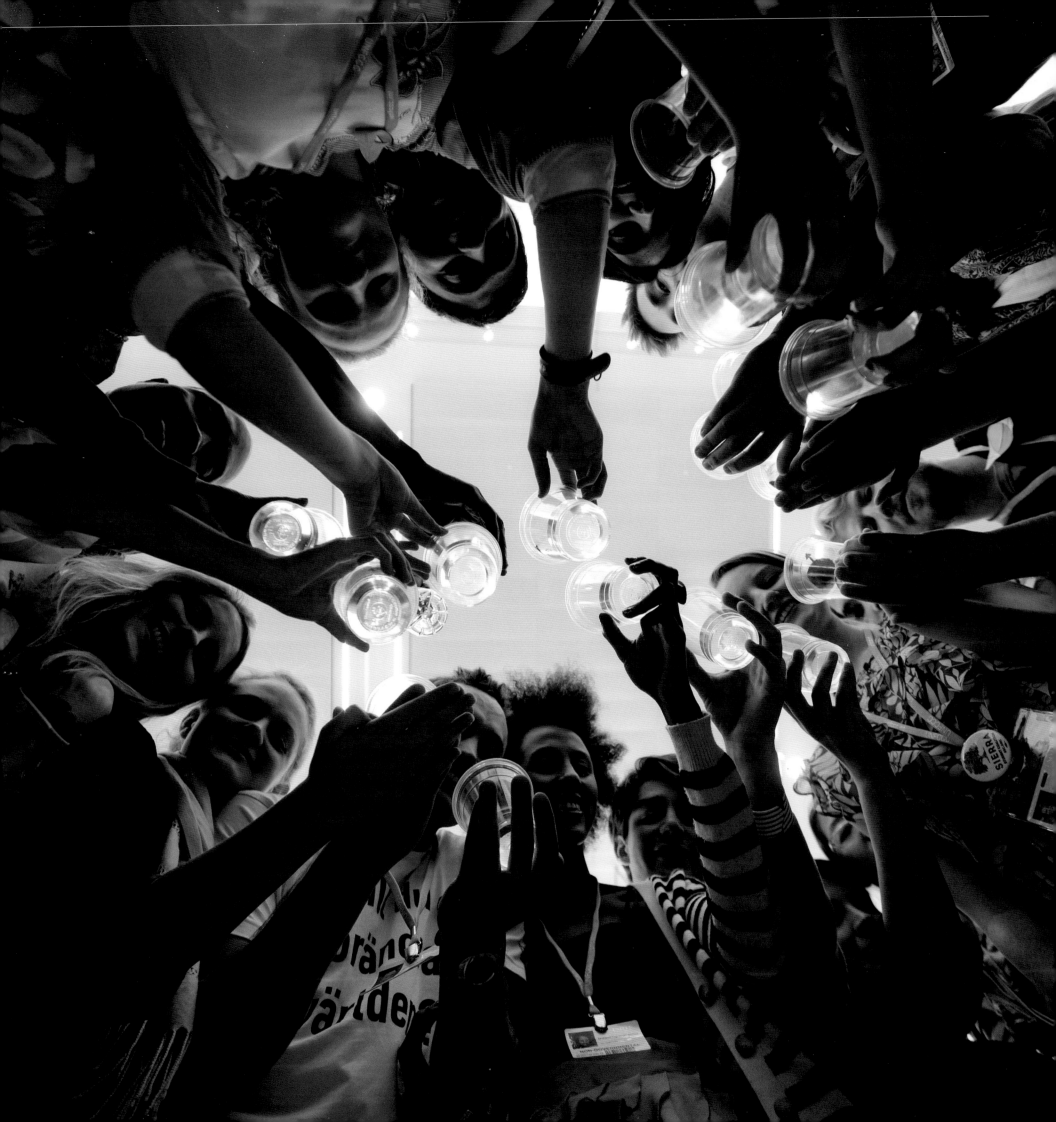

The atmosphere of goodwill allows for a free exchange of views, and for observers and participants to meet and discuss the critical issues.

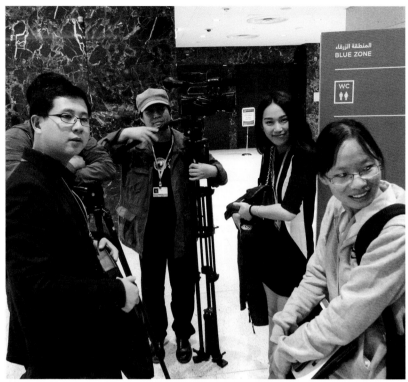

Participation and media interest in the conference comes from around the world. Along with national broadcasters, a wide variety of media, environmental and student groups record the event and broadcast via the internet and through conventional television services.

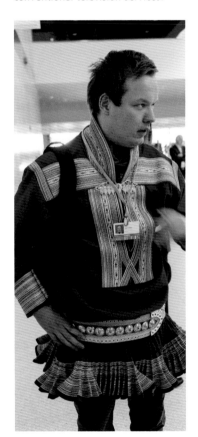

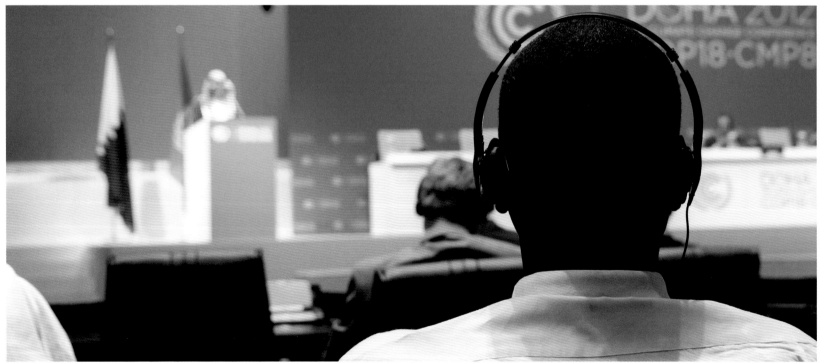

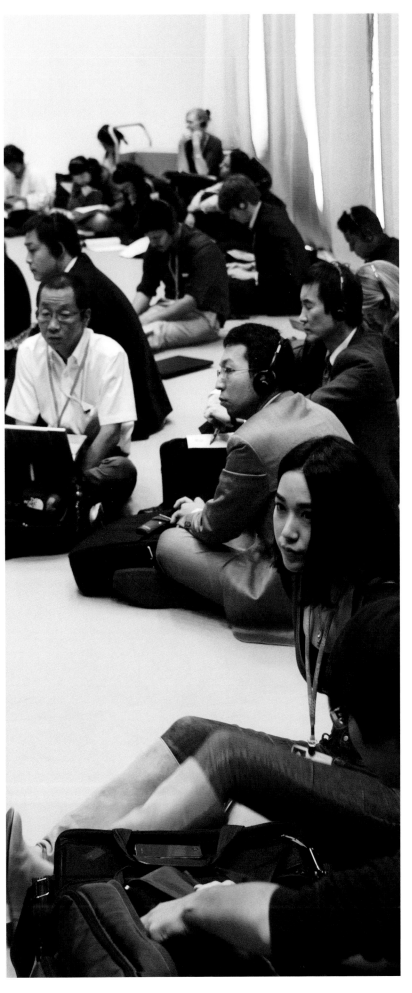

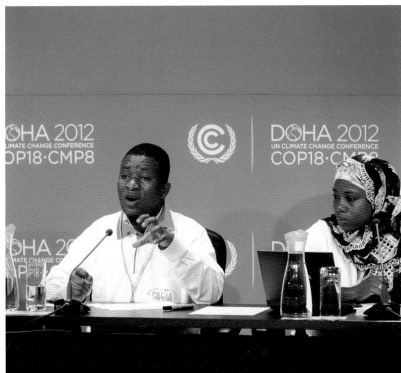

It also provides an atmosphere where participants feel comfortable to study and work together and even share floor space at unique events that draw large and diverse audiences.

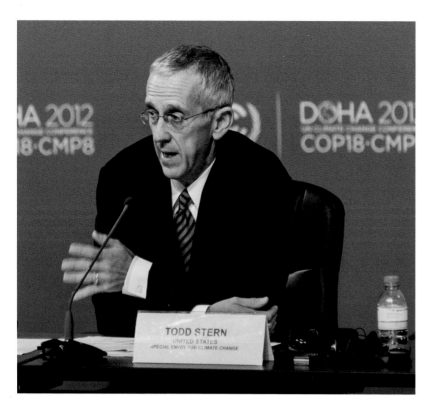

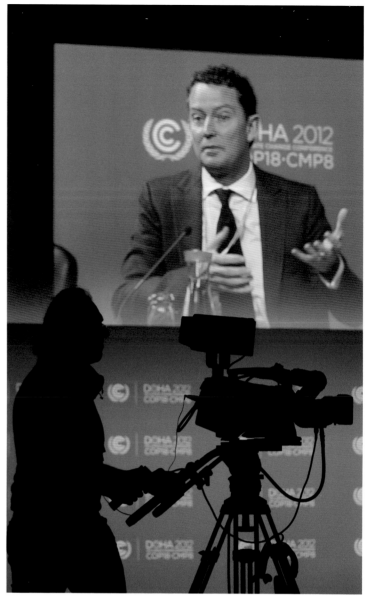

The conference is a venue for representatives from all around the world. Mr Todd Stern, the US Special Envoy for Climate Change, is a familiar face at the conference. He has been involved in negotiations since the Kyoto Protocol in 1997, and is always keen to discuss the issues.

Sheikha Noor Al-Thani is President of Doha Oasis, one of Qatar's most active environmental groups and organisers of the Global Day of Action march.

HE Claudia Salerno is head of the Venezuelan Delegation.

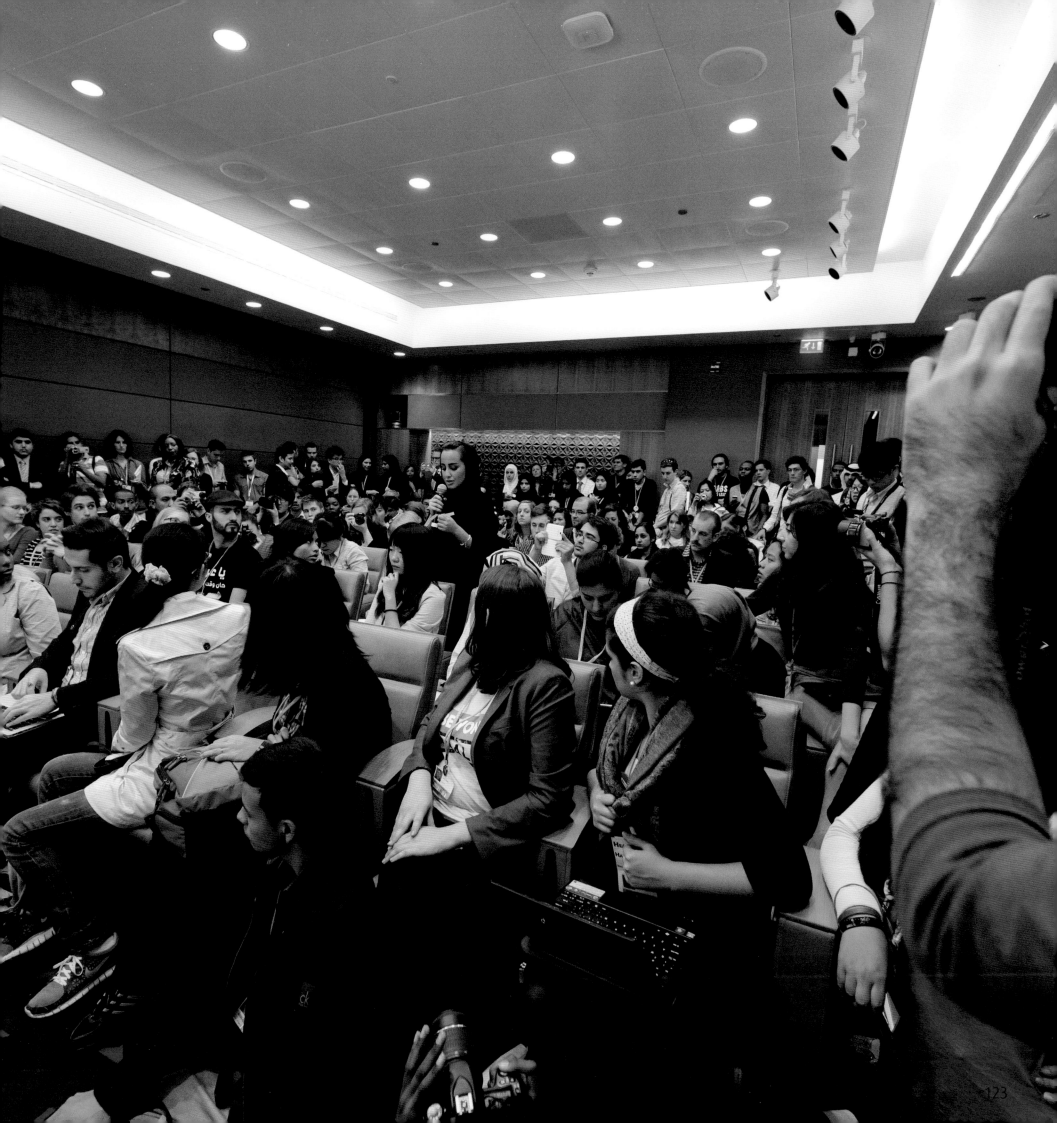

Visibility is a top priority of participating civil society groups. In the final hours of the conference, when it is feared that there will be no agreement, a delegate from the Philippines makes an impassioned speech to the assembly, and soon after, his words are repeated in a demonstration outside the plenary hall to pressure other delegates.

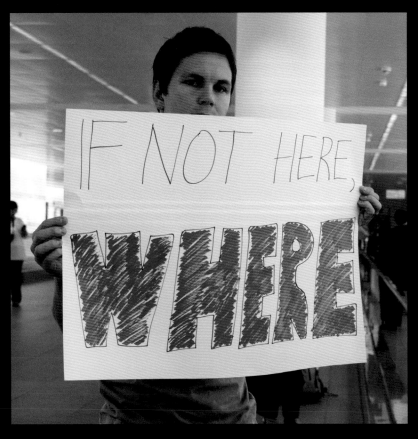

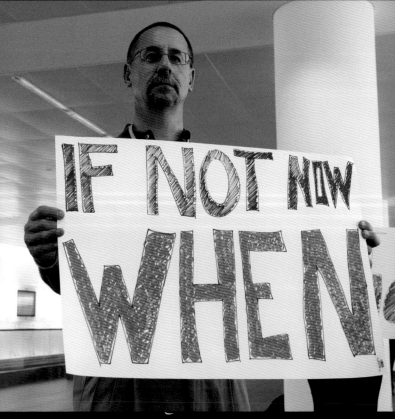

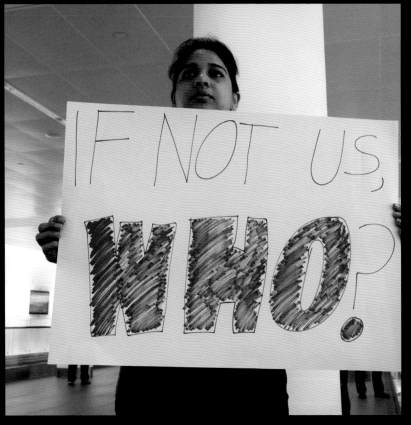

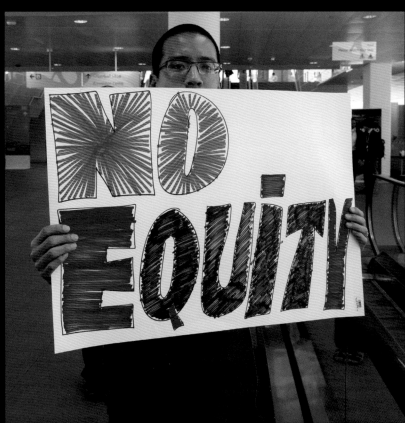

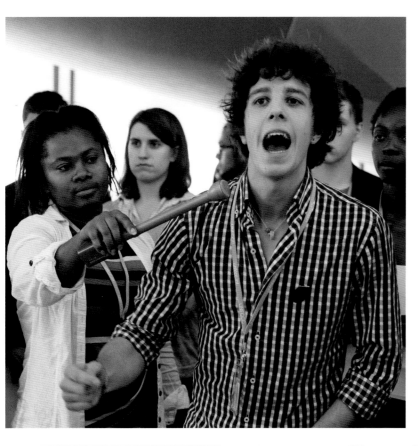

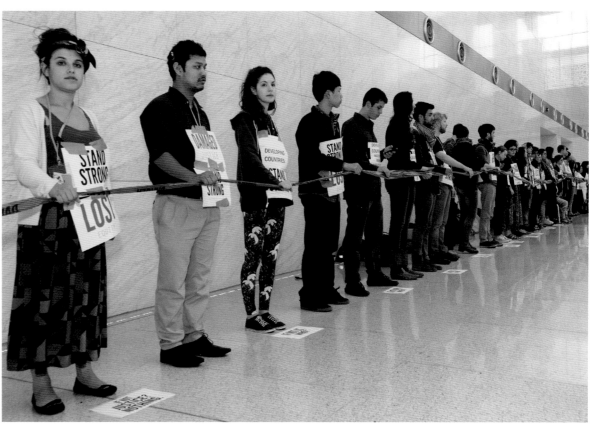

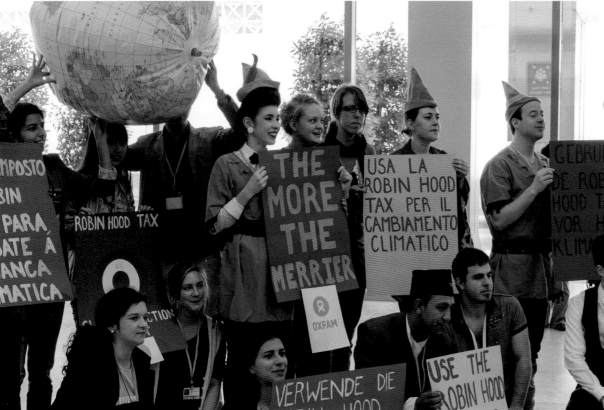

Yet others are silent, conveying simple messages, and asking participants to look to themselves, and their own consciences.

Some protesters use their voices in heartfelt pleas to convey the messages that they see as vital. Others use banners, but also costumes, props and humour.

Leadership

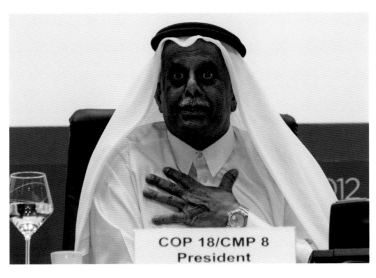

When proceedings begin, there are many at the conference who have not previously worked with HE Abdullah bin Hamad Al-Attiyah, *above*, President of COP18/CMP8 Doha. But by the end, through his tenacity, sharp mind, infectious humour and good spirits, delegates and observers alike have taken him to their hearts and, more importantly – he has achieved a seemingly impossible deal.

United Nations Secretary-General HE Ban Ki-moon speaks at the opening of the High-Level Segment of the conference. Global problems can only be tackled by global cooperation, and he reminds participants of the importance of the work ahead.

Reaching agreement within a family or among friends is not always easy. There are differing opinions, alternative views. Moreover, the larger the family, the greater is the scope for disagreement and consequently, the greater the challenge of reaching consensus and harmony.

The nations of the world, a family of about 200 members — each with its own opinions, challenges, problems and beliefs — is as diverse as could be imagined.

Seeking to forge agreement among this family can seem unattainable. Yet this is precisely the task of the annual UN climate change conference: to bring the nations of the world together and reach agreement on taking a step forward in addressing climate change. And every year one nation, and one individual, takes on the mantle to host and lead this seemingly impossible task.

The challenge is to bring together the States and peoples of the world; to listen to their ambitions, hopes and fears; and, based on these, to set adequate goals and targets in terms of the next achievable step in climate change negotiations. If the target is too ambitious, the venture will fail; and yet if it is too modest, it will also fail and be rightly condemned. And then comes the event: the listening, talking, reassuring, encouraging and cajoling of national representatives, coaxing them towards a deal.

Some say leadership is about forging ahead from the front, setting a path and persuading others to follow. Others say it is about building consensus, leading from within the group. The truth is that it is both. Only in such a way is it possible even to hope to bring together the nations of the world — especially on an issue that requires them to make sacrifices today for the good of tomorrow.

Climate change negotiations are the ultimate test for politicians. Providing leadership here is a heady challenge, but the rewards are high indeed: to make a positive change for the future of the world.

HH Sheikh Jassim bin Hamad bin Khalifa Al-Thani arrives as does HSH Prince Albert of Monaco; *below right*, United Nations Secretary-General HE Ban Ki-moon greets HE Ms Connie Hedegaard, European Commissioner for Climate Action.

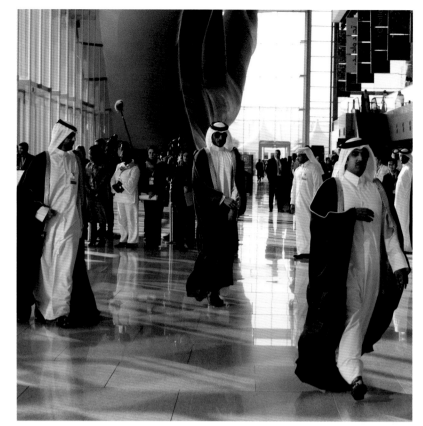

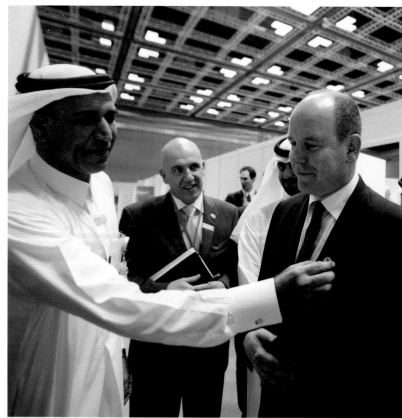

The High-level Segment begins in the second week. Delegations and advisors have spent a week or more learning each other's views and working on preliminary positions. Now the heads of state, ministers, political leaders and key figures arrive to push towards a deal.

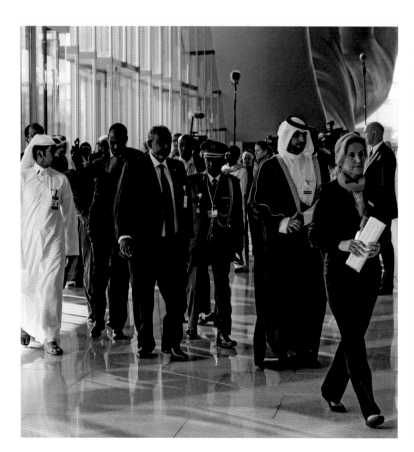

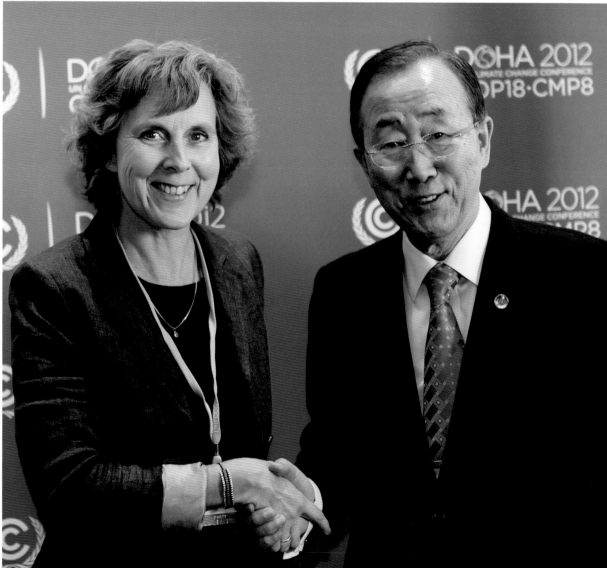

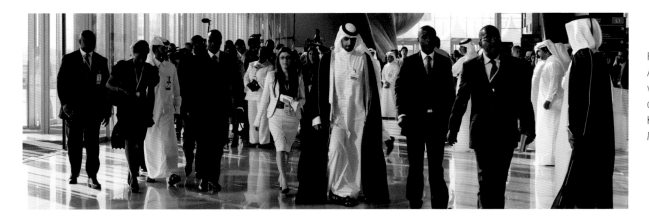

HH Sheikh Sabah Al-Ahmed Al-Jaber Al-Sabah, Emir of Kuwait, arrives with the Emir (now Father Emir) of Qatar HH Sheikh Hamad bin Khalifa Al-Thani, and HH Sheikha Moza bint Nasser.

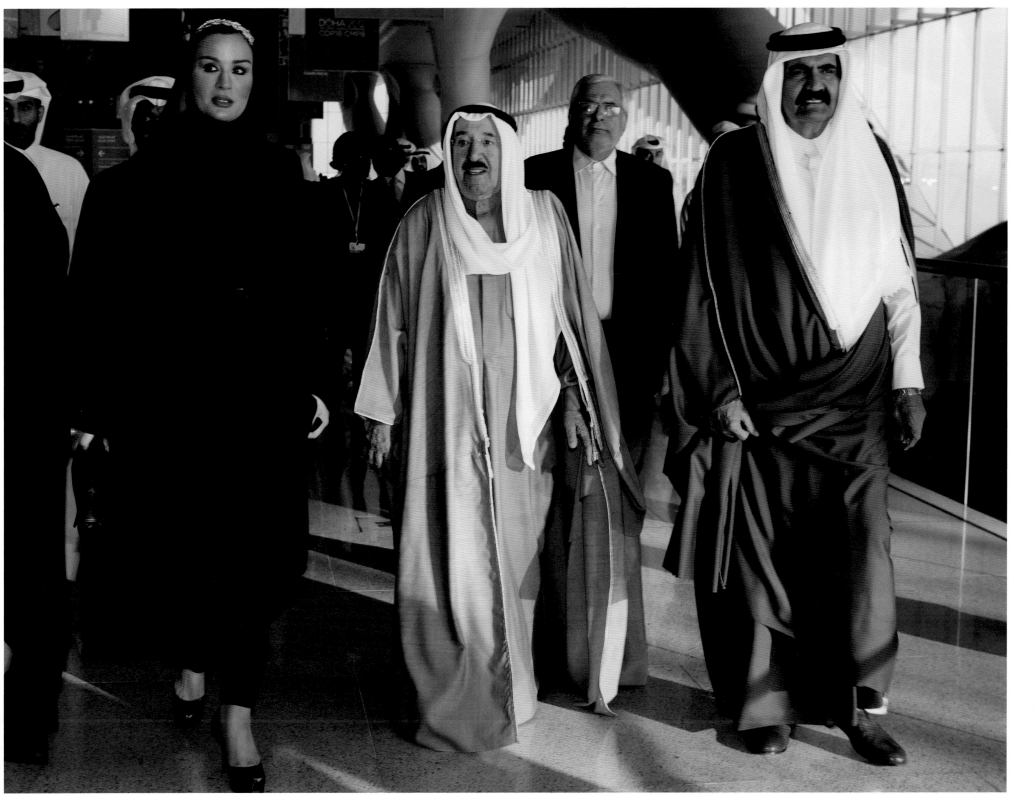

Behind the scenes of the conference, away from the crowds, senior figures have an opportunity to meet.

Right, HH Sheikh Tamim bin Hamad Al-Thani, Heir Apparent (now Emir) of Qatar, greets a dignitary. *Far right*, United Nations Secretary-General HE Ban Ki-moon greets HE Ali Bongo Ondimba, President of Gabon.

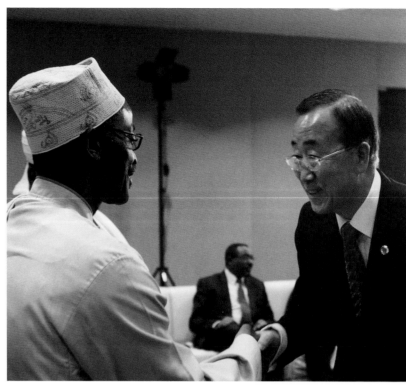

Right, United Nations Secretary-General HE Ban Ki-moon meets HE Fouad Mohadji, Energy Minister of Comoros.

Briefing papers and speeches are brought for the senior figures to study as they prepare for an important week ahead.

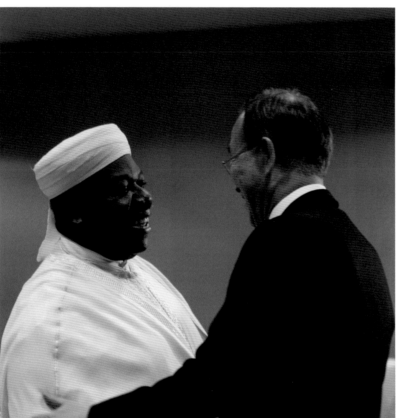

GOVERNMENT OF SWAZILAND

STATEMENT

BY THE RIGHT HONOURABLE
PRIME MINISTER,

DR B.S.S. DLAMINI

the 18th Conference of Parties
(COP 18) on Climate Change

At Doha, Qatar

26 November 2012

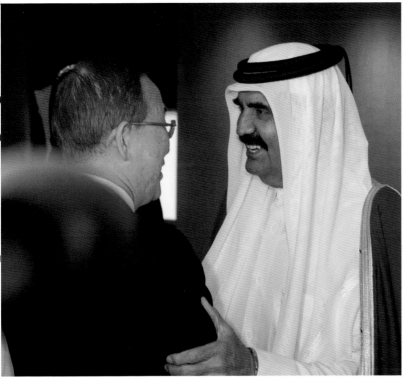

The Emir (now Father Emir) of Qatar HH Sheikh Hamad bin Khalifa Al-Thani, *far left*, with United Nations Secretary-General HE Ban Ki-moon.

HH Sheikh Sabah Al-Ahmed Al-Jaber Al-Sabah, Emir of Kuwait, talks to other distinguished guests, *left*.

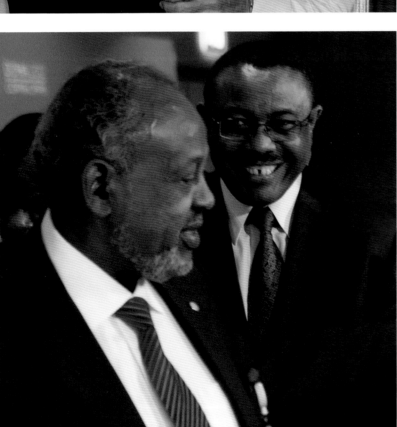

Far left, HE Ismaïl Omar Guelleh, President of the Republic of Djibouti, with HE Hailemariam Desalegn Boshe Prime Minister of Ethiopia.

HH Sheikh Tamim bin Hamad Al-Thani, Heir Apparent (now Emir) of Qatar listens intently to other dignitaries prior to the opening of the High-Level Segment of COP18/CMP8.

Senior figures hold talks before the work of the conference. *Below,* HE Ismaïl Omar Guelleh; *right,* HE Fouad Mohadji; *below right,* HE Ali Bongo Ondimba; and *bottom*, HE Denis Sassou Nguesso, President of the Republic of Congo.

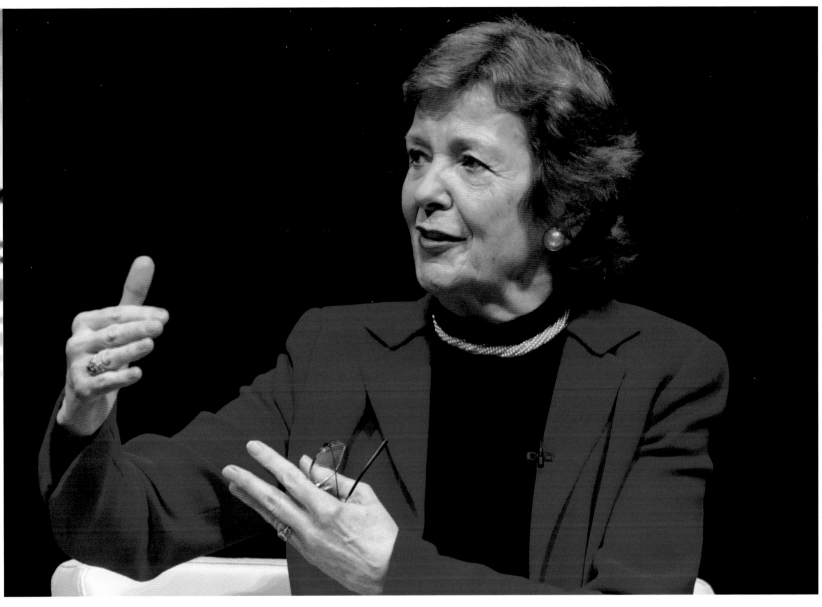

HE Mary Robinson former President of Ireland and the current Chair of the International Institute for Environment and Development, leads a panel discussion.

The Emir (now Father Emir) of Qatar HH Sheikh Hamad bin Khalifa Al-Thani, holds talks with the visiting dignitaries.

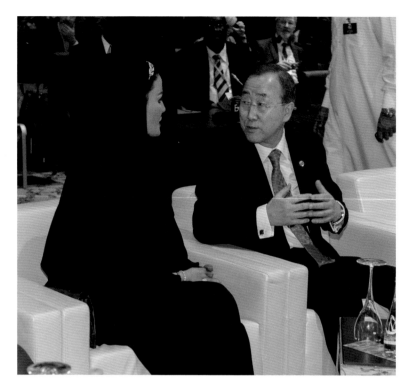

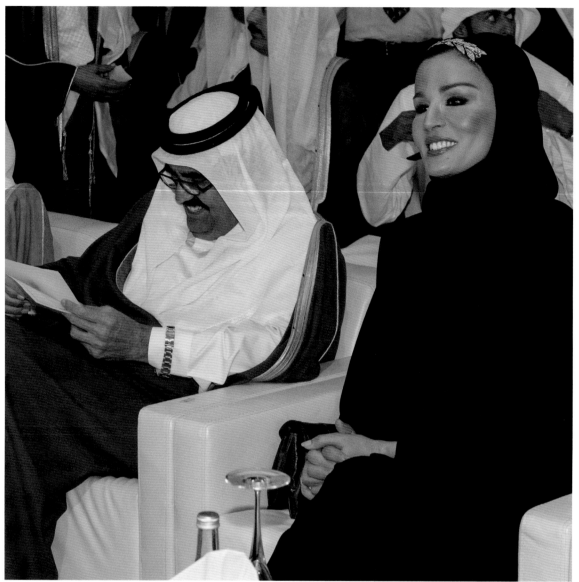

The senior figures move to the plenary room for the official opening of the High-Level Segment. HH Sheikha Moza bint Nasser with United Nations Secretary-General HE Ban Ki-moon, *above*; The Emir (now Father Emir) of Qatar HH Sheikh Hamad bin Khalifa Al-Thani and HH Sheikha Moza bint Nasser, *far right*; and HE Sheikha Al-Mayassa bint Hamad bin Khalifa Al-Thani, *below right*, with Dr Ibrahim Ibrahim, an economic advisor to HH Sheikh Hamad bin Khalifa Al-Thani.

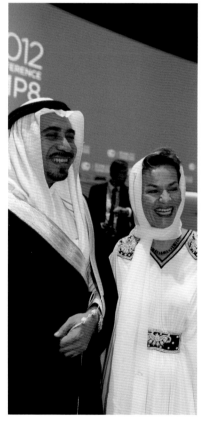

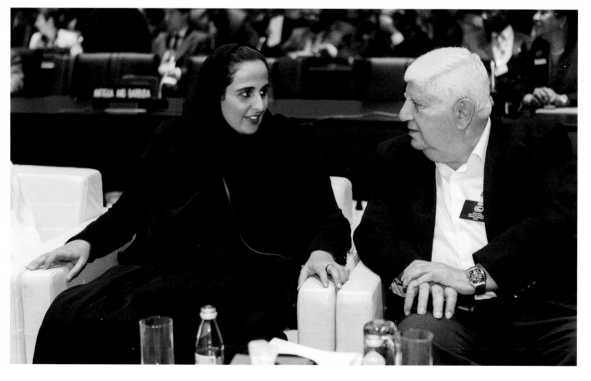

The delegates are all assembled, *opposite*, the lights are dimmed and the High-Level Segment of the conference opens, with a video presentation, outlining the challenge of global climate change.

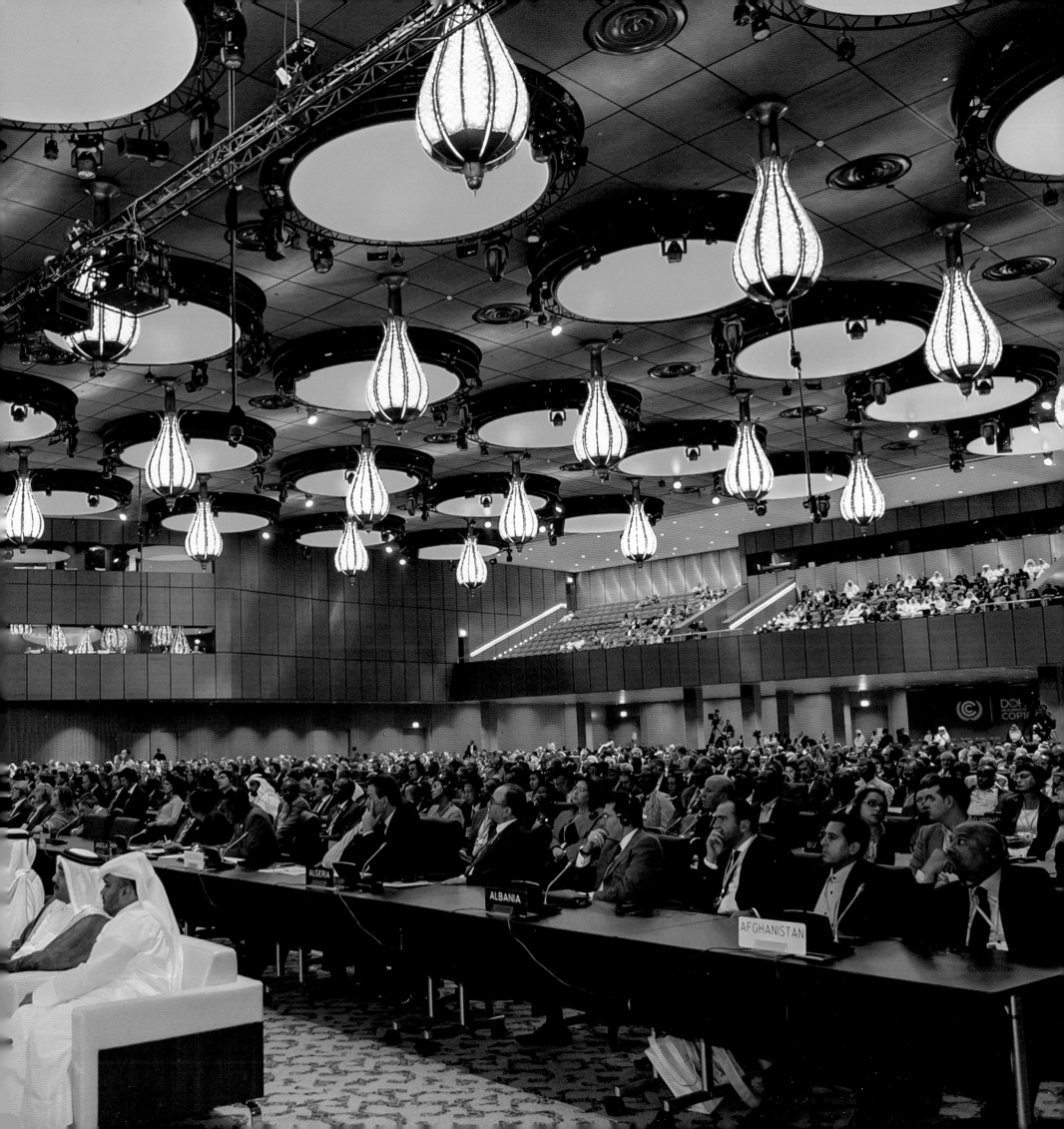

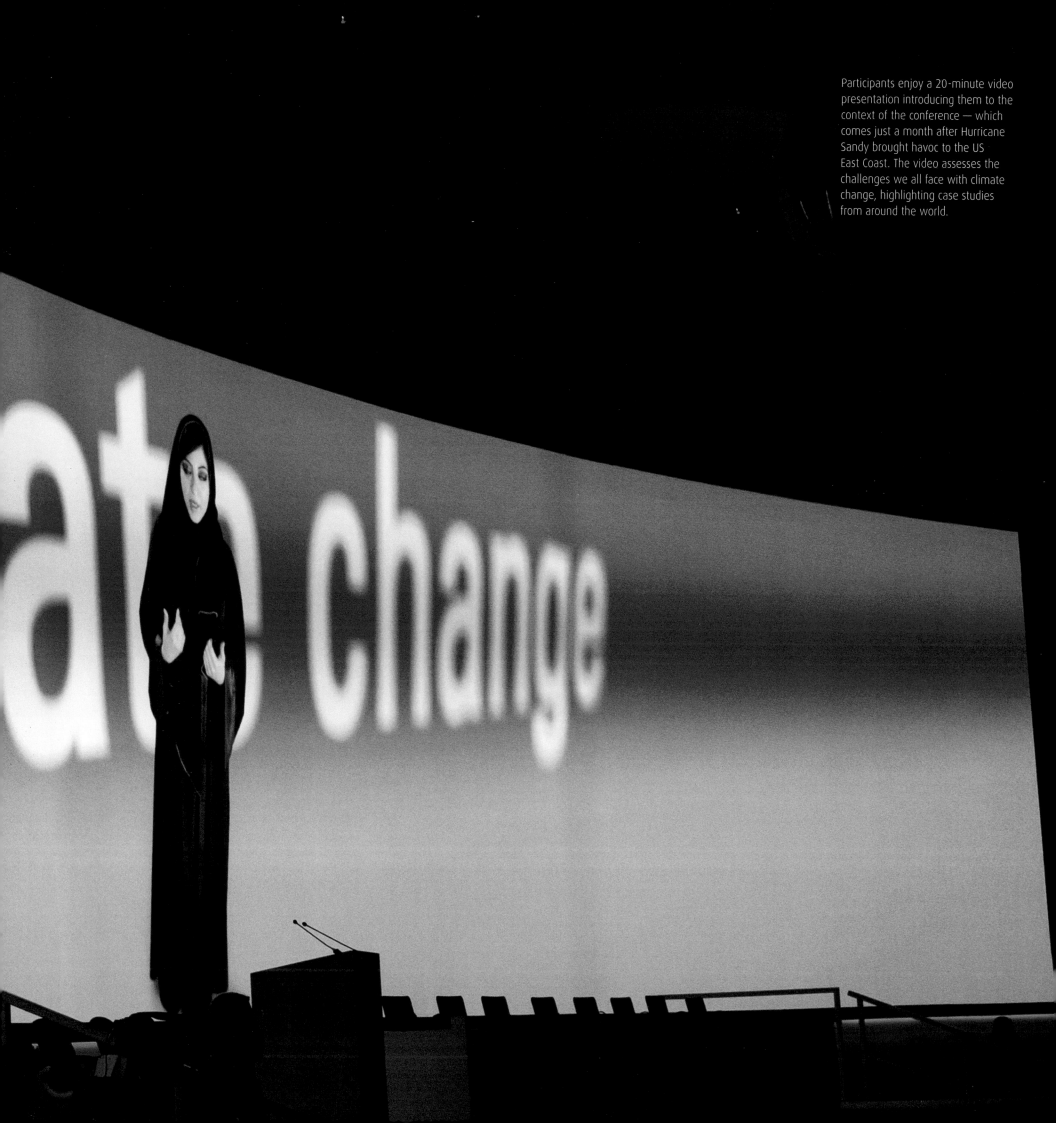

Participants enjoy a 20-minute video presentation introducing them to the context of the conference — which comes just a month after Hurricane Sandy brought havoc to the US East Coast. The video assesses the challenges we all face with climate change, highlighting case studies from around the world.

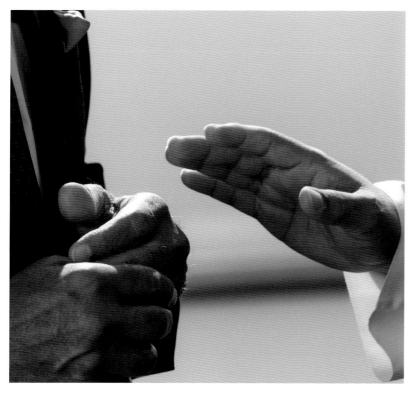

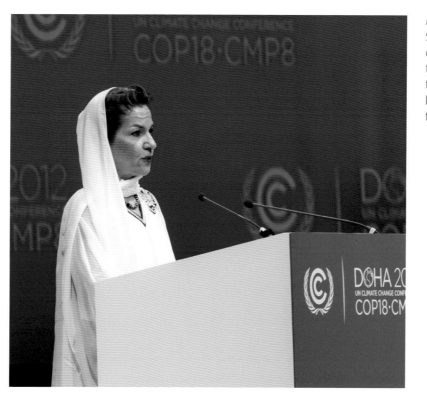

Ms Christiana Figueres, Executive Secretary of UNFCCC informs dignitaries that 'the eyes of the world are on us' and that the conference must change the long-term international response to climate change.

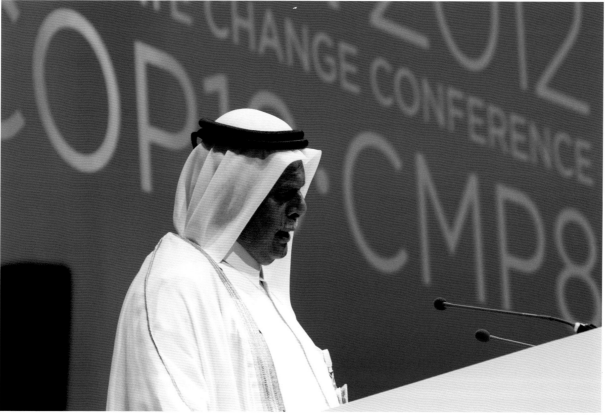

HE Abdullah bin Hamad Al-Attiyah, President of COP18/CMP8, relays that climate change is 'one of the most urgent challenges facing humanity' and assures participants that he is determined to work in an 'open and transparent' manner to achieve consensus.

In the opening statements that follow, the Emir (now Father Emir) of Qatar HH Sheikh Hamad bin Khalifa Al-Thani, *opposite*, tells participants that climate change is a challenge to us all, and must be dealt with from a multilateral 'comprehensive perspective'.

141

Members of the Qatari team after the official opening ceremony. *Right*, HE Sheikha Al-Mayassa bint Hamad bin Khalifa Al-Thani with HH Sheikh Jassim bin Hamad bin Khalifa Al-Thani.

United Nations Secretary-General HE Ban Ki-moon, *far right*, and members of his team, leave the opening ceremony, as the efforts begin towards a new international agreement.

Opposite, HH Sheikh Tamim bin Hamad Al-Thani, Heir Apparent (now Emir) of Qatar, and HH Sheikh Jassim bin Hamad bin Khalifa Al-Thani.

Ms Rachel Kyte, the Vice President of Sustainable Development at the World Bank, also gets down to business after the opening ceremony, with a briefing.

HE Ms Alcinda António de Abreu, Minister of the Environment for Mozambique, takes questions during a discussion of climate and gender policy, in one of the first sessions of the week.

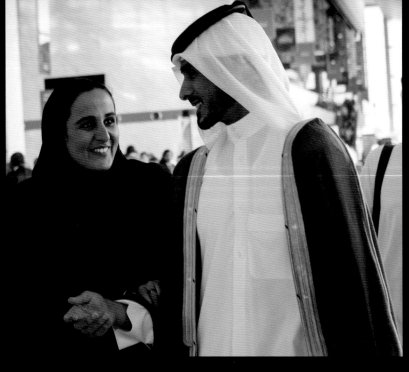

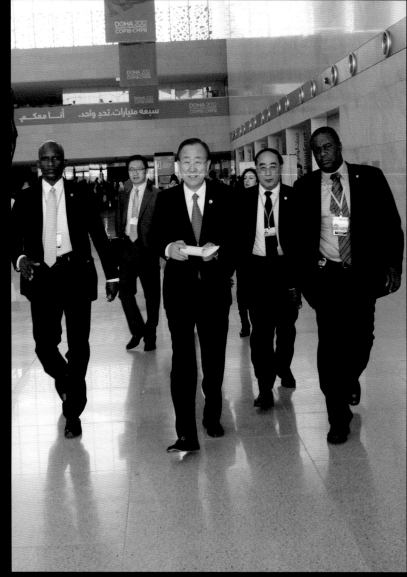

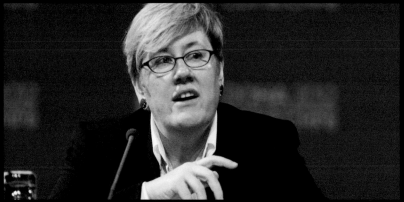

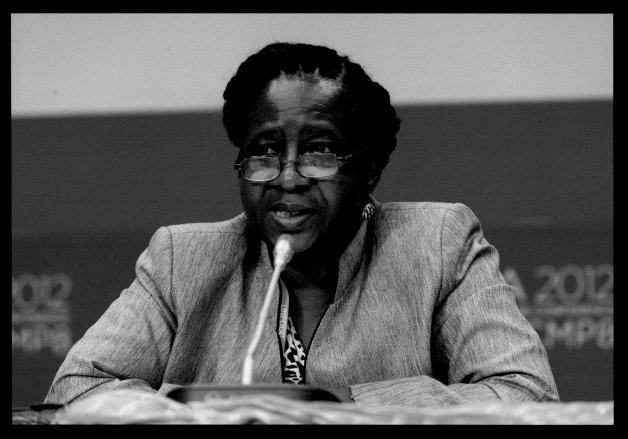

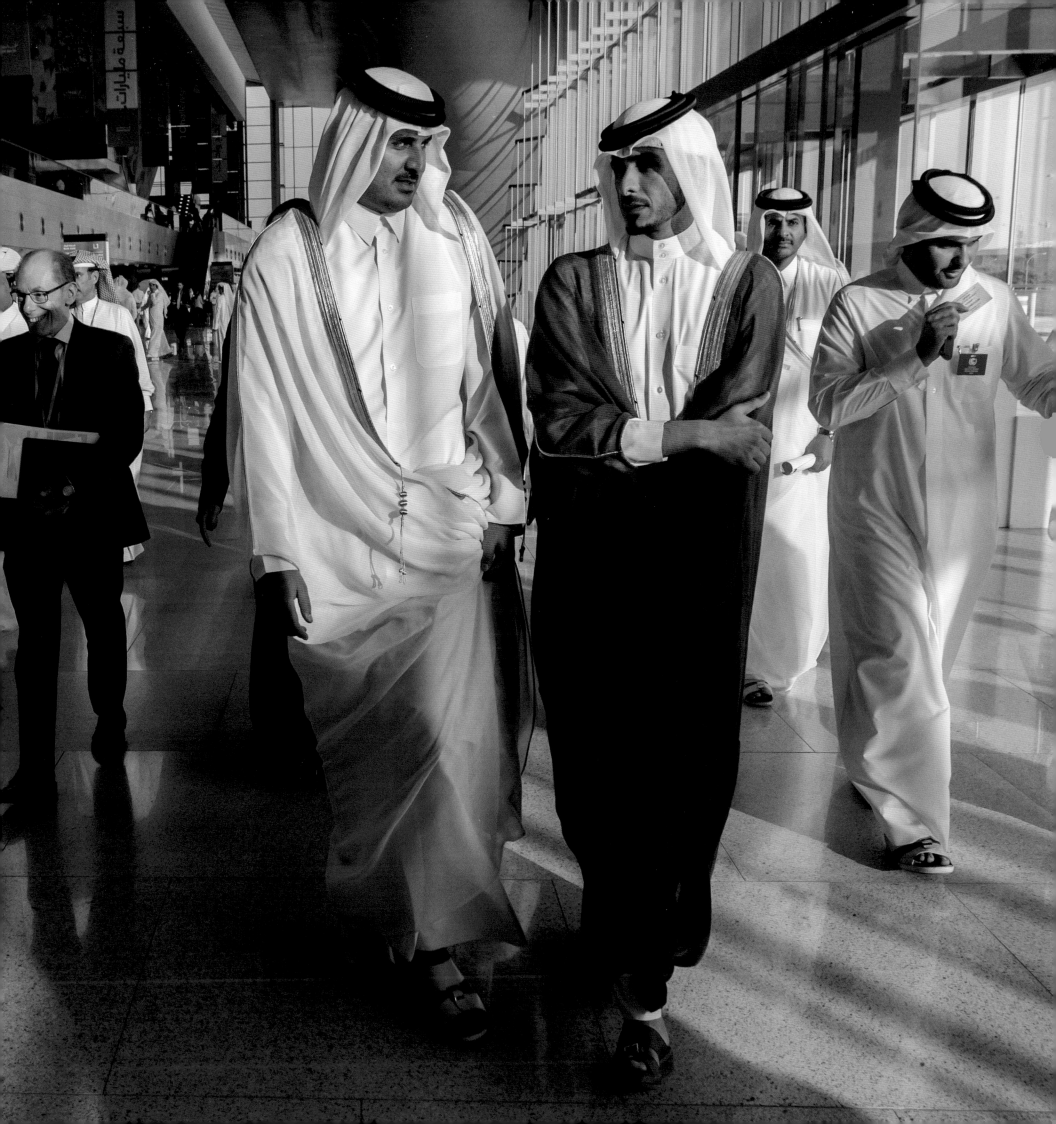

After the opening ceremony, the participants go into session, laying out their positions on the main issues of the conference. Each is trying to balance the demands of their home nation with those of the wider international community in order to achieve progress.

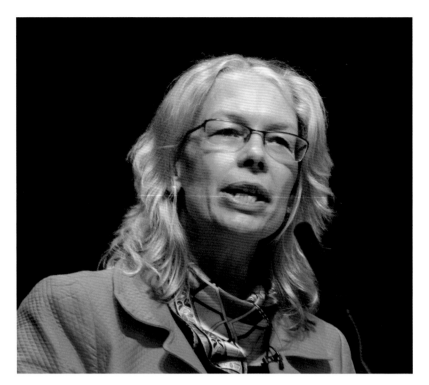

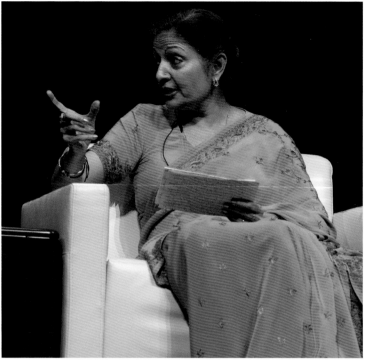

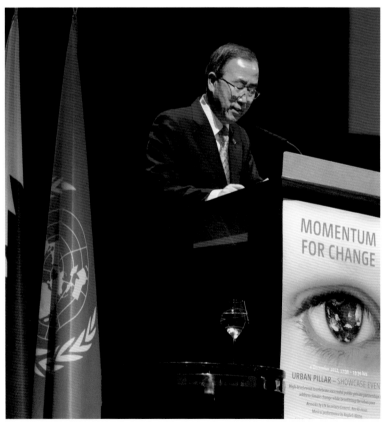

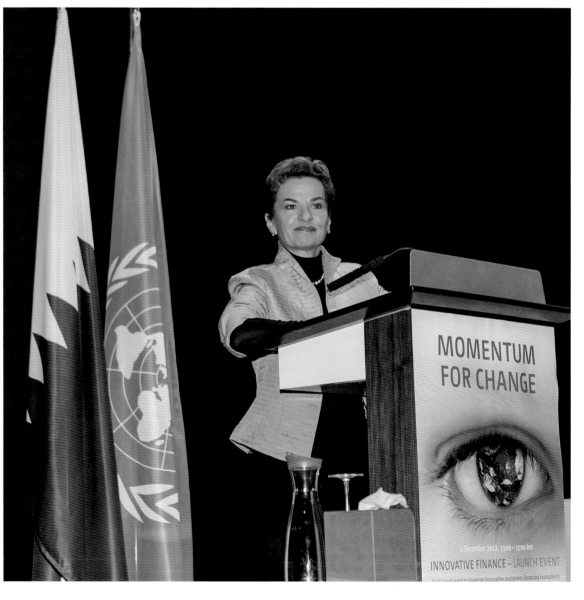

South Africa, *far left*, hosted the previous year's conference and has a big role to play. China, *left*, working with the Group of 77 Developing Countries, is also a key player in events.

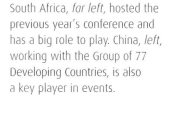

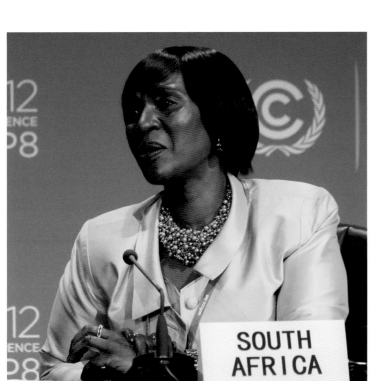

At COP18/CMP8 Doha, there are an unprecedented seven different conferences effectively taking place in parallel. For example, the Subsidiary Body for Scientific and Technological Advice (SBSTA), *left*, provides advice to the full conference on technical matters. In Doha, at its 37th session, it spent much time looking at deforestation and how it is being measured.

The Ad Hoc Working Group on Further Commitments for Annex I Parties under the Kyoto Protocol (AWG-KP), *far left*, is another of the seven parallel conferences, specifically looking at future commitments of developed countries to reduce their carbon emissions under the 1997 Kyoto Protocol.

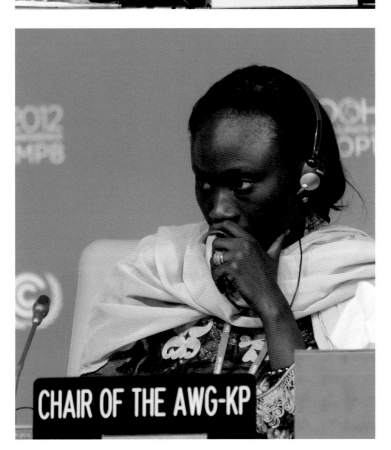

By the second week, international
participation has reached a peak,
with more than 16,000 badges
issued by the UN, and the venue
enjoying packed meeting rooms
as participants and observers hear
reports about initiatives to address
climate change.

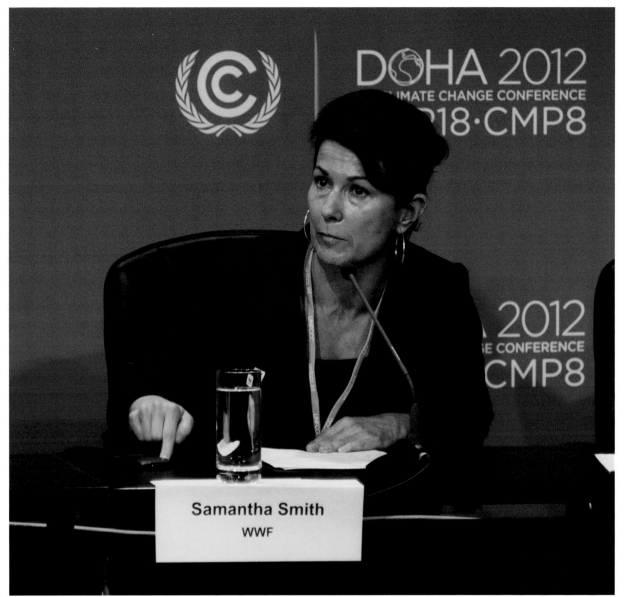

Much of the information brought to the conference comes from international civil society groups, such as the World Wildlife Fund and Greenpeace. Ms Samantha Smith of WWF tells delegates that many developed countries have 'backed away from past commitments on climate change, and refused to take on new ones'.

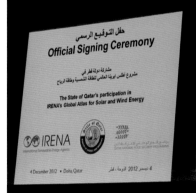

Efforts also continue to advance cooperation. For example, Qatar joins the Global Atlas for Renewable Resources, an initiative of the International Renewable Energy Agency, which maps data on wind and solar energy to help states target investment in renewable energy.

As negotiations continue in the main halls, a landmark announcement is about to be made elsewhere in the conference. Qatar has reached an agreement, *right*, with the Potsdam Institute for Climate Impact Research in Germany to establish a climate change research institute in Qatar through the Qatar Foundation. The centre will undertake pioneering work to address climate change.

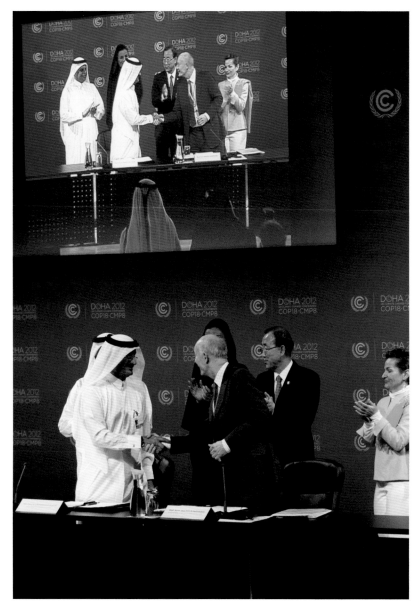

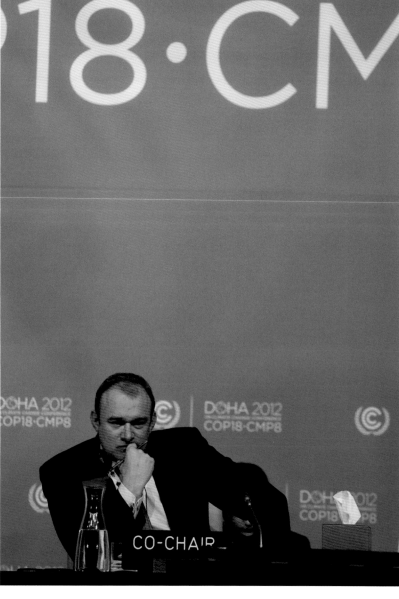

Right, Under the auspices of HH Sheikha Moza bint Nasser, Chair of the Qatar Foundation for Education, Science and Community Development, and in the presence of HE Abdullah bin Hamad Al-Attiyah, President of COP18/CMP8, and United Nations Secretary-General HE Ban Ki-moon, an agreement is signed by Mr Faisal Al-Suwaidi, President of Research and Development at Qatar Foundation and Professor Hans Joachim Schellnhuber, Founding Director of Potsdam Institute for Climate Impact.

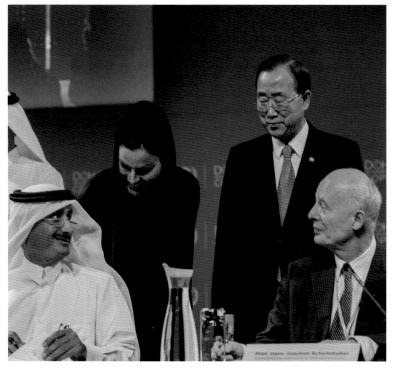

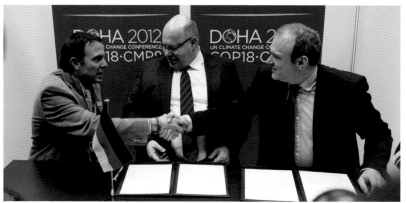

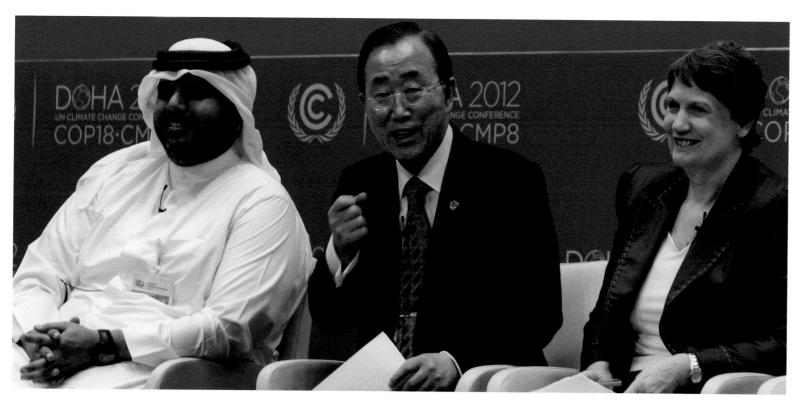

Left, Mr Fahad Al Attiya, United Nations Secretary General Ban Ki-moon and HE Mrs Helen Clark, former Prime Minister of New Zealand.

United Nations Secretary-General HE Ban Ki-moon and HE Abdullah bin Hamad Al-Attiyah, President of COP18/CMP8 work tirelessly to try to bring the many sides together.

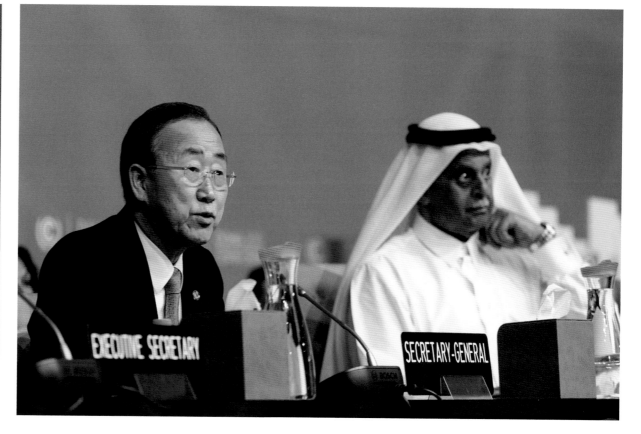

As public events continue, HE Abdullah bin Hamad Al-Attiyah, President of COP18/CMP8, draws conference delegates into a series of small meetings where they address the critical issues at the heart of the conference that may block progress.

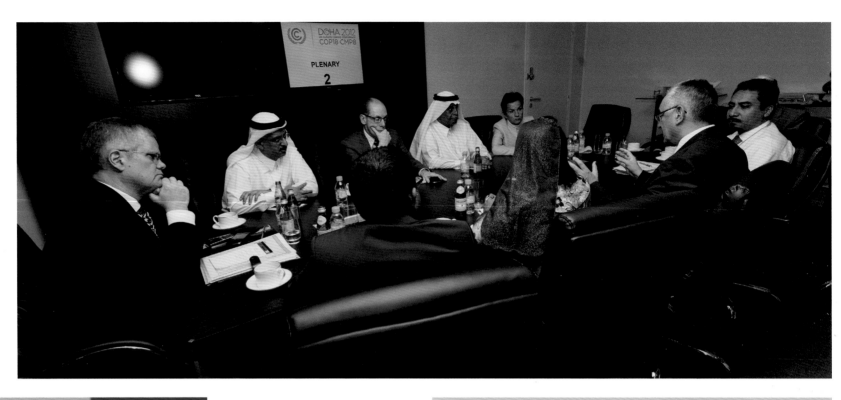

HE Maite Nkoana-Mashabane, *below*, President of COP17/CMP7, with former President of Ireland HE Mary Robinson, exchanging words during 'Gender Day' at the conference, which is intended to raise awareness of the impacts of climate change on women.

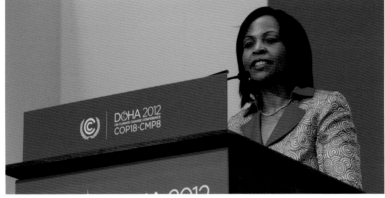

Back on the podium, HE Abdullah bin Hamad Al-Attiyah, President of COP18/CMP8, *right*, tells participants that they need to be prepared to compromise to reach agreement, and asks the watching world to have patience.

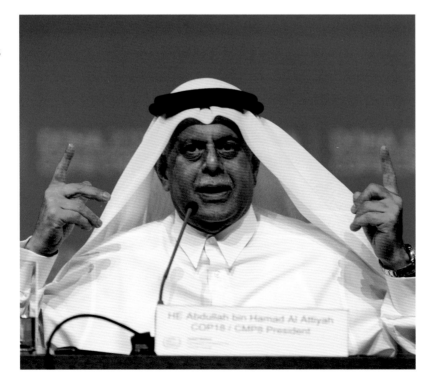

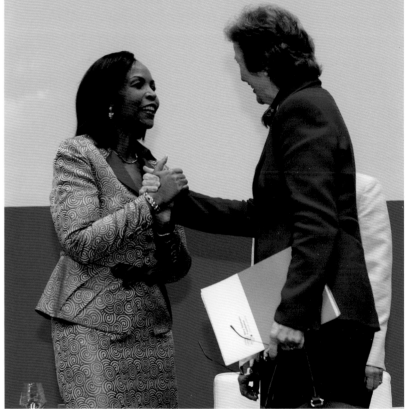

Sheikh Hamad bin Ali Al-Thani, the Vice-Chairman of the Qatar National Food Security Programme, which is committed to increasing the country's food security, attends the talks hoping to see progress.

Members of the Israeli negotiating team hold discussions on the floor of the plenary — but keep one eye on the laptop screen, watching for updates on the negotiations.

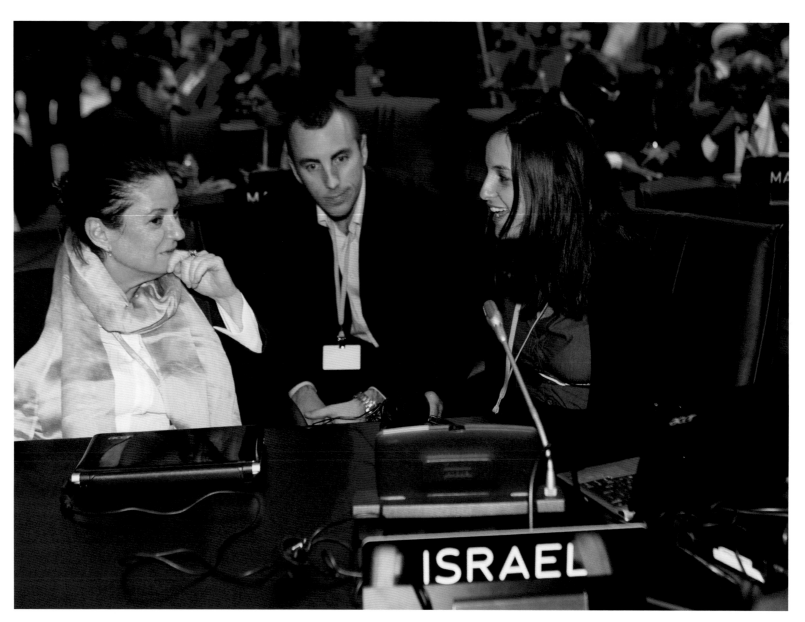

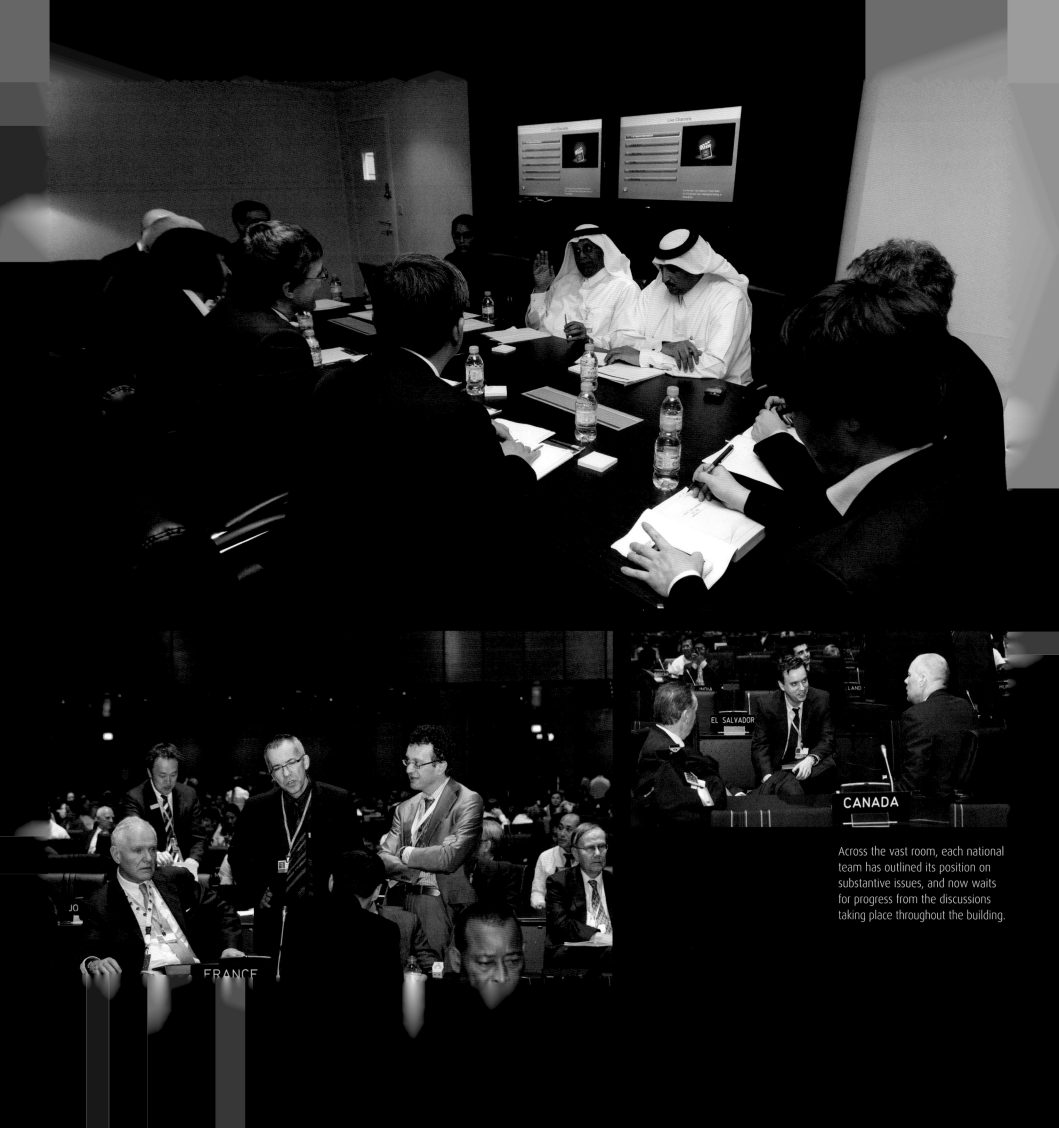

Across the vast room, each national team has outlined its position on substantive issues, and now waits for progress from the discussions taking place throughout the building.

Former President of Ireland HE Mary Robinson shares a joke from the podium with HE Ms Dessima Williams, Grenada's Ambassador to the United Nations, and Ms Christiana Figueres, Executive Secretary of UNFCCC. They are speaking before 150 youth delegates as part of Youth Day at the conference.

HE Khalid Al-Khater, (pictured centre-right in the picture below) is Qatar's Ambassador-at-Large for Climate Change, and also Chairman of the Negotiation Committee for COP18/CMP8 Doha. He plays a critical role in trying to bring delegates together, along with HE Abdullah bin Hamad Al-Attiyah, President of COP18/CMP8, and HE Dr Mohammed bin Saleh Al-Sada, Minister of Energy and Industry Affairs of Qatar, *below right*.

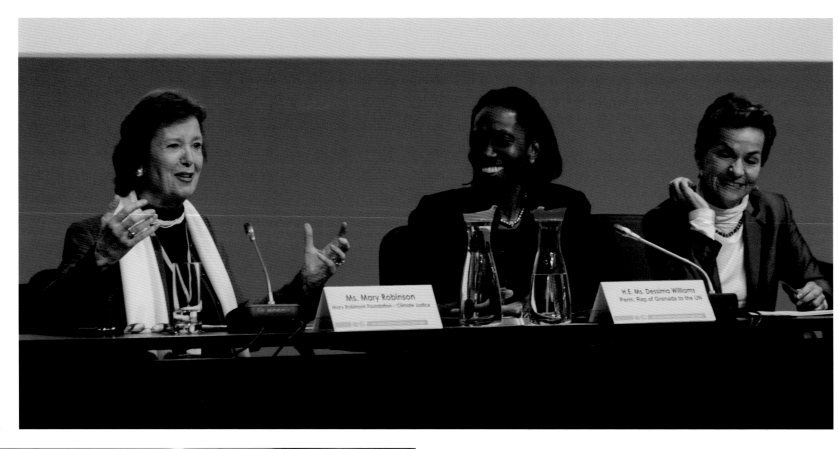

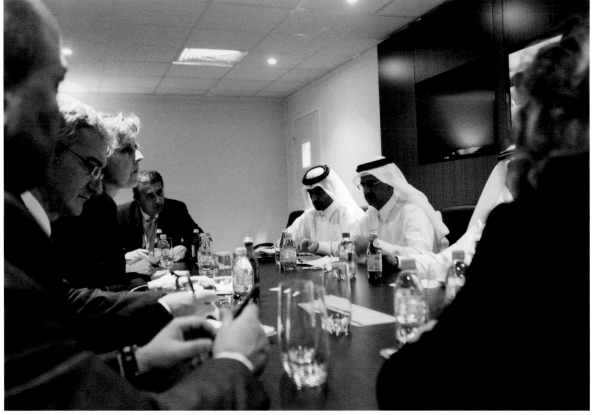

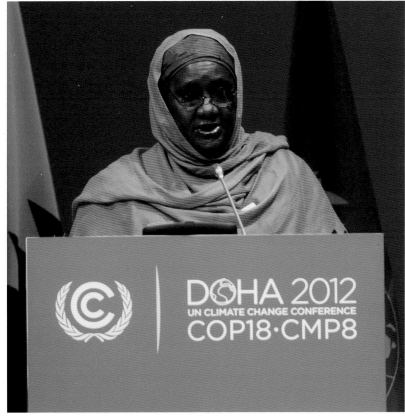

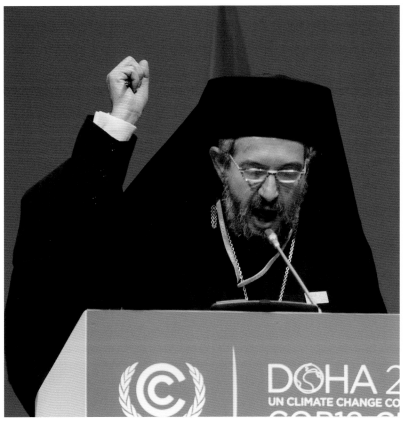

Faith leaders also make their presence felt: Archbishop Seraphim Kykkotis, *left*, of the Orthodox Church of South Africa makes an equally impassioned speech, telling delegates: 'We must do our work so that the future generations won't say that their grandparents' generation were murderers.'

Talks over such critical issues bring the most passionate speeches. On the last formal day of the conference, for example, Ms Munira Sibai, *far left*, of the US-based organisation SustainUS, offers an impassioned call for action, accusing developed countries of 'gambling with our future'.

As the hours tick by, the conference draws ever-closer to its conclusion. Talks in many of the different bodies reach an end point, but there is yet no resolution on the bigger issues, such as the hoped-for extension of the Kyoto Protocol. In the final days and hours, there are real fears the conference will fail on this issue.

Mr Todd Stern, *below*, US Special Envoy for Climate Change, briefs members of the world's media on the American position, as fears grow around the centre that the talks may not achieve what is hoped for.

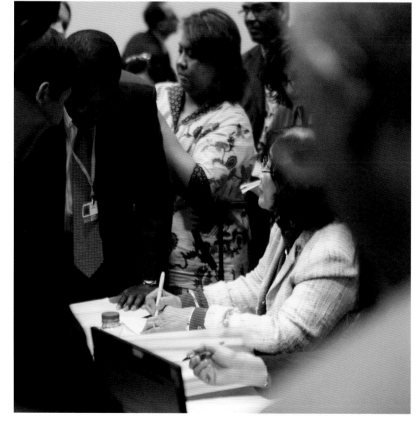

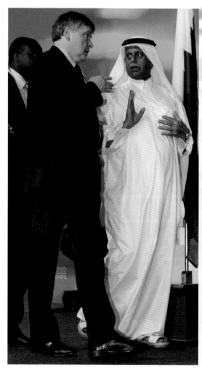

HE Abdullah bin Hamad Al-Attiyah, President of COP18/CMP8, *far right*, remains confident, repeatedly saying that he will hear the views of all sides, but is determined the conference will end with a significant global agreement.

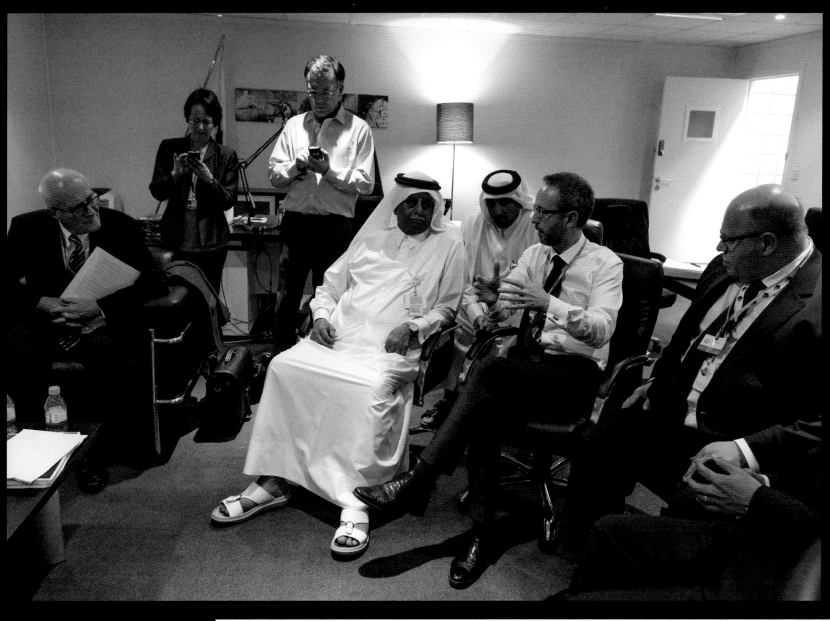

Behind the scenes HE Abdullah bin Hamad Al-Attiyah, President of COP18/CMP8, engages in non-stop meetings to try to make a breakthrough on the seemingly intractable issues. Some western countries are unprepared to make fresh commitments to cut green-house gases, and developing countries want financial assistance to catch up.

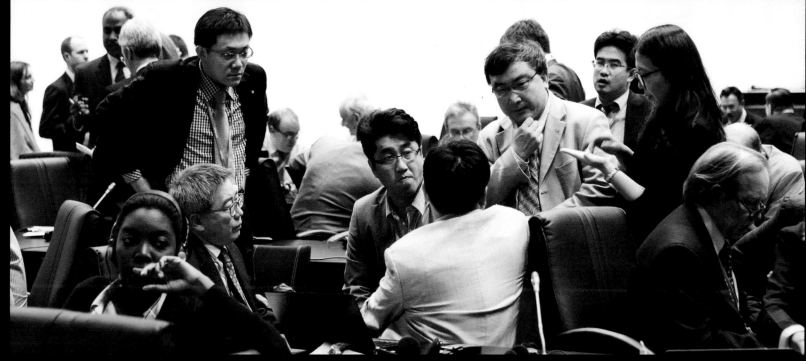

After weeks of talks, it has now come down to a few critical issues. Delegates from the different countries and blocks hold informal talks to try to find ways to overcome the remaining differences.

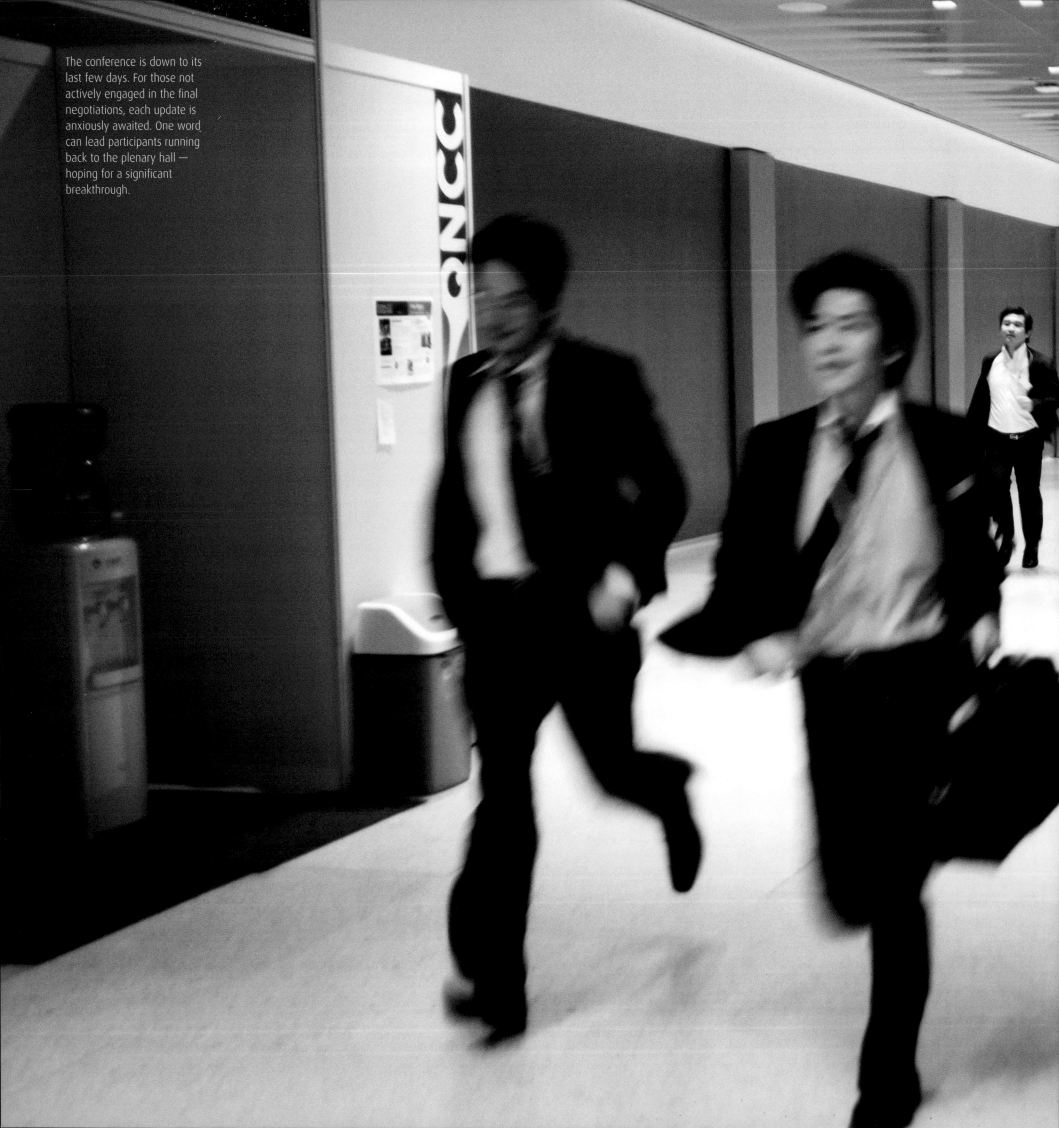

The conference is down to its last few days. For those not actively engaged in the final negotiations, each update is anxiously awaited. One word can lead participants running back to the plenary hall — hoping for a significant breakthrough.

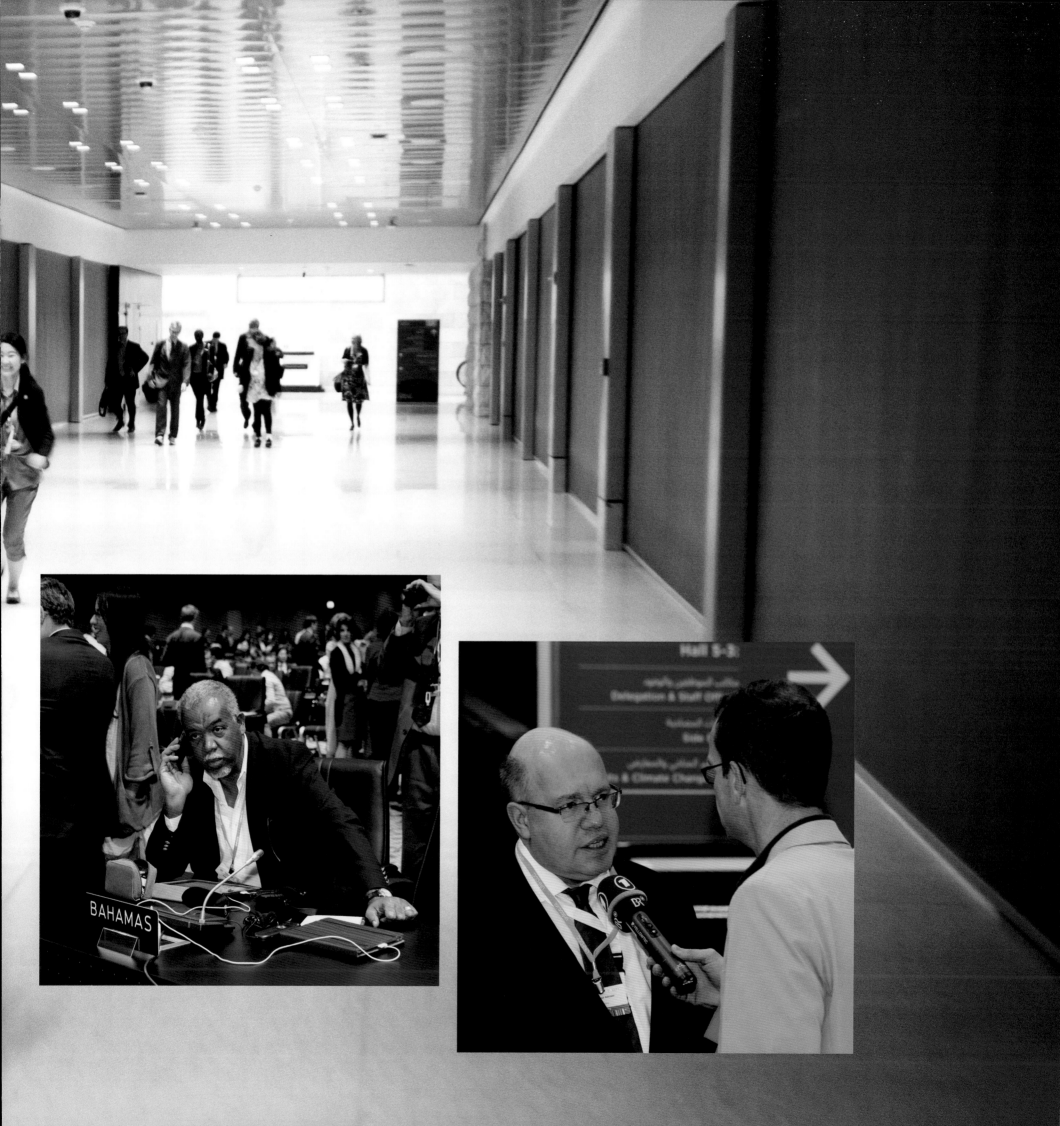

Hall 5-5

BAHAMAS

For those at the heart of the talks, the pressure is on. Negotiations begin to stretch into the night — every night. Will they be able to reach a deal? Many fear fatigue could be a bigger enemy than disagreements.

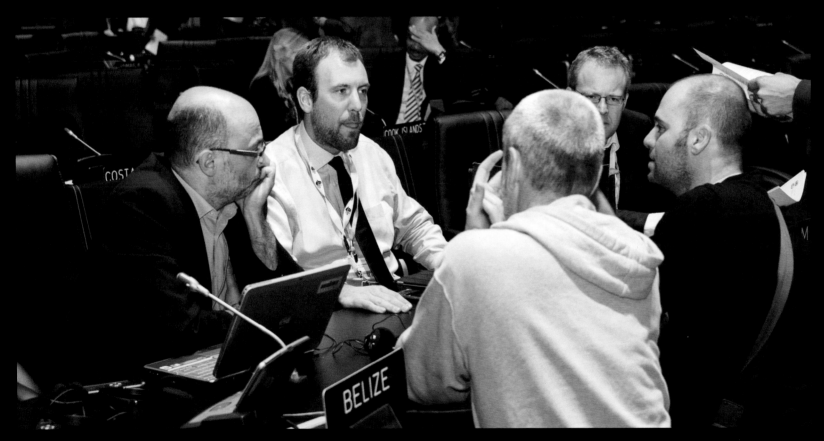

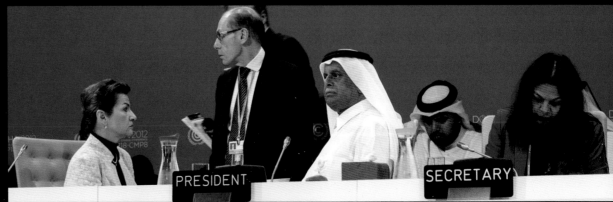

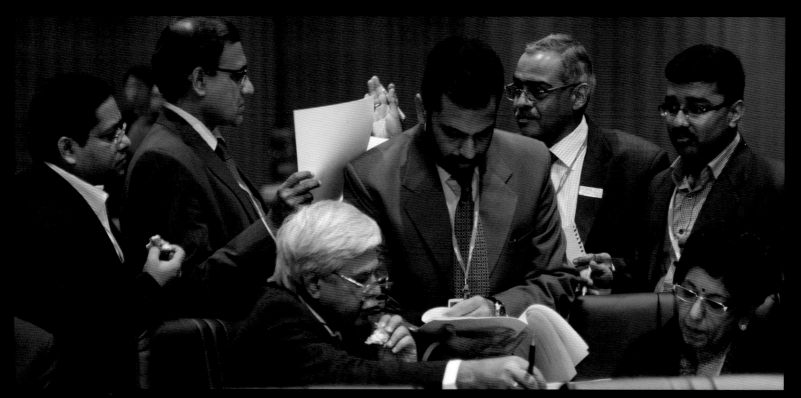

The language is technical — pages and pages of acronyms — as delegates methodically work to close each negotiating track dealing with the commitments of countries to cut their emissions, the provision of finance for developing and least developed countries, and global pledges linked to the magic words 'mitigation' and 'adaptation'.

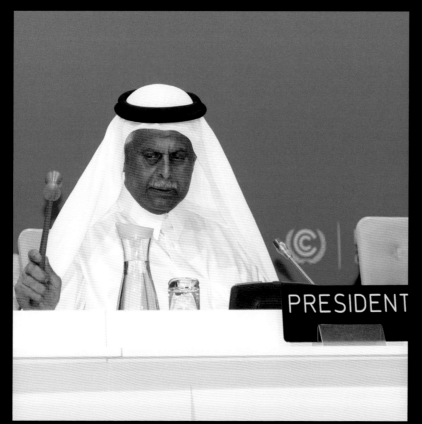

PRESIDENT

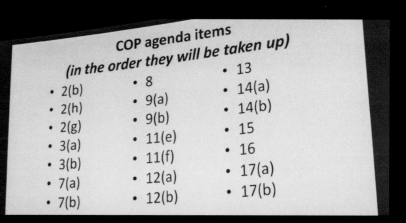

COP agenda items
(in the order they will be taken up)

• 2(b)	• 8	• 13
• 2(h)	• 9(a)	• 14(a)
• 2(g)	• 9(b)	• 14(b)
• 3(a)	• 11(e)	• 15
• 3(b)	• 11(f)	• 16
• 7(a)	• 12(a)	• 17(a)
• 7(b)	• 12(b)	• 17(b)

Slowly, delegates work through the agenda. Negotiations appear to be reaching a final stage on one round of talks, and then another. But there remains a logjam, and there are calls for the COP18/CMP8 President to intervene.

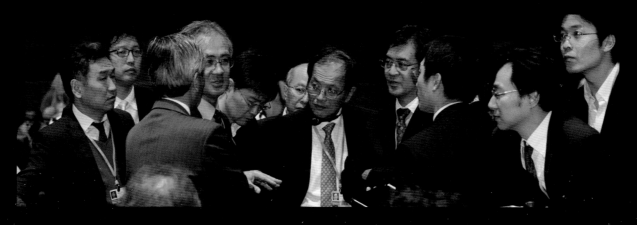

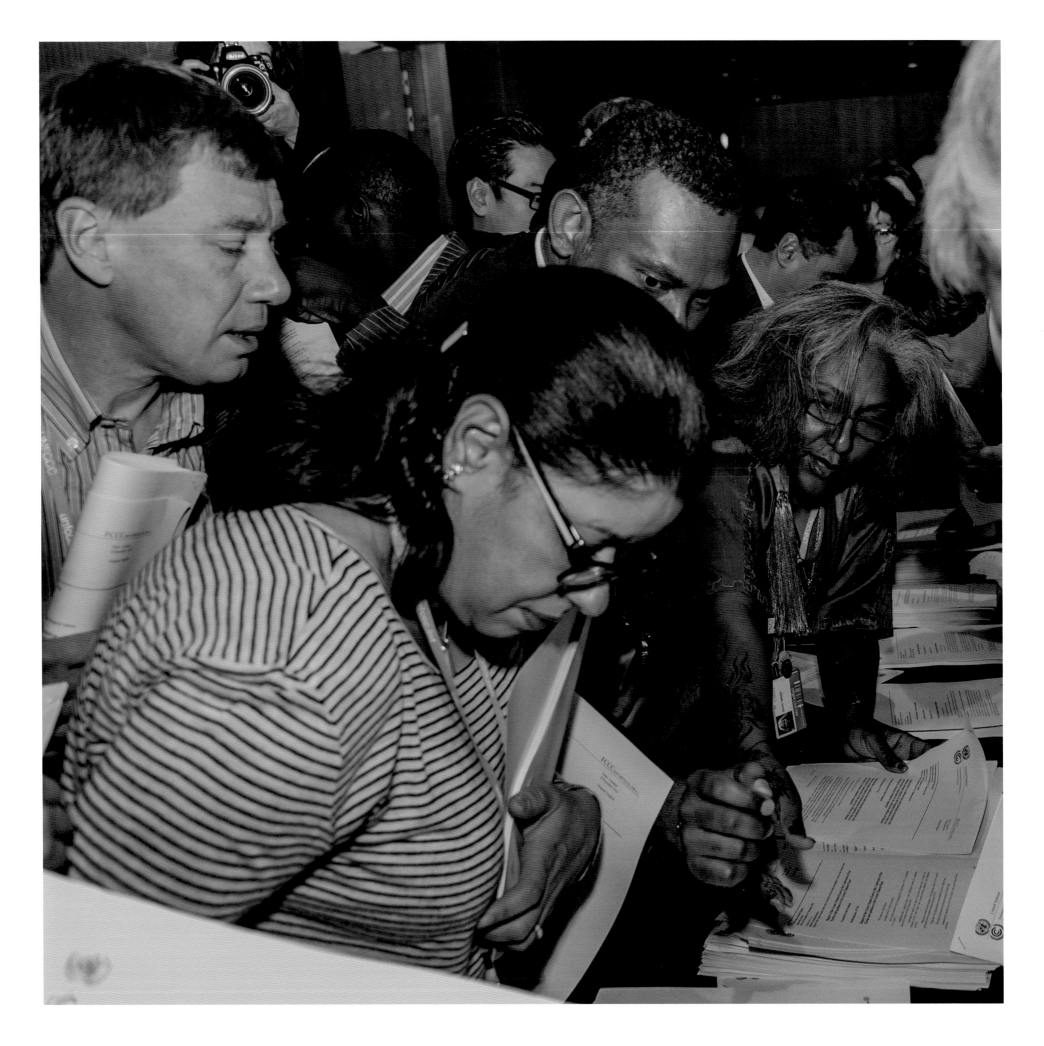

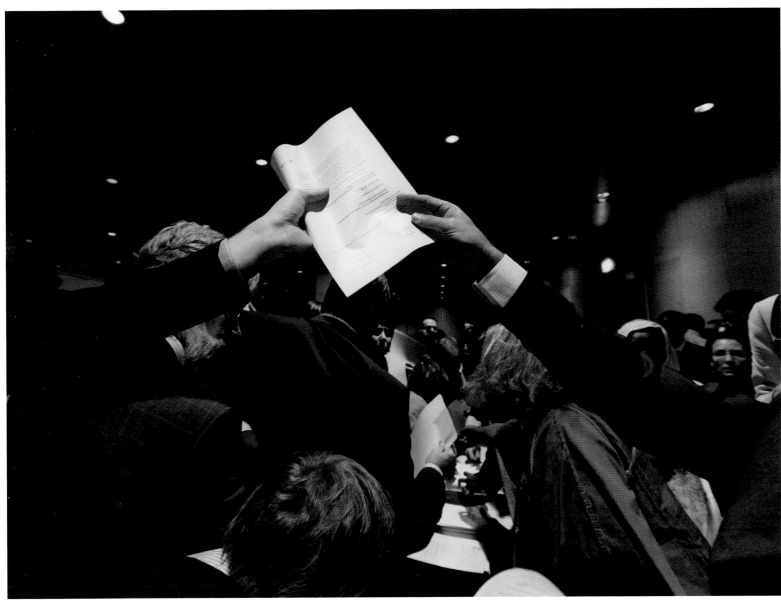

Each time a new draft proposal is released there is a flurry of activity. Delegates literally run the length of the plenary room to get in the line for copies. Hands dart forward grabbing at the ever-diminishing pile, passing them back to colleagues for review.

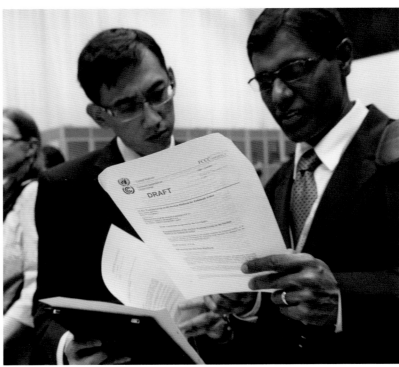

The same hall, but now eyes are turned to another corner. HE Abdullah bin Hamad Al-Attiyah, President of COP18/CMP8, *right*, is spotted entering the room, and walking purposefully towards the podium. Has there been a deal? Delegates turn to the exhausted COP President, but he is oblivious — engrossed in a detailed discussion with Mr Stern.

Moments later, across the room again, and HE Abdullah bin Hamad Al-Attiyah, President of COP18/CMP8, *far right*, is locked in talks with another delegate, carefully explaining a position, and then pausing to listen to a point, as advisors wrestle with paperwork behind him.

Another meeting, and then that by-now famous smile that the President uses so well to disarm and cajole delegates into agreement. It's infectious, and everybody around him is now smiling, easing the tension.

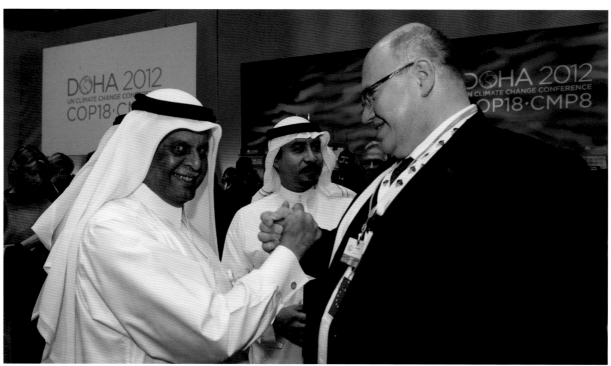

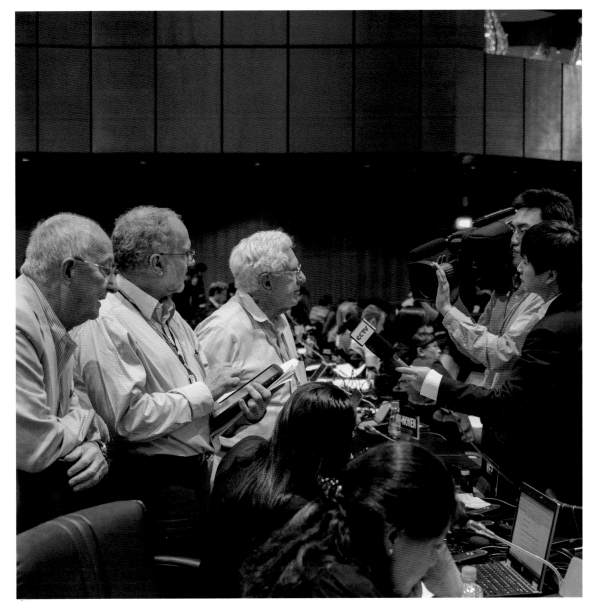

Television news camera crews amble around the hall, looking for an impromptu interview, or just standing back and filming the scene. On the podium, the high drama inevitably leads to ice-breaking moments.

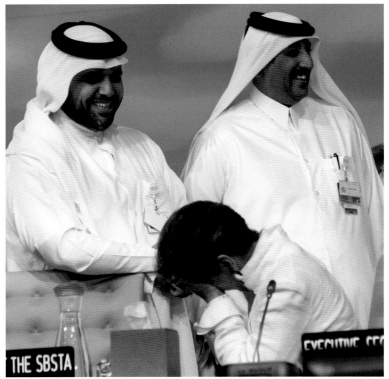

Above, Mr Fahad Al-Attiya, HE Abdulaziz Al-Malki and Ms Christiana Figueres, Executive Secretary of UNFCCC, share a joke.

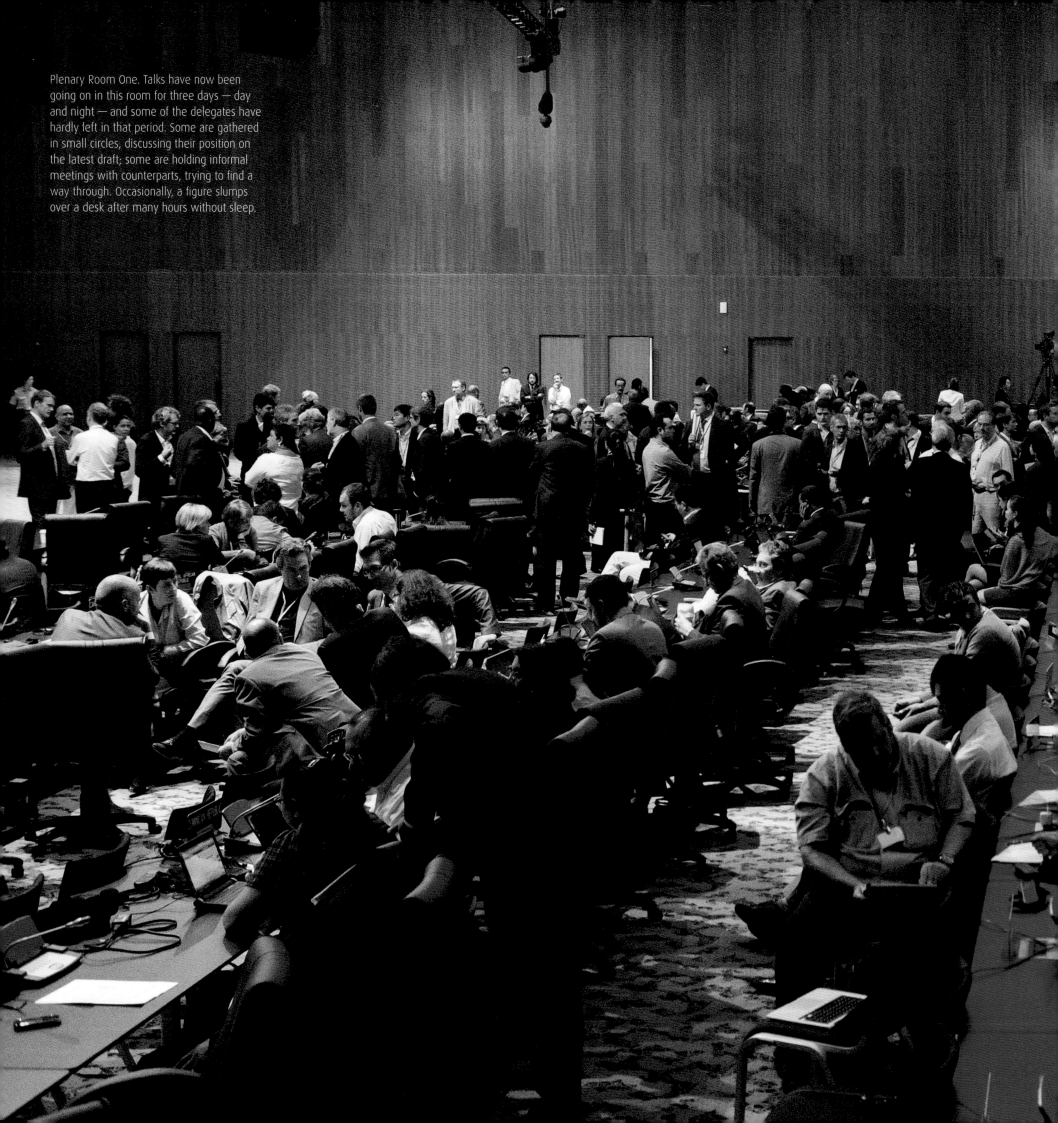

Plenary Room One. Talks have now been going on in this room for three days — day and night — and some of the delegates have hardly left in that period. Some are gathered in small circles, discussing their position on the latest draft; some are holding informal meetings with counterparts, trying to find a way through. Occasionally, a figure slumps over a desk after many hours without sleep.

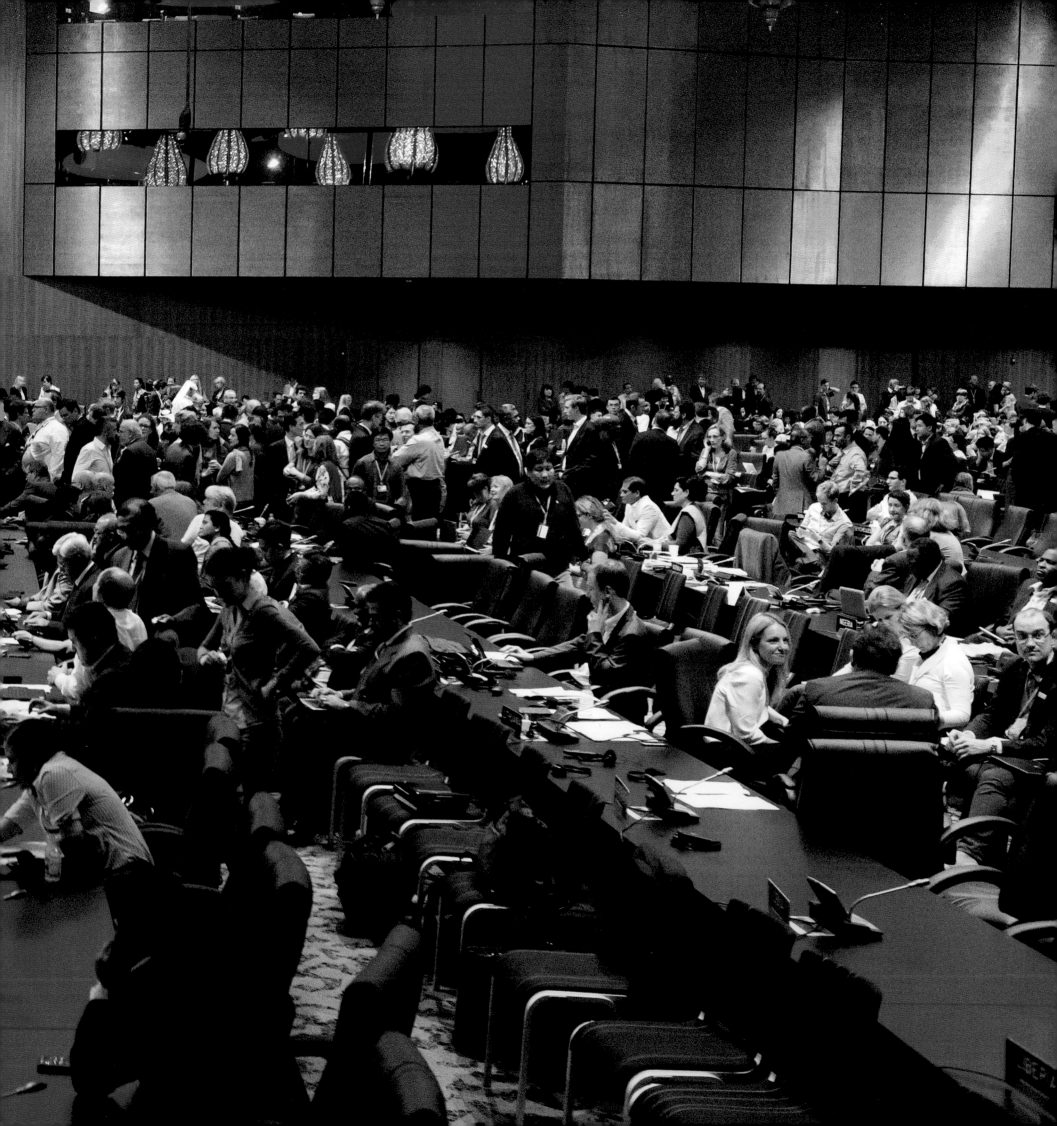

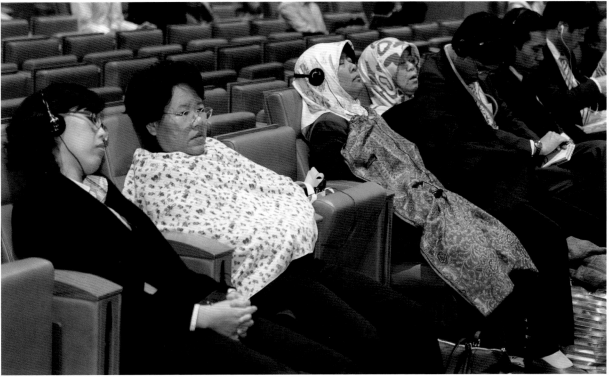

Stepping outside the plenary room to get a sandwich or a coffee, *opposite*, is an eerie experience. While there is a tangible buzz in the plenary, the rest of the conference is by now largely over; exhibitors have packed up, and many observers and participants have left. Back inside there is seemingly no end. Some participants try to sleep for a few hours on chairs, rather than risk going back to their hotels.

Suddenly, the COP President announces that the package of agreements must come to the floor. There will be no more negotiation; the plenary will sit together in open session until agreement is reached. Those countries that have been baulking at agreement will face public pressure if they persist.

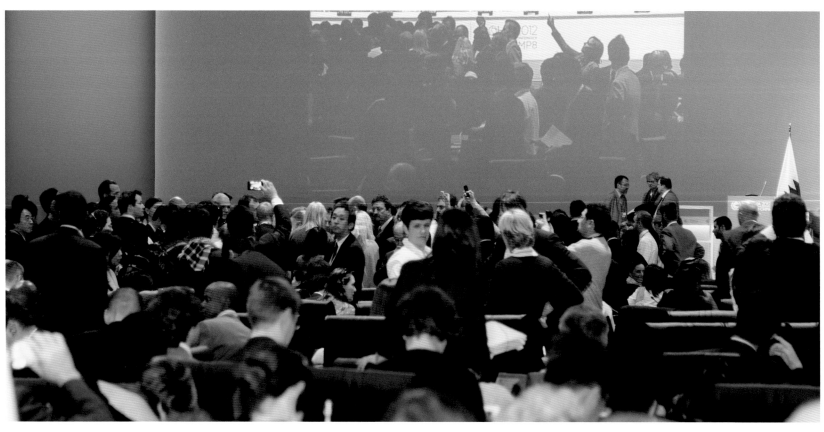

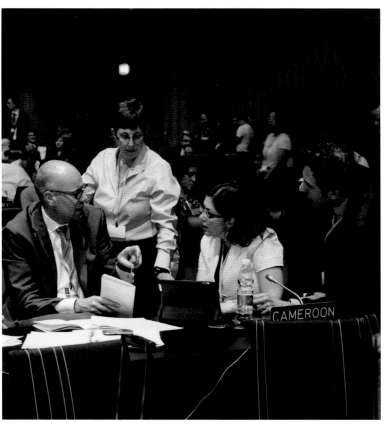

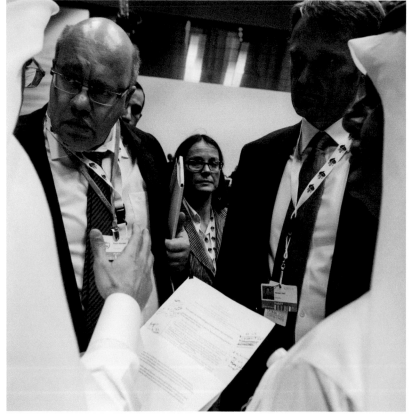

Almost imperceptibly, the word filters out that there is progress. Nations that were intractable over key issues are suddenly finding room to negotiate. Agreement is being reached on critical issues, such as finance and commitments. The list of outstanding issues is getting smaller.

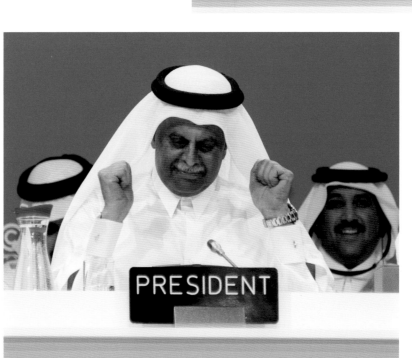

HE Abdullah bin Hamad Al-Attiyah, President of COP18/CMP8, *left* — who has had less sleep than almost anybody in the room — grasps this new momentum, and encourages delegates to move further and faster, and they do. A room where there was only doom and gloom a few hours ago has a renewed energy — there will be a deal!

The power of the moment: Mr Todd Stern, *left*, of the USA engages in direct and impromptu talks with HE Zhenhua Xie of China.

From the USA and China, attention switches to the EU. HE Ms Connie Hedegaard, *right*, European Commissioner for Climate Action, holds talks with her colleagues and then, *far right*, passes the word to HE Ms Christian Figueres, Executive Secretary of UNFCCC, things are ready to move forward.

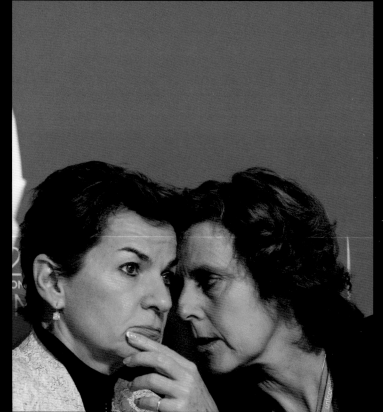

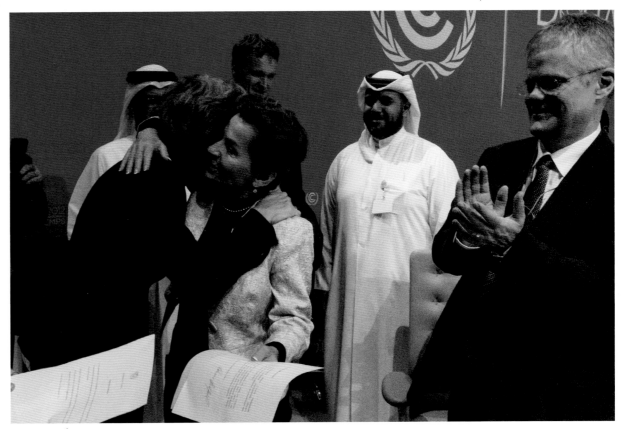

Texts are approved; a wave of celebration ripples around the vast hall, which has become the virtual home of so many participants in recent days, and attention turns to the podium for an expected announcement.

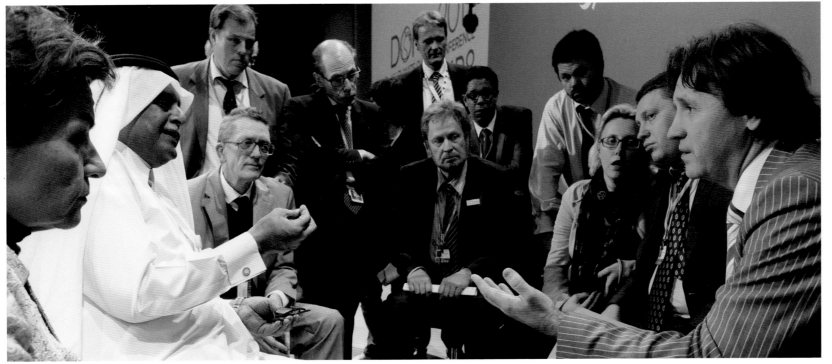

HE Oleg Shamanov, supported by the delegations of Ukraine and Belarus, is not fully convinced. HE Abdullah bin Hamad Al-Attiyah, President of COP18/CMP8, sits down to hear their concerns. Ms Christiana Figueres, Executive Secretary of UNFCCC, looks on as the COP18/CMP8 President engages in one final round of negotiations, explaining the advantages of the agreement to the delegates and seeking to bring them on board.

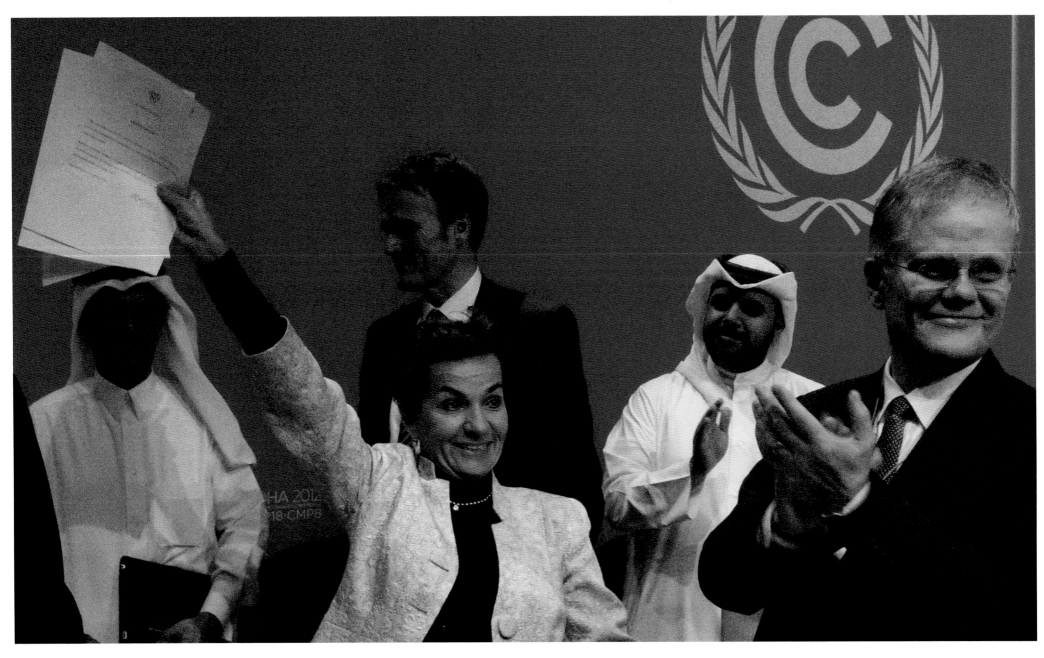

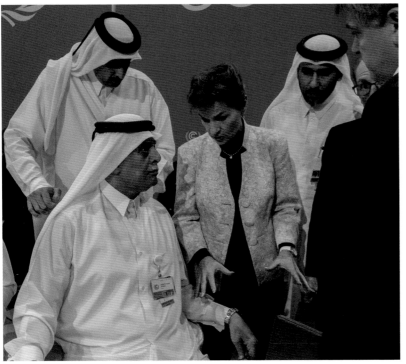

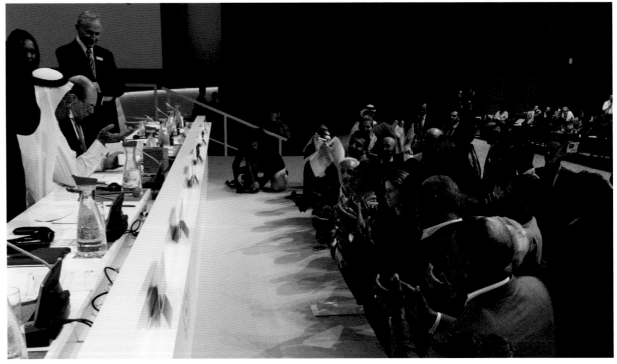

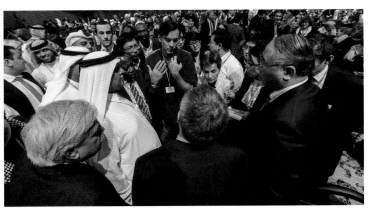

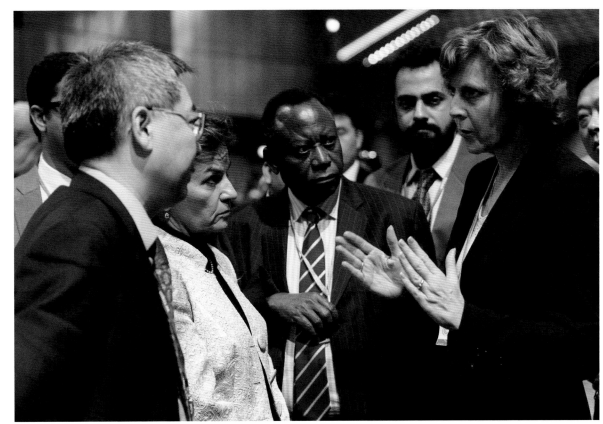

And suddenly, the deal is there. Consensus has been achieved. The hall breaks into wild applause; Ms Christiana Figueres, Executive Secretary of UNFCCC, *opposite,* waves the pages triumphantly. We did it!

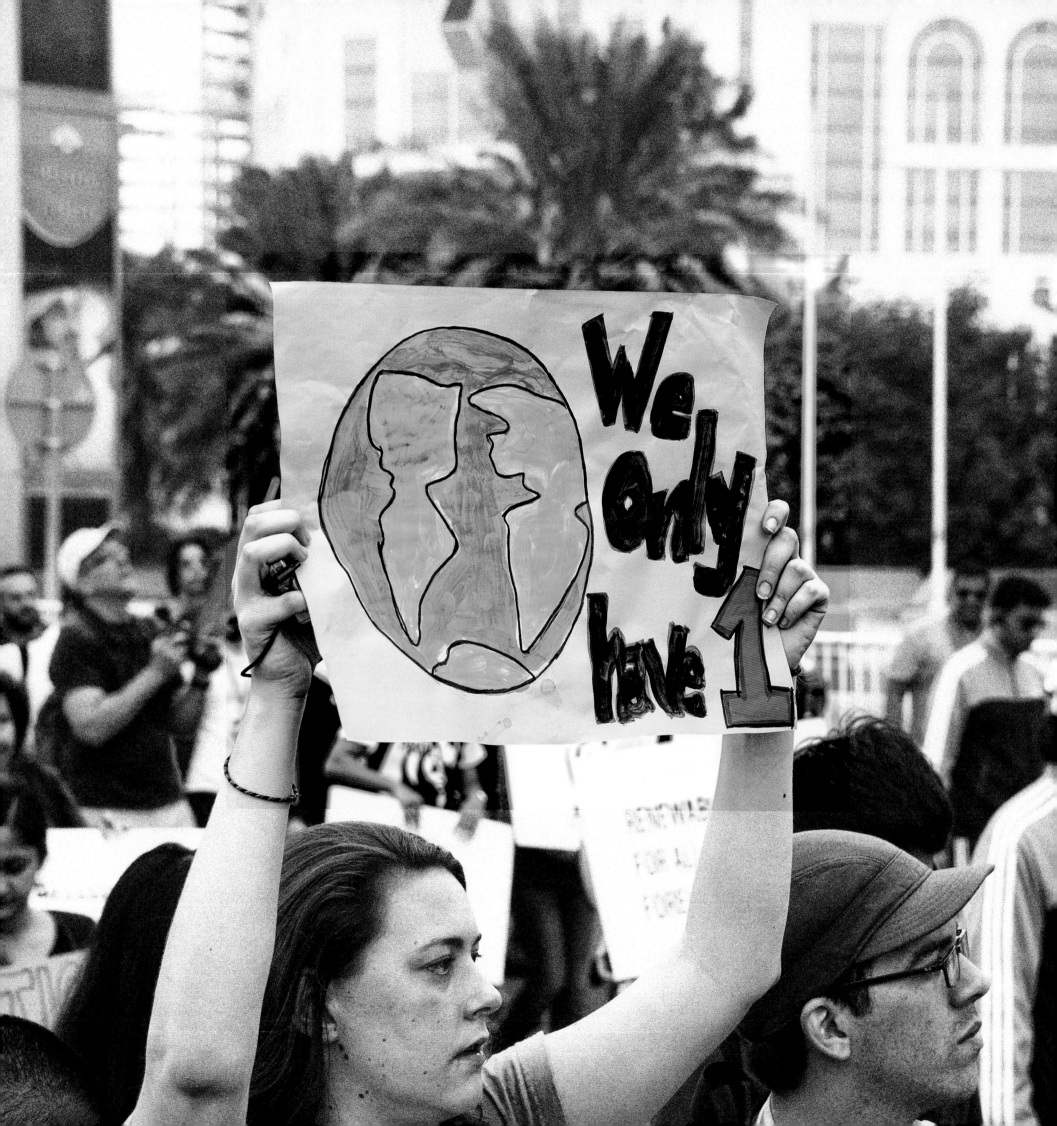

Thirteen days of talks, 16,000 participants, 2,276 meetings and 200,000 cups of coffee. In Doha, the world had come together and spoken in one voice, agreeing to move forward efforts to address climate change. At COP18/CMP8, world governments consolidated the gains of the previous three years of international climate change negotiations and opened a gateway to greater ambition and action on all levels.

The package of agreements from COP18/CMP8, now known as the Doha Climate Gateway, help to pave the way for governments to move into future negotiations with renewed vigour. The significant outcomes achieved in Doha include:

● A timetable for the 2015 global climate change agreement and a commitment to identify ways in which to go beyond existing pledges in order to scale up efforts to curb emissions before 2020.

● The pivotal amendment to the Kyoto Protocol that creates a second commitment period to cover the eight years between 2013–2020 and commits the Parties to the treaty to reducing greenhouse gas emissions by at least 18 per cent below 1990 levels during the period. The Kyoto Protocol would have expired if this crucial agreement had not been renewed at COP18/CMP8 in Doha.

● During this extended commitment period, international emissions trading and bi-national partnerships known as 'joint implementations' would also contribute a 2-per-cent share of proceeds to the Adaptation Fund, providing the framework for future international agreements.

● Agreement that governments will advance the completion of new support and infrastructure aimed at channeling both finance and technologies for climate mitigation and adaptation to developing nations. These measures include long-term climate finance commitments to developing nations with a view to mobilise US$1 billion annually from a variety of sources by 2020.

● A robust process to review the long-term temperature goal — providing by 2015, a reality check on the advancing threats of climate change.

● Institutional arrangements to provide the most vulnerable populations with better protection against loss and damage caused by slow events, such as rising sea levels.

● Support developing countries taking action on climate change, including a programme to build climate-action capacity through public awareness, education and training. Governments completed a flexible, web-based registry platform to record the mitigation actions of developing countries seeking recognition or financial support.

● Recognition and support of the actions of governments' fighting deforestration and clarification on ways in which to measure such action.

● Following a submission by Bahrain, Qatar, Saudi Arabia and the United Arab Emirates, the conference took note of the readiness of countries to put forward economic diversification plans and actions that include emission reductions and adaptation to the impacts of climate change.

The Doha Climate Gateway was achieved through the collective efforts and spirit of open and spirited negotiation produced by the unique environment of a COP conference. As the world strives to continue moving forward with increased ambition and action to address global climate change, this book serves as a window on the process and a tribute to those who continue to lead this endeavour to fulfill the great obligation we have to future generations.

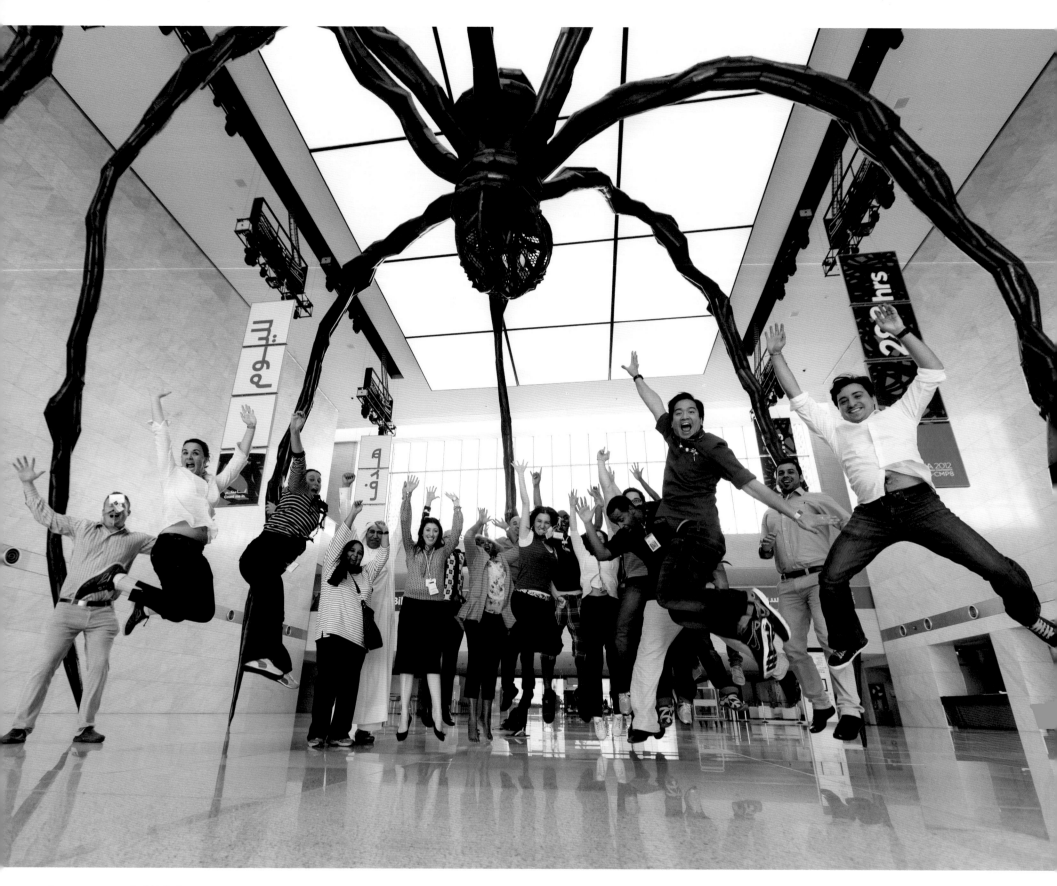

For every moment of high drama
and tension, there is an equal
moment of relief. Participants
celebrate the end of the conference
with a perfect cheer-jump — a
move that became something of
an impromptu ritual under the
spider during the conference.

Lighter moments

Any endeavour of great drama and pressure always has its lighter moments. Indeed, the more the stress and pressure, the more the need to step back, take a deep breath and release some of that tension.

There can be nothing of more importance than addressing the fate of humankind, which is — literally — what is at stake at UN climate change conferences. The pressures, therefore, can be immense on negotiators, organisers, advisors, activists, observers, journalists and those many thousands of others who work to make the event a success. And as day follows night, this pressure inevitably leads to a little folly: a moment of humour; a smile, a cheer and a little madness amid the madness.

Great bonds are also formed at such momentous events; deep, meaningful friendships forged in the scorching cauldron of international politics, high drama, 24-hour working schedules, impossible deadlines and life-changing achievements — friendships that will endure a lifetime.

And then, when it is all over — when the positions are taken, the deals reached (or not), the documents signed, the future mapped — and before fatigue sucks the remaining life out of the participant, there is another huge moment of joy, relief, solace, to gladden the heart. We came, we worked tirelessly, often against all odds, and we can now review our achievement.

One day, all of this — everything witnessed at a United Nations climate change conference, everything achieved, no matter how momentous — may be reduced to dry, ageing documents, gathering dust on a shelf or in the depths of a hard drive or website. For every conference is succeeded by another, and every new achievement inevitably overshadows that which came before.

It is for this reason that we want to highlight the very human moments of this conference, to remind you that this is a very human endeavour. People came here, they put their heart and soul into this momentous project, they looked beyond themselves, made sacrifices, and gave a little back – and they managed a smile along the way. There can be no more noble an endeavour or achievement.

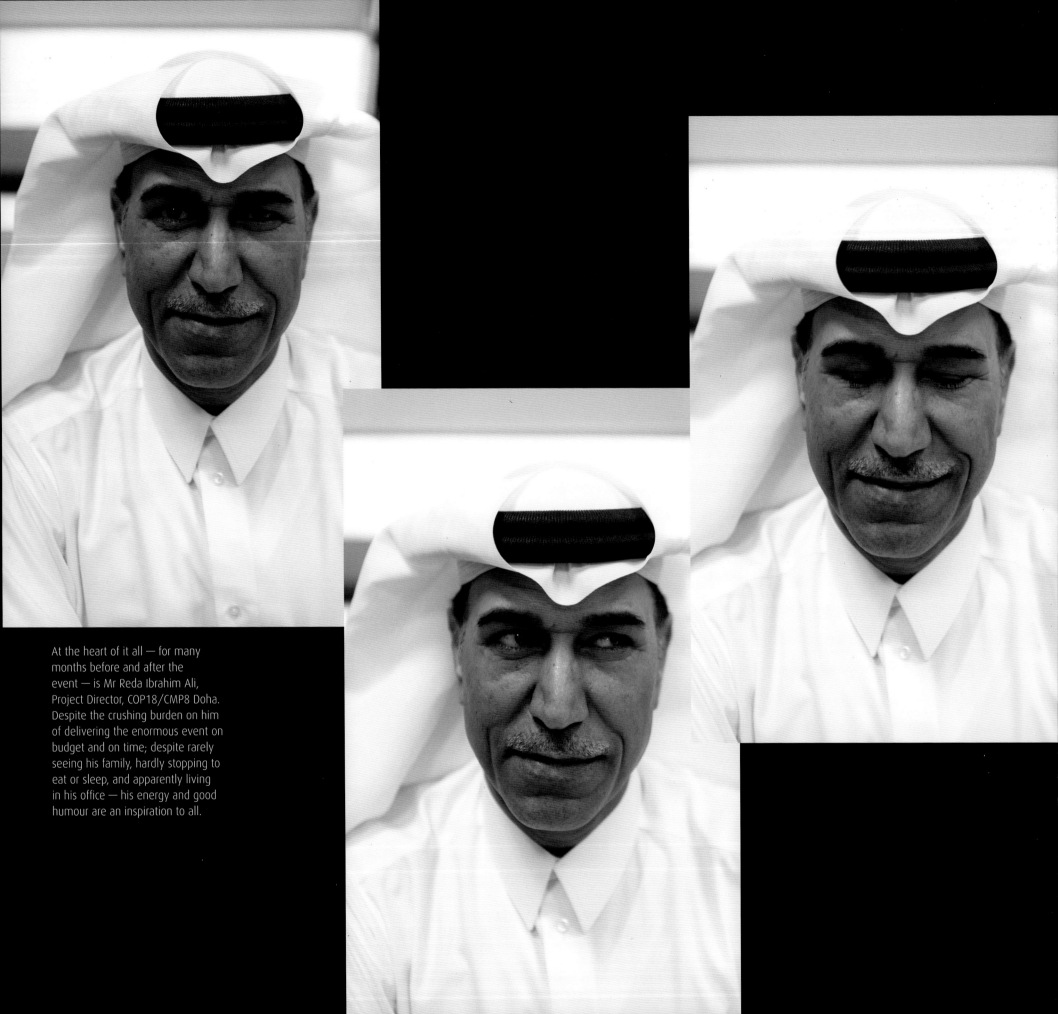

At the heart of it all — for many months before and after the event — is Mr Reda Ibrahim Ali, Project Director, COP18/CMP8 Doha. Despite the crushing burden on him of delivering the enormous event on budget and on time; despite rarely seeing his family, hardly stopping to eat or sleep, and apparently living in his office — his energy and good humour are an inspiration to all.

The COP18/CMP8 Doha dance? That would be Mr Jonathan E Smith, *right*, Senior Advisor to Mr Fahad Al-Attiya, who, as well as exotic dance moves, worked tirelessly to make the event a success.

A little conference fashion chic? That would come from Ms Kitty Ehn, *far right,* an observer at the event from Nature Youth Sweden, who urged her country's delegation to 'live up to its green reputation, and who always seemed to be a visible part of the event in her striking outfits.

Glass half full? Ms Salwa Dallalah, *below,* Coordinator for Conference Affairs Services for the UNFCCC, and her team could always be relied on to find the positive take of any situation. Meanwhile the leggings of this participant, *below right,* seemed to be making a clear message about global warming.

The indomitable Ms Christiana Figueres, Executive Secretary of UNFCCC. When not running the show, the anthropology graduate manages to find time to offer lessons in how to bow. Meanwhile one participant cannot allow the issue of global warming to get between him and an obviously crucial sports game. And if sport is your thing, *below*, a new line in sports shirts promises to be for the hottest team on offer. Then COP volunteers prove that at the end of the day – it is really all a piece of cake.

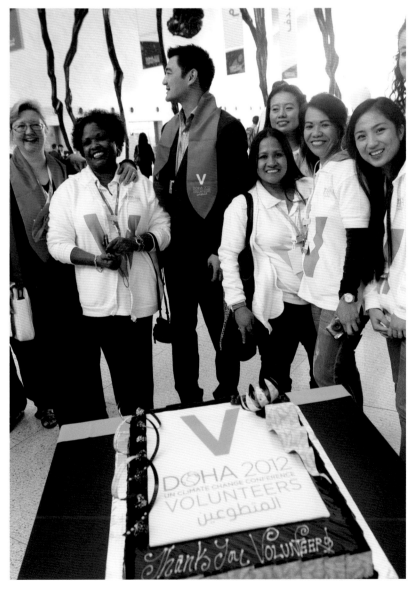

No event would be complete without a big thank you to those who put in the hard work, and at COP18/CMP8 Doha, there are a seemingly endless stream of appreciation ceremonies for those who made the event possible.

The 1,145 volunteers, who worked across every aspect of the conference, receive their thank you certificates and form a massive 'V' under the spider in the middle of the conference centre.

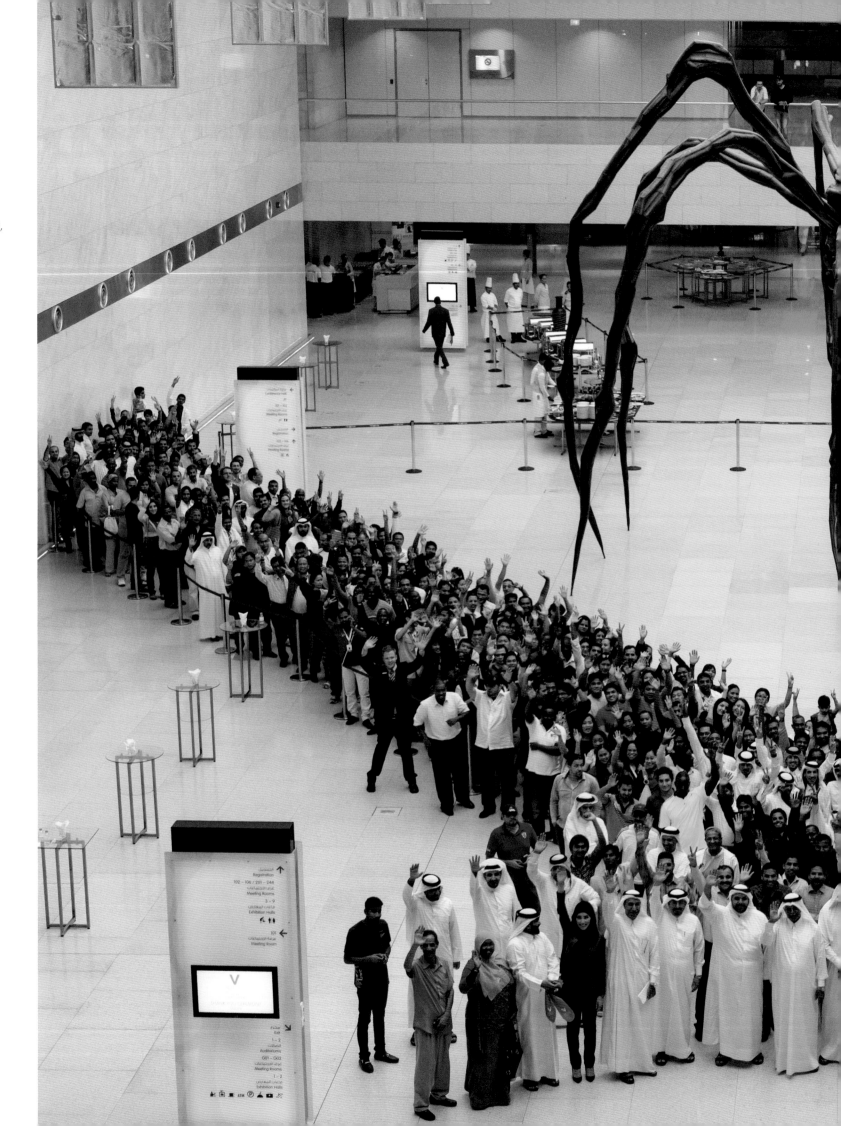

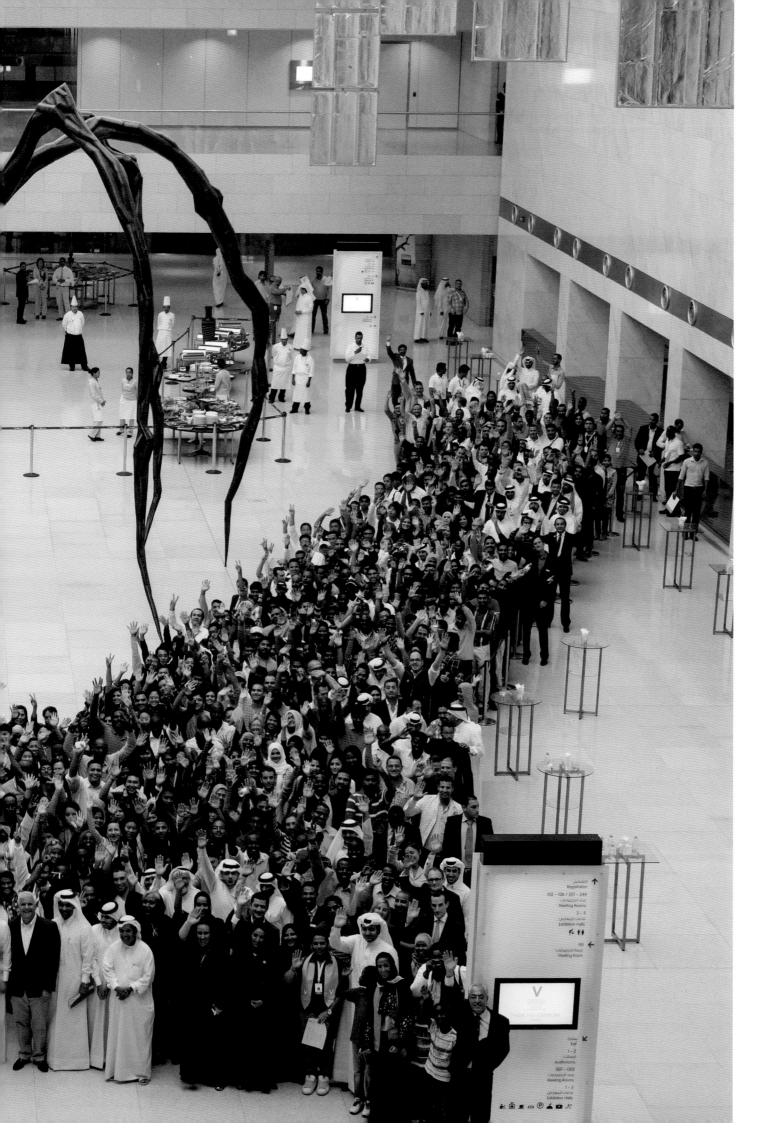

Thirteen days of endless negotiations is all too much for some at the event, as this sleepy volunteer negotiating tracker proves.

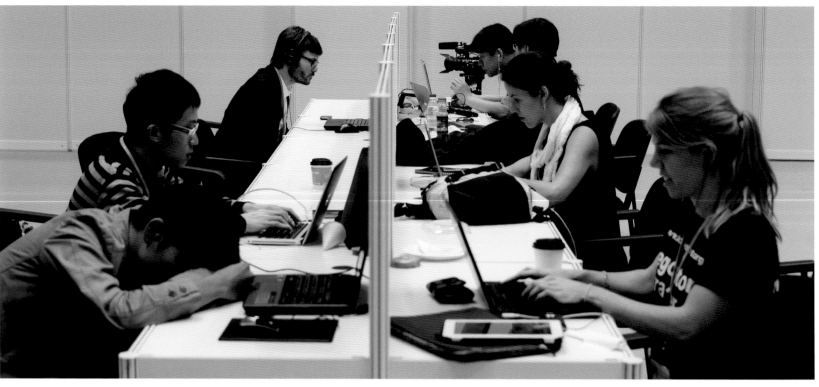

Are you ready to commit to climate change? It's a marriage made in heaven, *above*, and one that we all need to be part of, just like Sweden's ever-present Ms Kitty Ehn, *far right*.

The conference is about the future, and here are some of the (younger) Chinese conference participants showing their affinity with the host country with a little costume work.

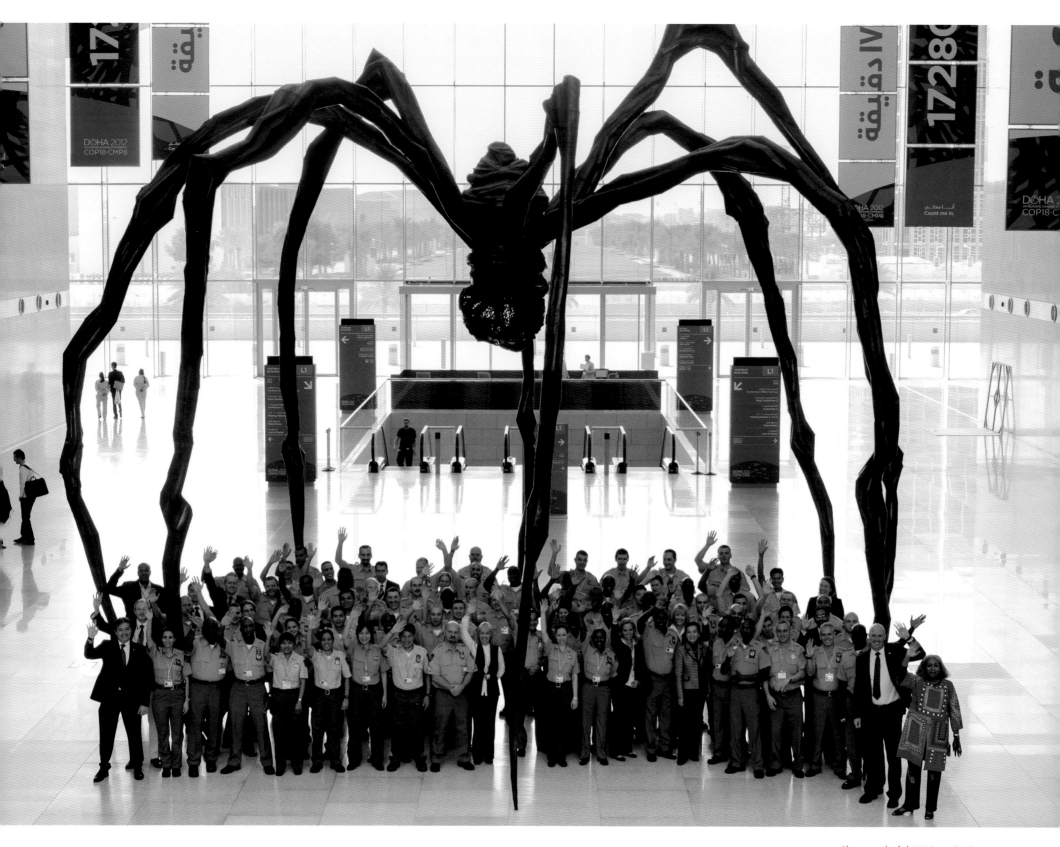

The wonderful UN Security Team, *above*, who made the conference possible, and always managed to remain good-humoured despite the inevitable trials of their profession during such a prominent and distinguished event.

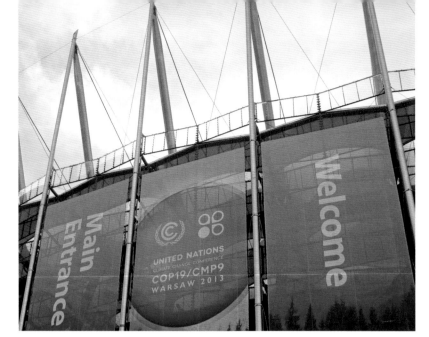

The National Stadium in Warsaw, the site of COP19/CMP9, is the largest and most modern multifunctional arena in Poland, with a capacity for more than 58,000 participants. The stadium's façade reflects the Polish national colours of red and white.

The Road Continues

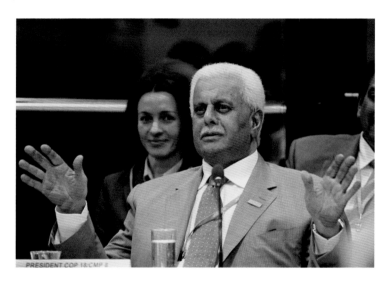

Prior to the opening of the Warsaw Conference, the President of COP18/ CMP8, HE Mr Abdullah bin Hamad Al-Attiyah, leads a meeting of the COP/CMP Bureau, the executive body that advises the President on organisational issues, to ensure that everything is in order for a smooth opening and handover of the Presidency.

At the United Nations Climate Change Conference in Warsaw, formally known as COP19/ CMP9, governments took another essential step toward a new global climate agreement. In 2009, the Copenhagen Conference produced a comprehensive political agreement that, one year later, translated into a set of formal COP decisions at the Cancun Conference. Further agreements, adopted the following year at COP17/CMP7 in Durban, kept the Kyoto Protocol alive through 2020 and launched the Durban Platform, a new round of negotiations to craft a universal climate agreement — one with legal force that is 'applicable to all' countries — in time for the Paris Conference in 2015. Continuing the momentum, COP18/CMP8 in Doha delivered the formal amendment needed to establish legally the Kyoto Protocol's second commitment period and kept governments on track for the next critical phase of the new negotiating process.

Under the leadership of HE Marcin Korolec, President of COP19/COP9, the Warsaw Conference agreed on a structure and timeline for defining the new agreement's key aspects — the legal character, the different obligations of developed and developing countries and the informational requirements for measuring national actions. Recognising that international coordination will be essential, countries also decided to submit clear and transparent plans for their contributions to the new agreement well in advance of the Paris Conference.

In Warsaw, governments also established a new international mechanism to help the most vulnerable nations cope with the loss and damage caused by extreme weather events and the inevitable impacts of climate change. Agreement was also reached on ways to help developing countries reduce emissions from deforestation and the degradation of their forests.

The Warsaw Conference marked an increased focus on flexible and practical approaches, which will help governments in aligning their international climate commitments with their national needs and circumstances. Countries also resolved to accelerate their current national actions to reduce emissions by intensifying their technical work and seeking more ministerial-level engagement in climate policy. Together these actions signaled a renewed interest by the international community in building a more robust global regime to address climate change.

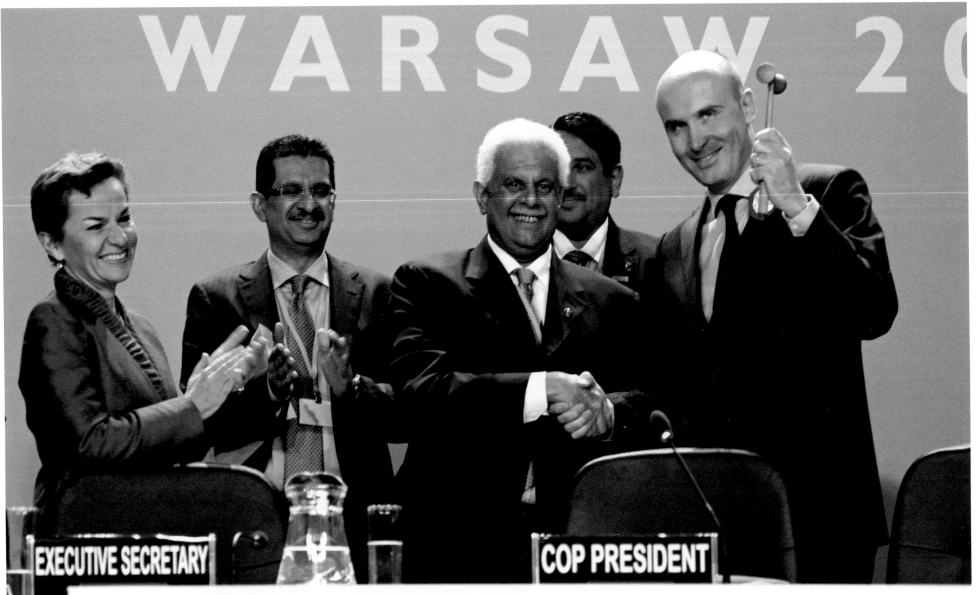

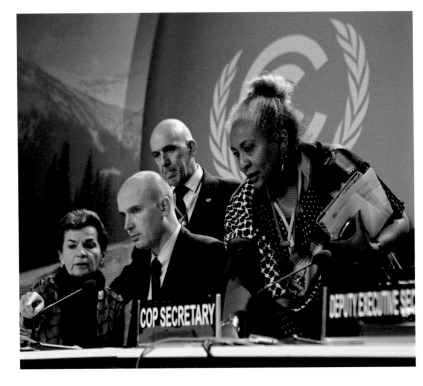

Above, HE Marcin Korolec, President of COP19/CMP9, accepts the gavel at the opening ceremony in Warsaw. From this point on, he will oversee the work of the COP and CMP by providing impartial leadership to governments. He will work closely with ministers, heads of delegation, chairs of negotiating bodies, and the COP/CMP Bureau to help deliver meaningful outcomes.

Members of the UNFCCC Secretariat, *right*, help prepare the incoming President for the opening of for COP19/CMP9. On opening day, Ms Christiana Figueres, UNFCCC Executive Secretary, bids farewell to outgoing President HE Abdullah bin Hamad Al-Attiyah, *far right*.

HE Marcin Korolec, *left*, the newly elected President of COP19/CMP9, makes his inaugural address at the Warsaw Conference. He characterised climate change as a global problem that must be turned into a global opportunity: 'It's a problem if we can't coordinate our actions. It becomes an opportunity where we can act together. One country or even a group cannot make a difference, but acting together, united as we are here, we can do it'.

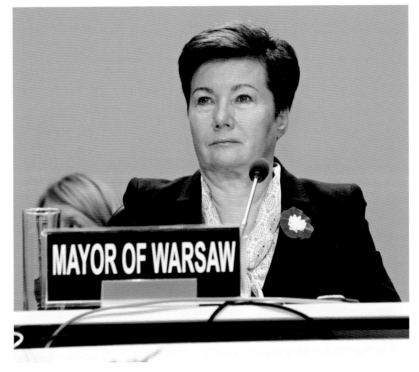

Welcoming delegates, Ms. Hanna Gronkiewicz-Waltz, Mayor of Warsaw, *left*, highlighted her city's sustainable activities in water management, transportation and energy.

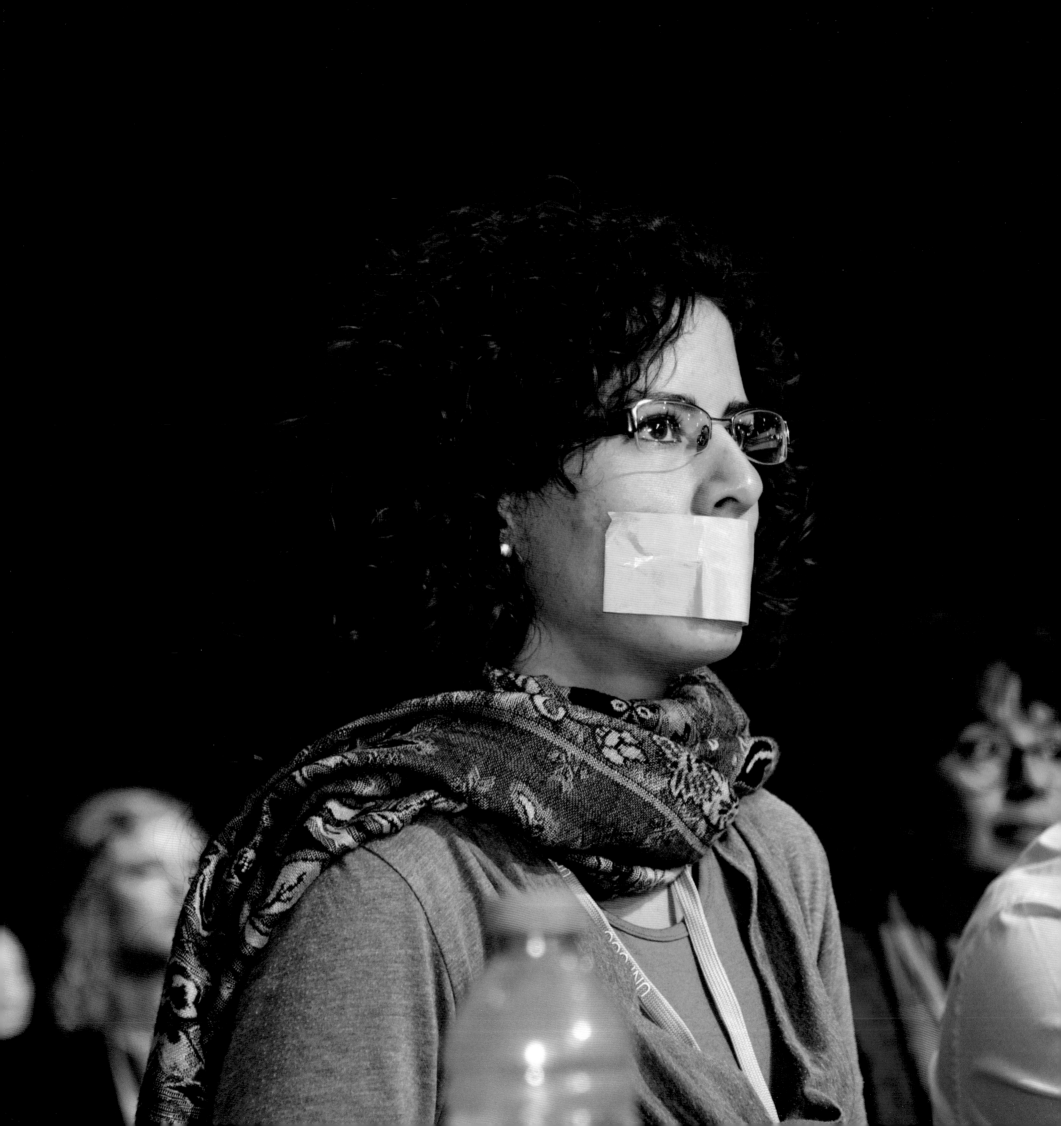

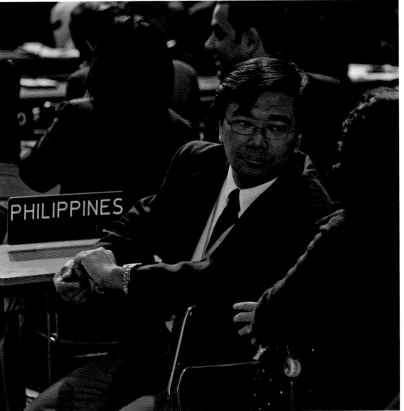

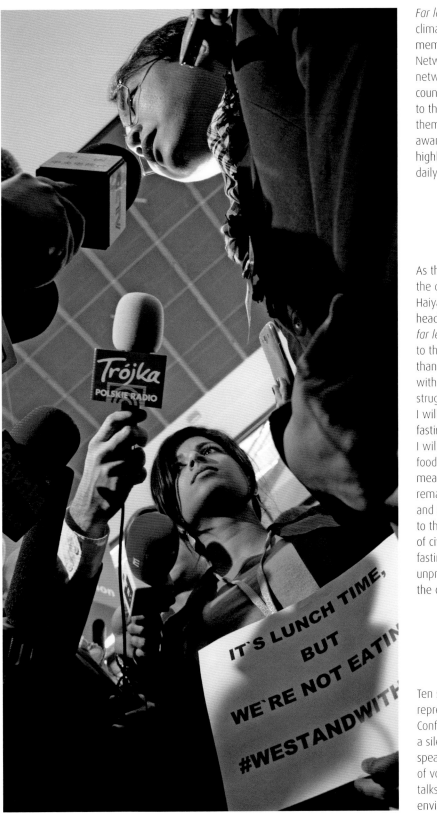

Far left, During United Nations climate change conferences, members of the Climate Action Network, a worldwide environmental network of NGOs, vote for the countries that made the worst input to the negotiations and present them with the 'Fossil of The Day' award. The slightly sarcastic yet highly popular awards are presented daily during climate talks.

As the world watched with horror the devastation wrought by typhoon Haiyan, Mr Naderev 'Yeb' Saño, the head of the Philippines delegation, *far left*, made an emotional appeal to the negotiating teams of more than 190 countries. 'In solidarity with my countrymen who are struggling to find food back home, I will now commence a voluntary fasting for the climate. This means I will voluntarily refrain from eating food during this [conference], until a meaningful outcome is in sight.' His remarks triggered a standing ovation and one minute of silent respect to the hurricane victims. Members of civil society, *left*, joined Saño in fasting, in a move many said was unprecedented in the history of the climate conferences.

Ten seconds of silence from an NGO representative during the Warsaw Conference, *opposite*. She made a silent protest during her allotted speaking time to highlight the lack of voice for youth at the climate talks and their demands for a better environment for future generations.

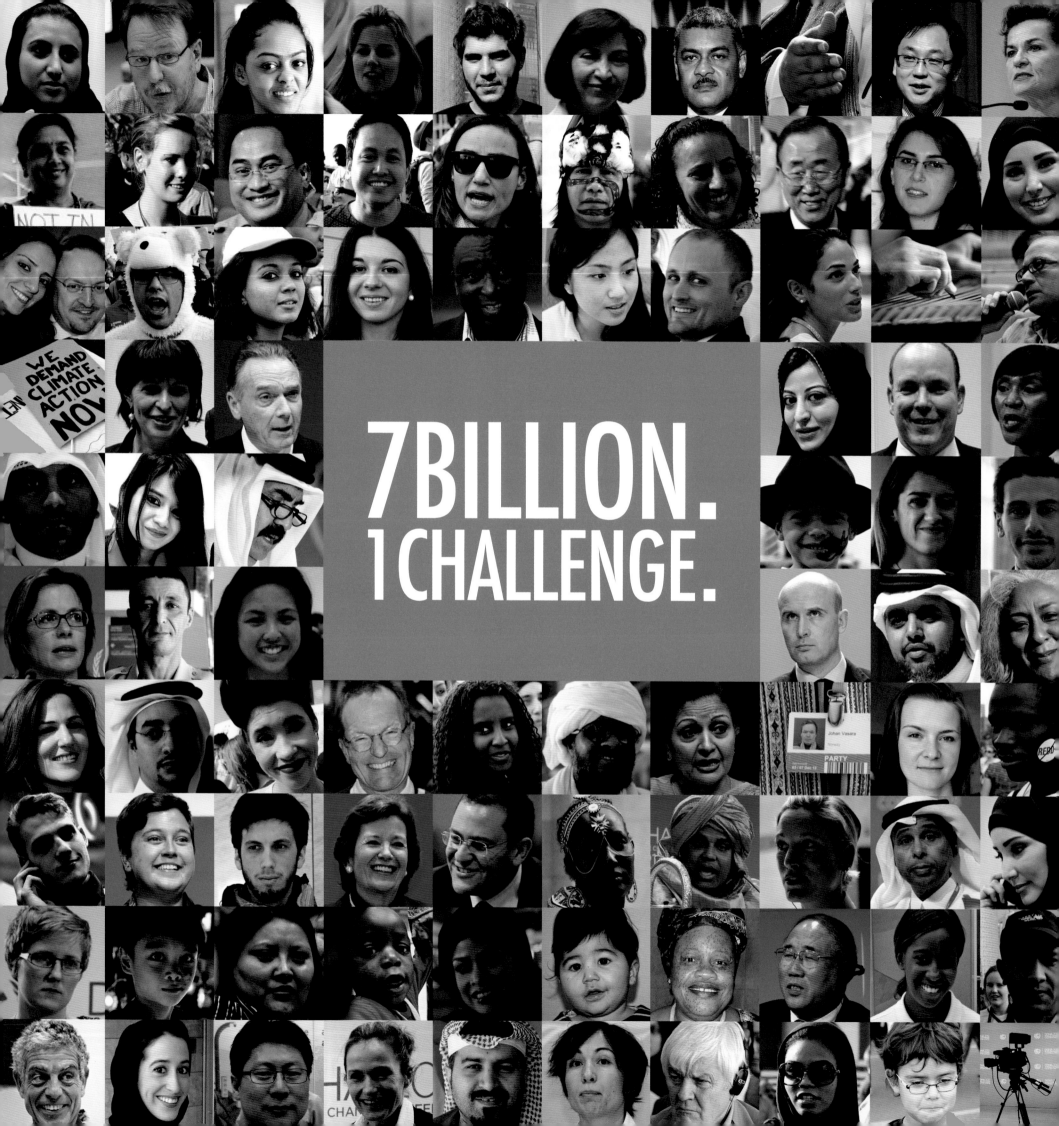

7BILLION.
1CHALLENGE.

Epilogue

COP18 was a remarkable experience and the event was particularly significant since it was held in the Arab region for the first time, in a country which is a major exporter of hydrocarbons. The facilities and services provided by all sections of society in Qatar, and especially by the Government, were of an extremely high order.

This book is a reminder of the COP18 journey, capturing the hard work and dedication of the organisers, the enthusiasm of hundreds of NGOs and activist groups, and the presence of dignitaries from across the world, all striving for solutions to the problem of climate change.

The Chairman of the Intergovernmental Panel on Climate Change (IPCC), Dr Rachendra Pachauri, *above*, presented the findings of the Fifth Assessment Report, which strengthened the call for urgent action. Each of the last three decades has been successively warmer at the Earth's surface than any preceding decade since 1850, and it is extremely likely that human influence has been the dominant cause of the observed warming since the mid-20th century. Since the early 1970s, glacier mass loss and ocean thermal expansion from warming together explain about 75 per cent of the observed global average rise in sea level.

Climate change is a global threat and must be addressed urgently. In the contribution of Working Group 1 to the Fifth Assessment Report of the IPCC, it states that warming of the climate system is unequivocal: that the 'atmosphere and ocean have warmed, amounts of snow and ice have diminished, sea level has risen, and the concentrations of greenhouse gases have increased.' There is also stronger evidence in support of the anthropogenic nature of a warming atmosphere and oceans.

Given existing lifestyles, a rapidly expanding population, growing demand for energy and unsustainable growth patterns, emissions of greenhouse gases (GHGs) continue to increase. According to findings of IPCC's Special Report on Managing Risks of Extreme Events and Disasters to Advance Climate Change Adaptation, a 1-in-20 years hottest day is likely to become a 1-in-2-year event by the end of the 21st century; average tropical cyclone wind speed is likely to increase; and there is high confidence that changes in heat waves, glacial retreat, and/or permafrost degradation will cause slope instabilities, movements of mass and glacial lake outburst floods. Sectors affected most will be water, agriculture and food, forestry, health and tourism.

Only if prompt action is taken towards both mitigation of GHG emissions and adaptation by vulnerable societies to the risks of climate change can there be holistic protection of the earth's ecosystems, all forms of life, cultural heritage and property. To facilitate mitigation, enhancement of renewable energy capacities and improvements in efficiencies of energy-intensive activities would need to be considered. Clean energy initiatives would need to be expanded on a local, national as well as international scale. Moreover, adaptation measures such as early warning systems, climate proofing infrastructure, multi-hazard risk assessment and education and awareness would assume importance. The State of Qatar has a very progressive approach, guided by an inspired leadership, towards tackling the challenge of climate change. It is heartening to see that Qatar, despite being a largely hydrocarbon-based economy, has invested heavily in clean energy technologies and has committed itself to minimising environmental damage caused by burning of fossil-fuels .

The Qatar National Vision 2030 states: 'Wherever there is an environmental cost to be paid for economic progress, it must be compensated with investments in technologies that help improve the environment.' This is a doctrine that the global community must consider embracing if it wants to leave a better world for future generations.

Dr R K Pachauri
CHAIRMAN, IPCC

Photographer's Statement

The hours seemed to blend into one elongated 'trance' during the days and nights of the UNFCCC COP18/CMP8 conference in Doha. Walking through the vast halls and seeing thousands of people passionately engaged in addressing the issue of climate change — one that involves rich and poor, large countries and small, and is crucial to the future of our planet — was truly memorable.

Hiding behind the camera lens to capture the highs and lows and the preparation behind the scenes, whether in the vast kitchens, the hallways, the plenary sessions or the VIP lounge, where the world leaders informally gathered before coming into the main plenary for the High-Level opening, were all highlights for me. What an honour it was and how exciting to be able to experience the work of UNFCCC first hand.

Having spent several years photographing all across the State of Qatar, I felt I had a more intimate relationship with the country. I have witnessed its rapid transformation over the past few years, and I therefore felt particularly proud to see how well Qatar hosted such a large and important event on the world stage.

In creating this book, I was very pleased to have received such a warm welcome from all those who played a part at the conference, from the members of the Higher Organising Committee, to UNFCCC, to the participants, to the UN security team. As a single photographer, it is impossible to capture every moment of such an event, and I am therefore grateful for additional images contributed by fellow photographers, Sallie Shatz and her team, and to Andreas Hofer, Elena Stavenko and Terry Jeavons.

Thanks also to Christopher Hack, who was intimately involved even before the conference started and who, together with Chad Carpenter, provided the text for this book. Much appreciation also goes to others who helped with the creation of this book, including COP18/CMP8 President HE Abdullah bin Hamad Al-Attiyah, HE Fahad bin Mohammad Al-Attiya, Chairman of the Organising Sub-Committee for COP18/CMP8, Mr Reda Ali, Jonathan Smith, Leanne Arnold, Antoine Artiganave, Olfa Guetata and Samer Frangieh. And finally I am indebted to Salwa Dallalah of UNFCCC who provided me with a better insight into the organisation and the ever-changing, hour-by-hour happenings as events unfolded in Doha and again in Warsaw at COP19 the following year.

This book serves as a memento of a great event and one that occurs every year. Camaraderie is formed when so many people gather for a global cause, whether world leaders, NGOs, volunteers, security staff, cooks, drivers and everyone behind the scenes. They spend so much time together at the event, they make many friends, and the adrenaline of the conference itself is both exhilarating and exhausting. Favourite moments still remain with me — especially sipping tea amid the hustle and bustle of Doha's Souq Waqif after the conference had drawn to a close.

Sign the

to show

commitme

envir